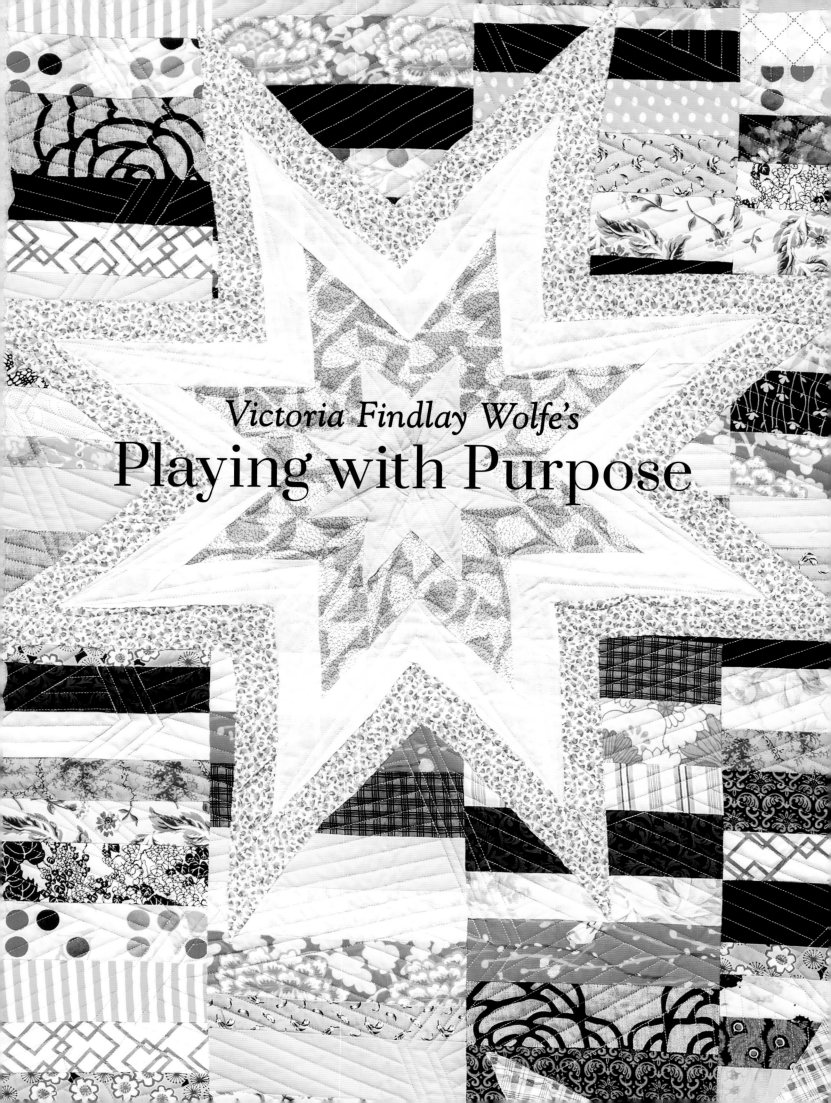

Victoria Findlay Wolfe's
Playing with Purpose

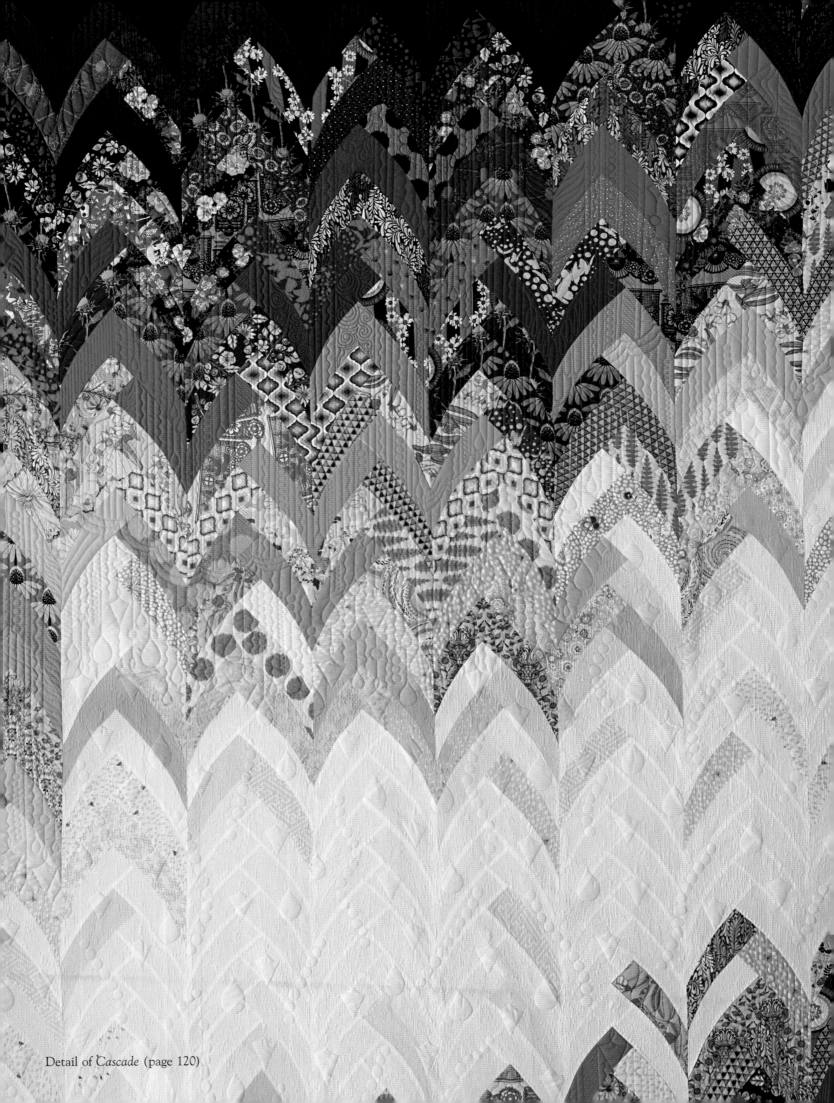

Detail of *Cascade* (page 120)

Victoria Findlay Wolfe's
Playing with Purpose

A QUILT RETROSPECTIVE

stash BOOKS.
an imprint of C&T Publishing

Text copyright © 2019 by Victoria Findlay Wolfe

Photography copyright © 2019 by C&T Publishing, Inc.

Publisher / Amy Marson

Creative Director / Gailen Runge

Acquisitions Editor / Roxane Cerda

Managing/Developmental Editor / Liz Aneloski

Cover/Book Designer / April Mostek

Production Coordinator / Zinnia Heinzmann

Production Editor / Alice Mace Nakanishi

Photo Assistant / Rachel Holmes

Cover photography by Kelly Burgoyne of C&T Publishing, Inc.

Interior photography by Kelly Burgoyne and Mai Yong Vang
of C&T Publishing, Inc., unless otherwise noted

Cover quilt: Detail of *Texture, Travel, and Happiness: Life of Experiences
and the Responsibilities of Dreams*, page 151

Title page star quilt: Detail of *POW!*, page 59

Published by Stash Books, an imprint of C&T Publishing, Inc.,
P.O. Box 1456, Lafayette, CA 94549

Library of Congress Cataloging-in-Publication Data

Names: Wolfe, Victoria Findlay, 1970- author.

Title: Victoria Findlay Wolfe's playing with purpose : a quilt retrospective /
Victoria Findlay Wolfe.

Other titles: Playing with purpose

Description: Lafayette, CA : C&T Publishing, Inc., [2019]

Identifiers: LCCN 2018046738 | ISBN 9781617458286 (hardcover : alk. paper)

Subjects: LCSH: Quilting--Anecdotes. | Patchwork quits--Pictorial works.
| Wolfe, Victoria Findlay, 1970---Anecdotes. | Quiltmakers--United
States--Anecdotes.

Classification: LCC TT835 .W64265 2019 | DDC 746.46--dc23

LC record available at https://lccn.loc.gov/2018046738

Printed in China

10 9 8 7 6 5 4 3 2 1

Detail of *Modern Square Dance* (page 107)

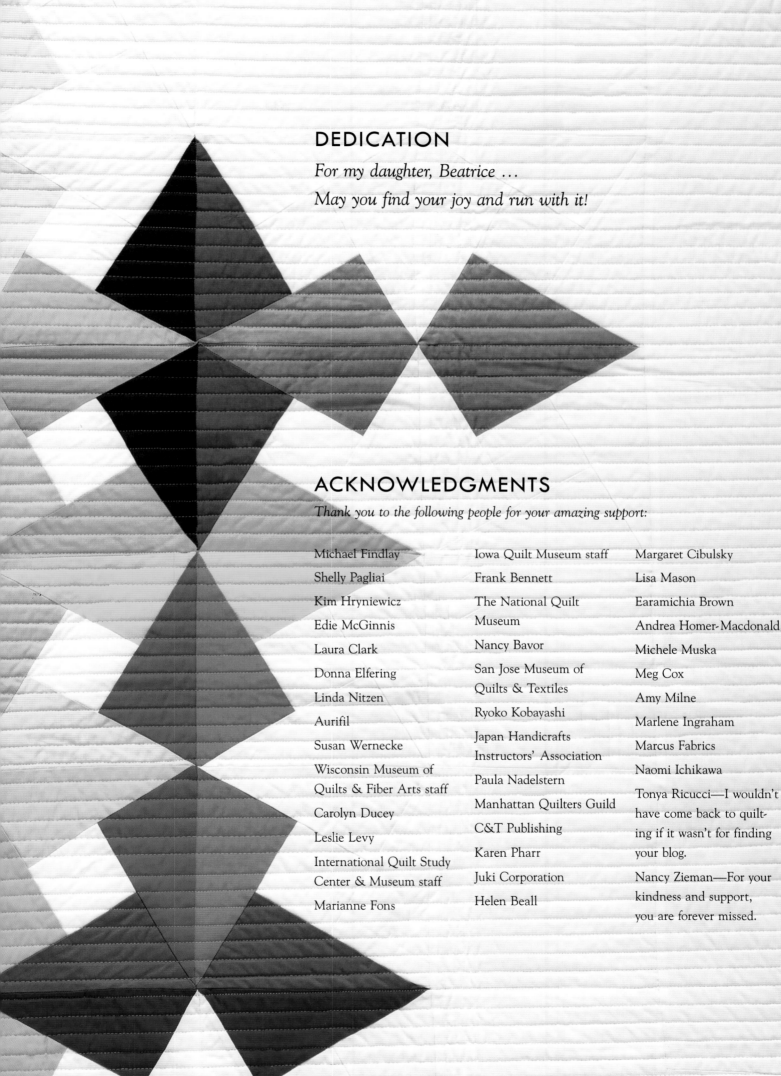

DEDICATION

For my daughter, Beatrice …
May you find your joy and run with it!

ACKNOWLEDGMENTS

Thank you to the following people for your amazing support:

Michael Findlay

Shelly Pagliai

Kim Hryniewicz

Edie McGinnis

Laura Clark

Donna Elfering

Linda Nitzen

Aurifil

Susan Wernecke

Wisconsin Museum of
Quilts & Fiber Arts staff

Carolyn Ducey

Leslie Levy

International Quilt Study
Center & Museum staff

Marianne Fons

Iowa Quilt Museum staff

Frank Bennett

The National Quilt
Museum

Nancy Bavor

San Jose Museum of
Quilts & Textiles

Ryoko Kobayashi

Japan Handicrafts
Instructors' Association

Paula Nadelstern

Manhattan Quilters Guild

C&T Publishing

Karen Pharr

Juki Corporation

Helen Beall

Margaret Cibulsky

Lisa Mason

Earamichia Brown

Andrea Homer-Macdonald

Michele Muska

Meg Cox

Amy Milne

Marlene Ingraham

Marcus Fabrics

Naomi Ichikawa

Tonya Ricucci—I wouldn't
have come back to quilt-
ing if it wasn't for finding
your blog.

Nancy Zieman—For your
kindness and support,
you are forever missed.

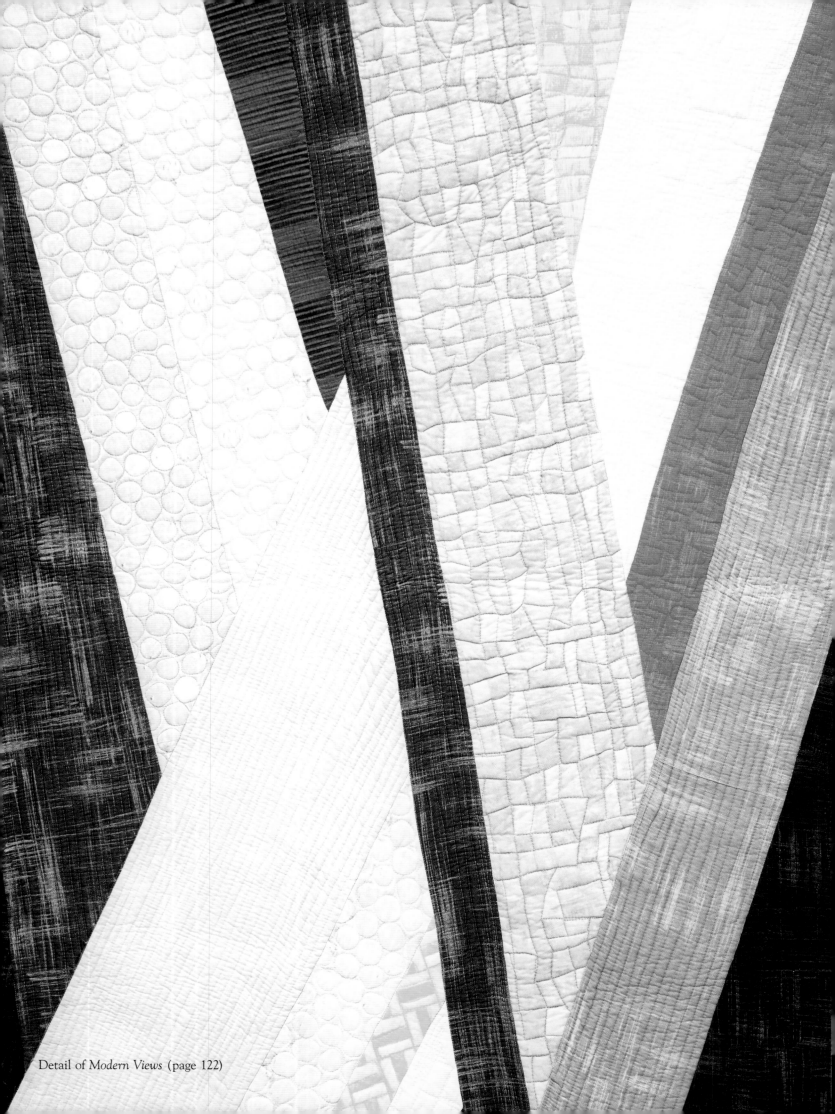

Detail of *Modern Views* (page 122)

Contents

Finding My Way

My earliest memory, in kindergarten, was being asked what I wanted to be when I grew up: "An artist!" I would chirp. I was always fascinated by color, pattern, and design. Sleeping under double-knit polyester scrap quilts certainly set my color sense from a young age! A sign of the times!

Growing up on the farm, though, I knew I would not stay there; I always had a wandering spirit. I wanted to explore and see what else was out there—both as a physical journey and a creative one.

I enjoyed the basic skills I learned on the farm—sewing, gardening, fixing fences, making clothes—but I did not think that anything I learned on the farm would serve me in my artistic future. I was, however, a teenager, and that explains a lot. ... I wanted my life to go beyond the parameters of the farm, there was more to *see* in life, and I wanted out of the country.

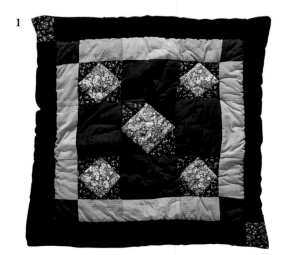

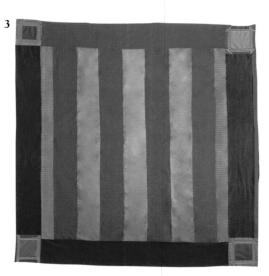

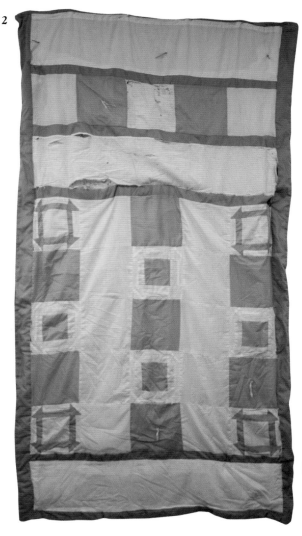

[1] *First Quilt*
Victoria Findlay Wolfe,
1983, 27″ × 27″,
hand quilted

[2] *Sadie's Quilt*
Victoria Findlay Wolfe,
1989, 45″ × 84″

Photo by Victoria Findlay Wolfe

[3] *Amish Inspired*
Victoria Findlay Wolfe,
1989, 81″ × 78″,
unfinished top

In college, I knew I would never waver from being an artist. I looked for anything I could do different from my peers. If they were designing on the computer, I was cutting paper. If they were gessoing canvases, I painted on cotton with acrylics. Instead of appreciating my innovative techniques, my teachers would pull me into the hallway and say that stitching fabrics together was just a *craft*, not *art*. To me, that is a tireless 500-year-old controversy that does not need to exist. Of course quilts are art!

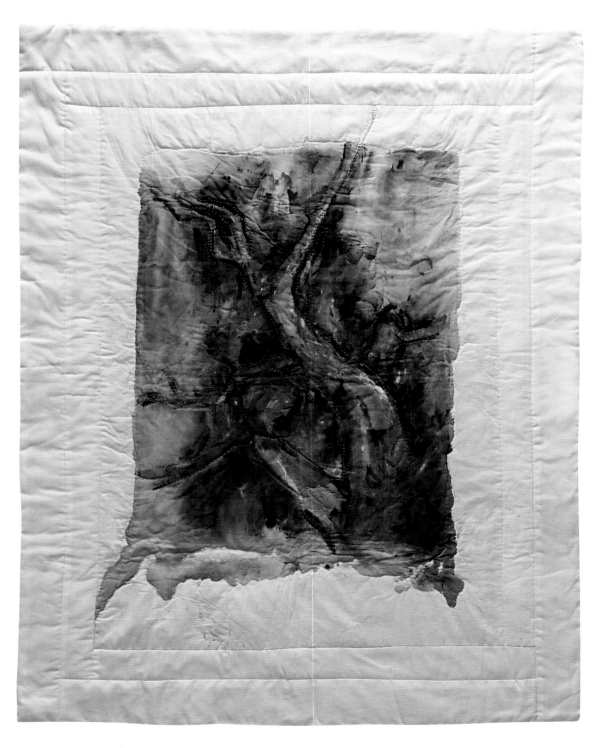

When I was in college, I made a painting on canvas titled "A Tree on Summit Ave." Then, I painted a similar tree with acrylics on cotton that became this quilt. I was very inspired by the effects I achieved. But I was told that this was *craft* and it didn't belong in art school. Our path is always varied. I wonder where my path would have taken me sooner had I been encouraged to explore textile design back then. In a way, it made me work even harder to go after my goals.

Tree on Summit / Victoria Findlay Wolfe, hand quilted by Donna Elfering, 1992, 42½″ × 42½″

I left Minnesota in 1994 to move to New York City. I worked at a picture-framing store for three years and another year in antique frame sales, framing amazing works of art like Cézanne, Picasso, and Braque.

I had a painting studio in SoHo until there was a devastating flood in the building and I lost most of my work. This certainly put a hold on my world of creating. My brain stopped thinking about painting, but I never stopped seeing. I picked up my camera and did a lot of work digitally and immersed myself in looking at images, text, and layering within the photography format.

During this time, I had also started my family. We awaited for the news to travel to China to meet our baby girl. While I waited, I was gardening and canning my delicious produce. I got obsessed with learning to make everything fresh and can it all myself. I've always been fascinated by the way things are made.

I also started making baby quilts and the furnishings I'd need for the nursery. So, although the painting was erased from my lifestyle, I was finding joys in other aspects of creating ... from gardening and cooking, to baby quilts and clothing, to photography and crochet. It's hard for me not to try something new or find creativity in anything I am doing.

Quite unexpectedly, I started a small business making custom children's clothing, and I did that for about a year before solidly working only in quiltmaking.

Figure 1 / Victoria Findlay Wolfe, hand quilted by Donna Elfering, 1991, 39˝ × 46˝

The key goal in my journey has always been following the joy. That is the *purpose*. If it's not the one thing that grabs my attention most, I would move on to the next creative project. But quiltmaking has held my attention the longest; I can push fabrics around like paint on the canvas, and to me, that is the *play* I enjoy most. I love the challenges of learning new techniques, combining skills, and seeing what else I can do! What else can I try? I am like a kid in a candy store, looking for the next sugar rush. The process of playing with color and pattern actually gives me a physical feeling of joy, so I call it an extreme sport. I take risks, I challenge myself, I force myself out of my comfort zone on a daily basis. By doing so, I glow in my creative process. The physical outcome is not as important to me as is the journey to get me from the start of one project to the start of the next. I do hope your journey gives you joy, because if it does not, dig deeper and find something that does.

If anyone had told me when I was thirteen that I would be a quiltmaker when I grew up, I would have said, "You're crazy." But I am clear that being an artist is what I am. Quilter, artist, maker. I make.

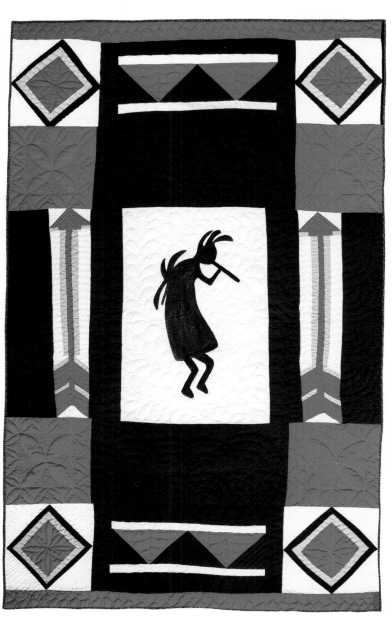

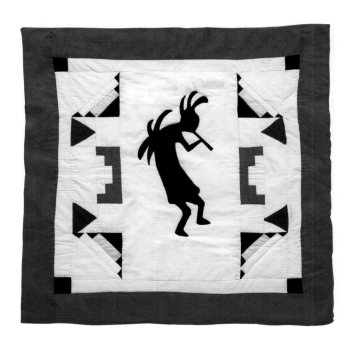

Kokopelli / Victoria Findlay Wolfe, 1991, 42″ × 42″

Kokopelli Revisited / Victoria Findlay Wolfe, 1993–2012, 59″ × 94″, from the collection of Michael C. Meier

Sharing moments. Back in early 2000s, my daughter and I learned about the Gee's Bend quilters (Alabama) while watching a documentary on Dr. Martin Luther King, Jr. We were so moved by the Gee's Bend quilters' story that we ordered a book that day. Once we received it, we flipped through the pages and picked out our favorites. My daughter helped choose the fabrics for this quilt, because it was made for her bed. Quilting has a magic of bringing people and stories and moments together. *Beatrice's Quilt* was hand quilted with love in every stitch. The improv aspect of this quilt is something I carry with me in every quilt I make.

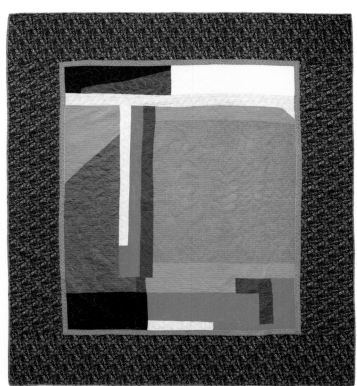

Color Block Quilt / Victoria Findlay Wolfe, 2009, 81˝ × 93˝

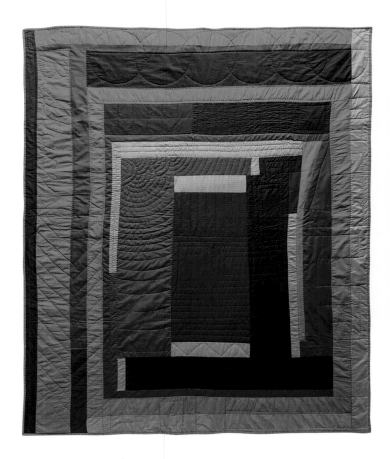

Beatrice's Quilt / Victoria Findlay Wolfe,
2008, 71˝ × 86˝, hand quilted

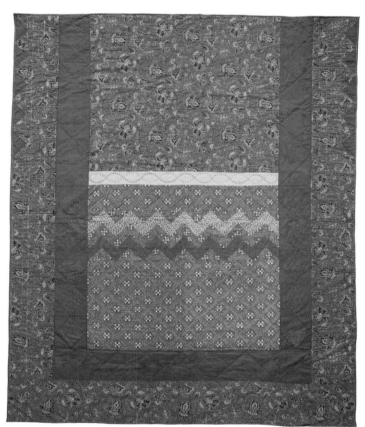

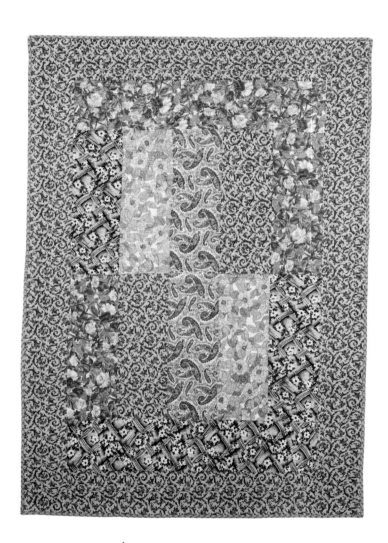

Red Matisse / Victoria Findlay Wolfe,
2009, 71″ × 87″, hand quilted

Vintage Browns / Victoria Findlay Wolfe,
quilted by Linda Sekerak, 2009, 58″ × 83″

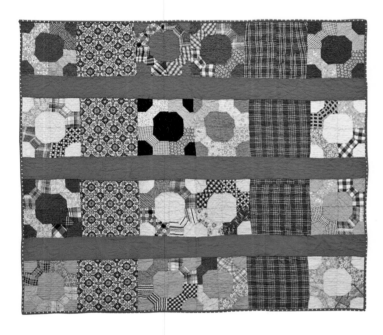

Birthday Wishes Redo / Victoria Findlay Wolfe,
2008, 65″ × 56½″, from the collection of Ron Reeves

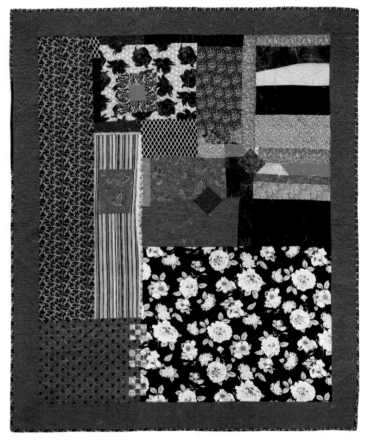

3-Minute Challenge / Victoria Findlay Wolfe, 2009, 68″ × 86″

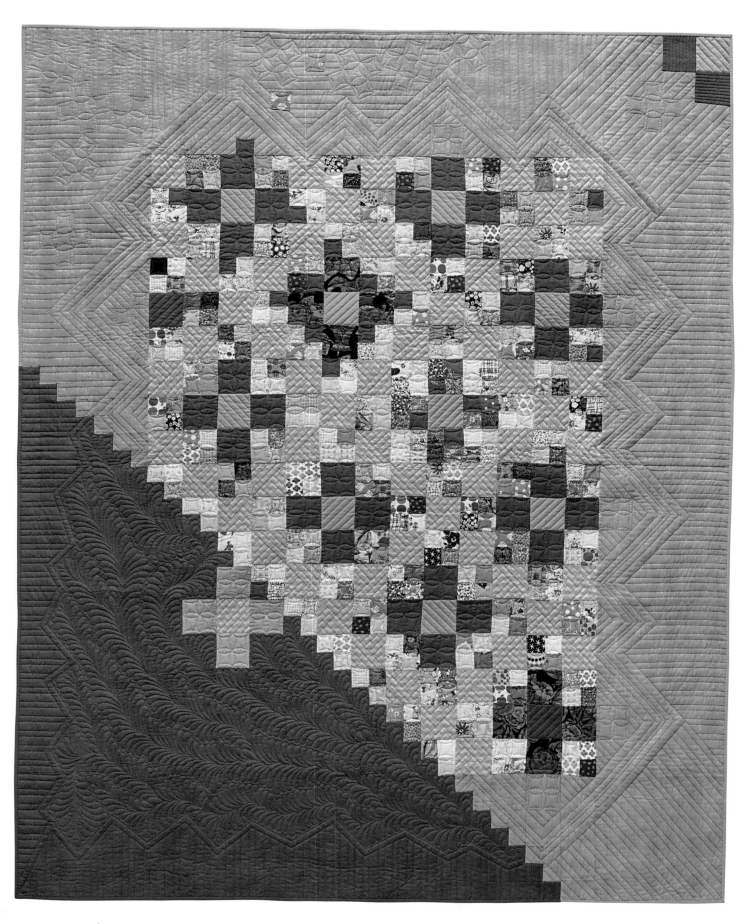

Red Crosses / Victoria Findlay Wolfe, quilted by Frank Palmer, 2009–2017, 59˝ × 74˝

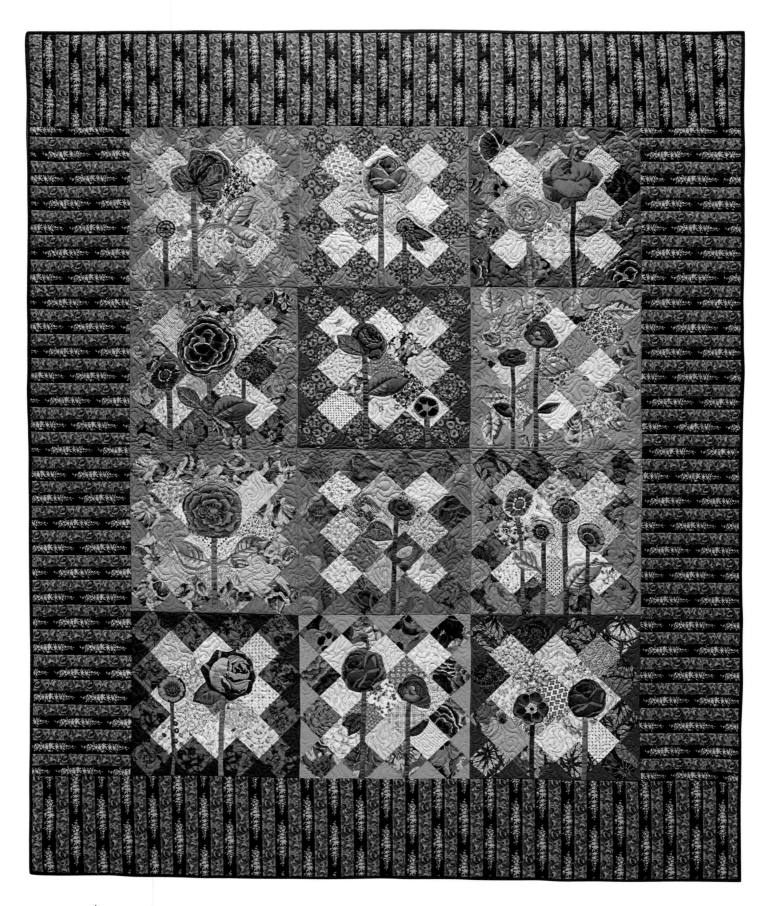

On Point / Victoria Findlay Wolfe, quilted by Linda Sekerak, 2009–2011, 75˝ × 98˝

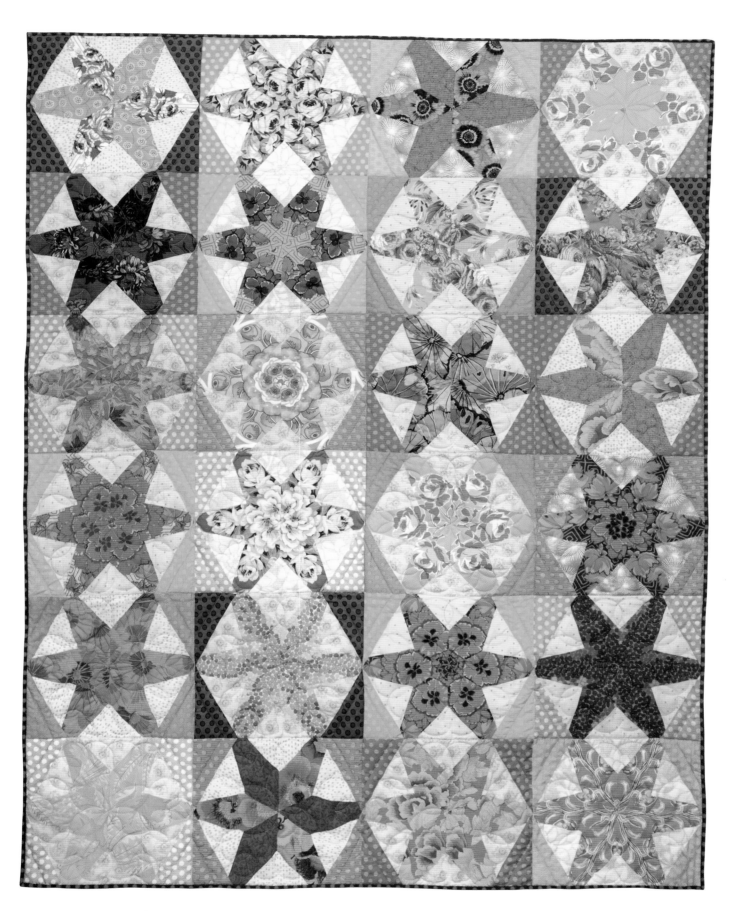

Hex Star Fussy Cut / Victoria Findlay Wolfe, 2016, 54˝ × 68˝

Photo by Michael McBride, Sizzix

Complete quilt instructions and acrylic templates
can be found on my website (page 159).

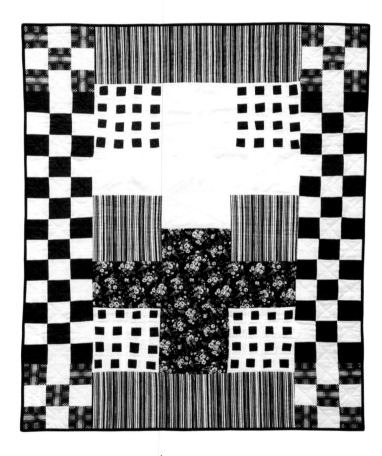

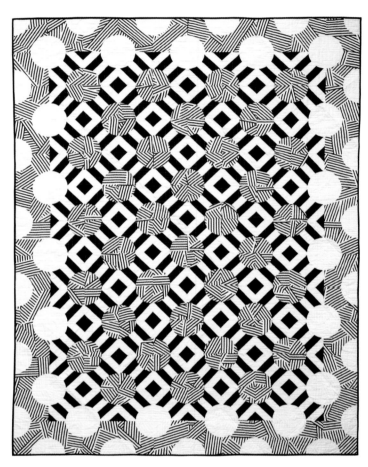

Mirror Ball / Victoria Findlay Wolfe, 2017, 70˝ × 91˝

Complete quilt instructions and acrylic templates
can be found on my website (page 159).

Blue & White Crosses / Victoria Findlay Wolfe,
2009, 38˝ × 46˝, hand and machine quilted

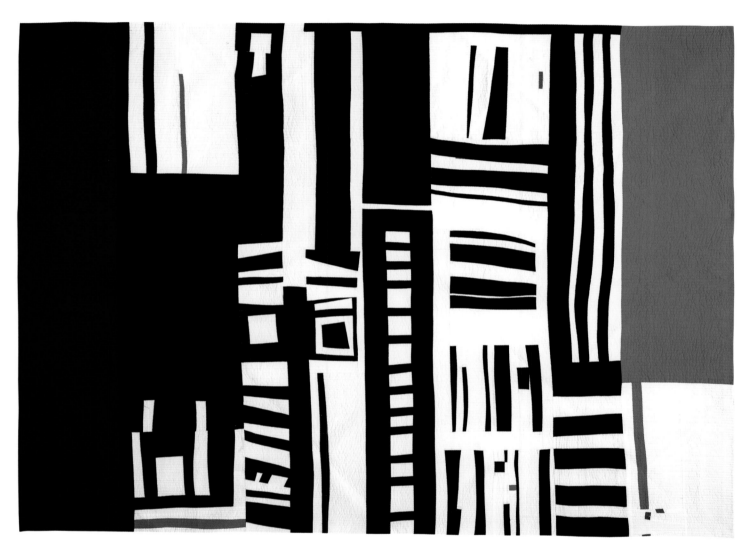

Cheap Hotels / Victoria Findlay Wolfe, 2010, 60˝ x 79˝

Purposeful Play

Purposeful play is a deliberate free-form practice with one goal in mind: to ultimately improve the outcome of the finished product while capturing a thought, emotion, or technique.

I have a lifelong desire to make and to learn how anything is made, and I am persistent about it. I am currently focused on quiltmaking and the traditions of those who came before me. This gives me a path to think about where I am going. It's a very thoughtful process.

I CAN THINK OF THE IDEA,

I CAN SEE IT COME TO LIFE WITH MY EYES,

I CAN FEEL IN MY HEART IF IT'S WHERE I NEED TO BE,

AND I CAN PHYSICALLY CONSTRUCT SOMETHING THAT REPRESENTS ALL THOSE SENSES.

My purpose is to use art as a self-healing tool. I can search my past to work through issues, ideas, and memories. After all, I can only dig from my own experiences. Although I could choose to work through sadness or grief, I like to think that every quilt/art I make is all about joy, even if made from a place of sadness.

Repeating a technique over and over until it's easy or stumbling onto an easier way to do something is part of what excites me about quilting. Jumping in and cutting up textiles is a great way to watch and see how fabrics come together and learn construction and techniques. There is also the satisfaction I get from knowing that I can dismantle something and put it back together in a way that tells a story.

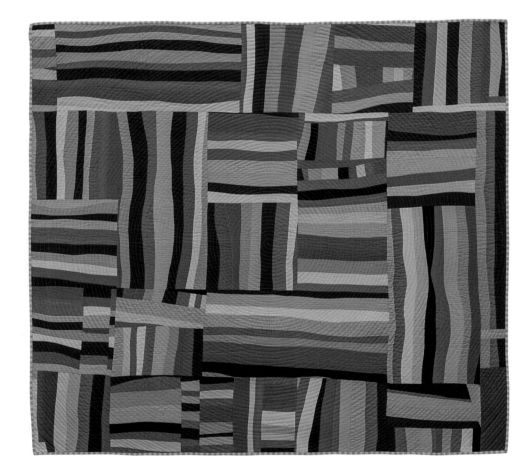

Waverunner II / Victoria Findlay Wolfe, 2009, 45˝ × 45˝

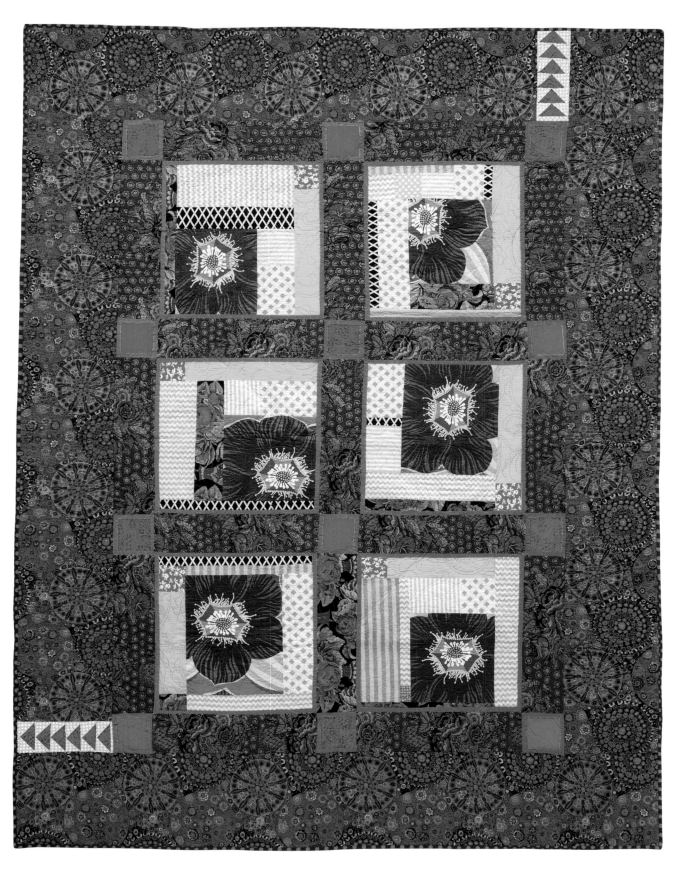

Lattice Blooms / Victoria Findlay Wolfe, quilted by Linda Sekerak, 2010, 66˝ × 86˝

A lot of my early work is just okay. Some of the color palettes I used were awful, even my choices in fabrics are questionable! But by all of those choices I made over the years, I have trained my eyes to know what I like, what works well with each other. You have to make ugly pieces and then learn from them. You have to make something that is just so fabulous that you look at it and think, *Wow! I can't believe I did that!* For myself, the failure and the successes are equally valuable.

I am not saying everything I make is great. This is me saying the current work is slightly better than the last quilt I made, and every quilt I've made in the past has led me to making better quilts now.

One never reaches perfection. If that is your goal, then good luck with that! I make to satisfy myself. If I feel I have pushed myself as far as I can on the given project, then I feel I've done a good thing. Sometimes after working so hard on one project, I do something that is ridiculously easy just to get it done. After I make a quilt like that, I am recharged and ready to take on another challenge. I might consider that quilt a warm-up exercise … before the big game.

Being aware of why I "play with purpose" keeps me connected to my creative thoughts and my purpose. I must enjoy the journey, express myself, tell my story. To do this, I find I have to work quickly, capture the energy when I have the moment where the hairs stand on end, and just push forward. I make choices quickly, live with them, and make more quilts. I let go of outside noise—meaning the likes or dislikes from others have no purpose here, unless it's from a handful of people whose opinions I value and who push me a little further along in my journey.

With every quilt I make, I learn something about myself and my art. I enjoy pushing the limits to see just what I can do. I am my own worst critic. I am my own quilt police. And that is totally okay. That is a part of my purpose. I can self-edit, I can change, I can grow, I can make mistakes, and I can create. Ultimately, I must make.

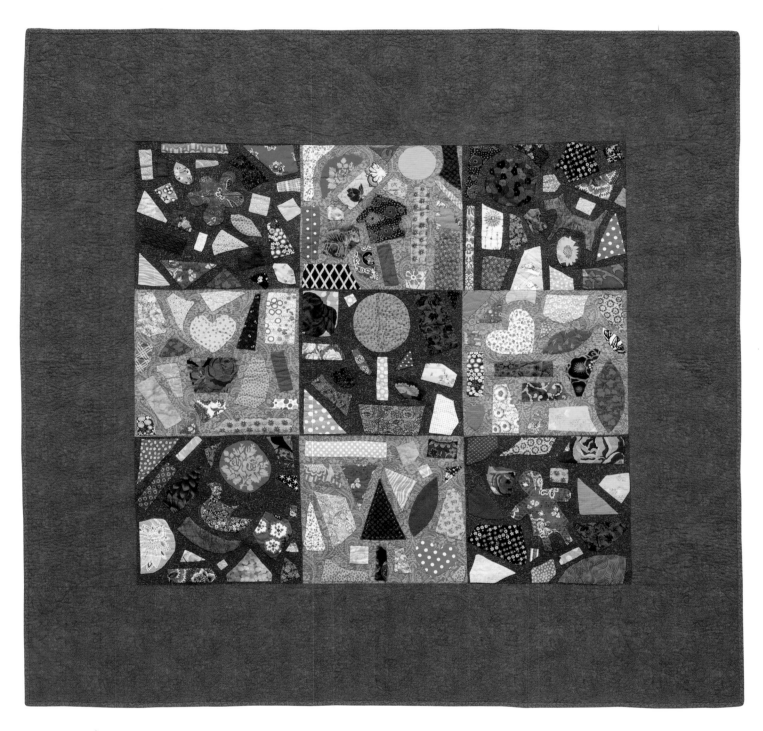

Tile Quilt / Victoria Findlay Wolfe, 2009, 60˝ × 60˝

Sometimes I have an idea that incorporates many different block options and sometimes, I kick parts out of the quilt once I get a firm grip on where I'm going visually. The blocks for *Sun Showers* (next page) were made for *Black Flowers in the Sky*, but the scale of the blocks did not fit my final vision for the quilt. The color palette was inspiring though, so I went on and completed *Sun Showers*, using black as my negative space to push foreground and background.

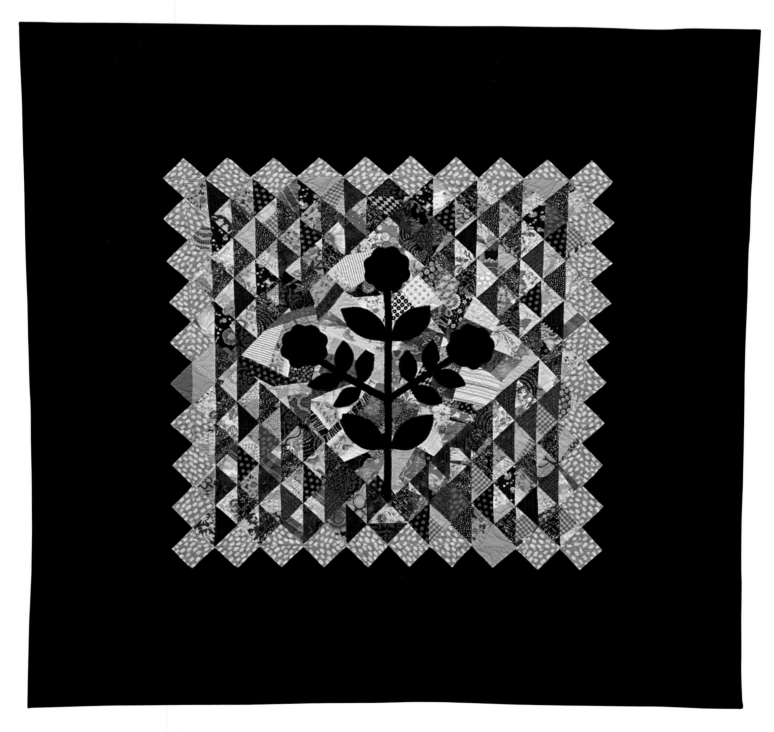

Black Flowers in the Sky / Victoria Findlay Wolfe, quilted by Angela Walters, 2011, 65˝ × 65˝

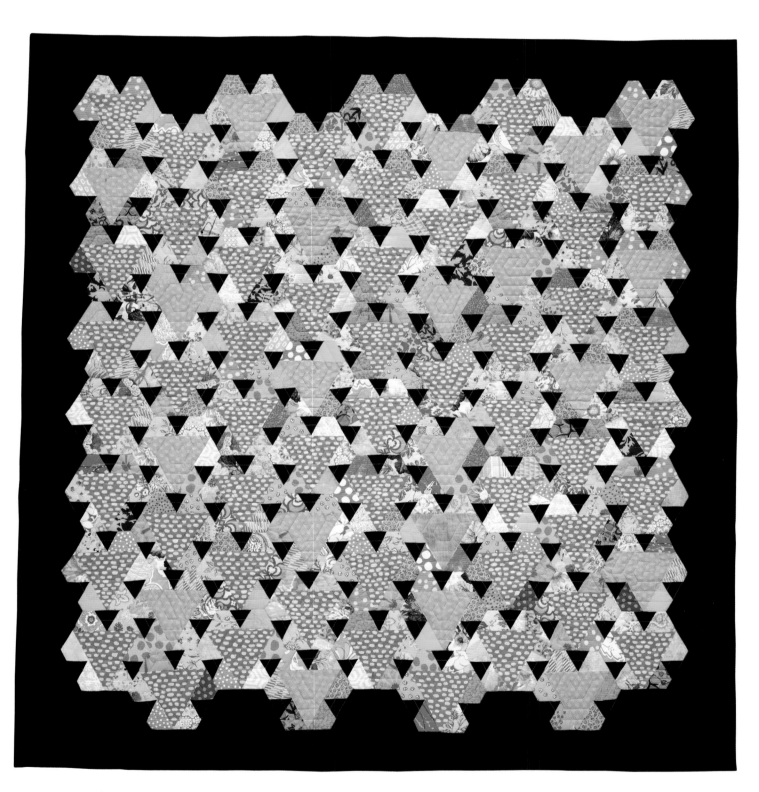

Sun Showers / Victoria Findlay Wolfe, quilted by Shelly Pagliai, 2012–2013, 68˝ × 72˝

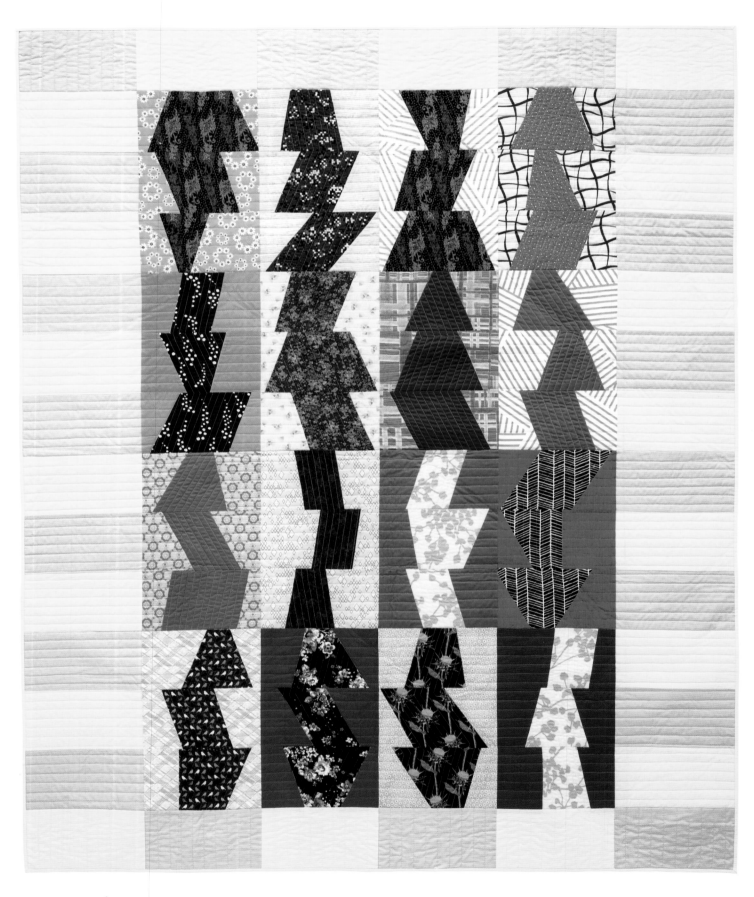

Short Stacks / Victoria Findlay Wolfe, quilted by Shelly Pagliai, 2017, 59˝ × 72˝

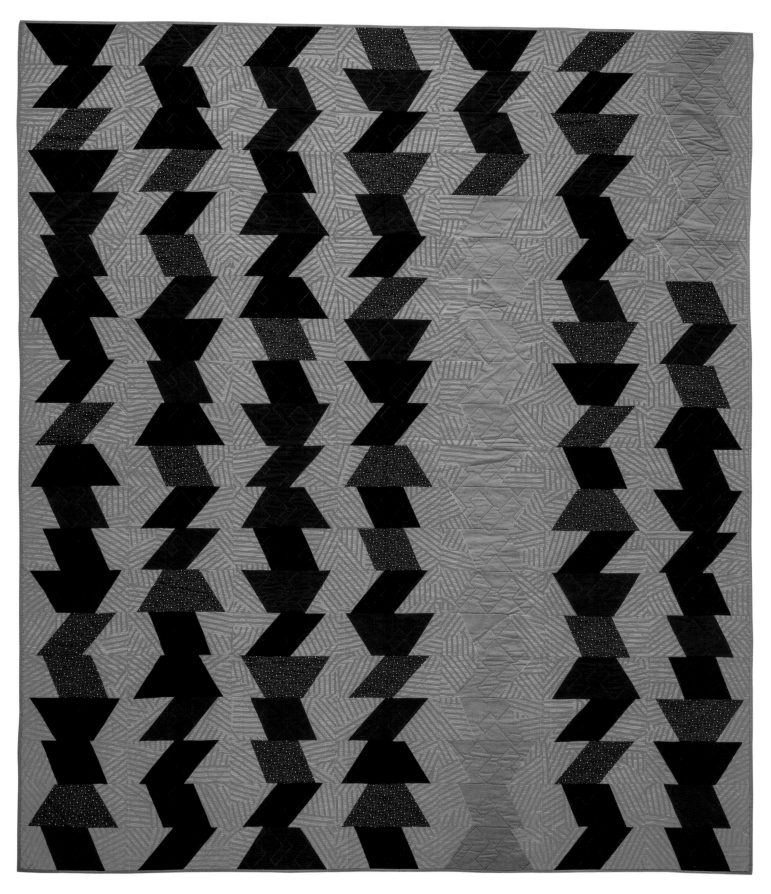

Pattern Play / Victoria Findlay Wolfe, quilted by Shelly Pagliai, 2015, 69˝ × 81˝

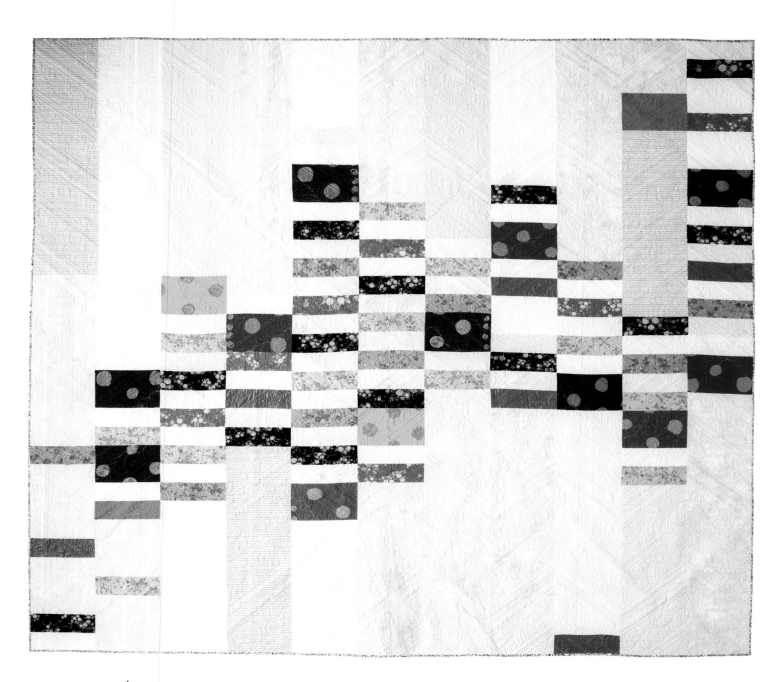

Quilter's Cairn / Victoria Findlay Wolfe, quilted by Shelly Pagliai, 2013, 107˝ × 94˝

This is a quilt I always wished was king size, so I could have it on my bed. This is why I make so many large quilts! In building this quilt, I put four little triangles in the wrong direction on purpose. (I like people to look at my quilts to find the not-quite-right thing or the "Made-Fabric" in each quilt.) Three years later, I found an "error" that I never saw (nor did anyone else) until after the quilt was done. This shows us that looking and thinking are two different things. Your brain tells you what to see, but take a photo of it and look at it again—it will look completely different. Stepping back for perspective helps you see what is really there. My method 15 Minutes of Play can go a long way! Mistakes are how you learn and grow. Train your eyes to see. Make more quilts.

The Star Splitter / Victoria Findlay Wolfe, 2010, 81˝ × 91˝

Complete quilt instructions can be found on my website (page 159).

I love pushing foreground and background by making the two elements play off each other. I do this by using the white improvisational piecing within the star and as a background color. Mixing improv with technical piecing is one way to add visual layers to your quilts. You can also see by adding three more blocks to *Thunderstruck*, the visual affect gets extremely more powerful in *Thunderstruck Four Block* (next page).

Thunderstruck / Victoria Findlay Wolfe, quilted by Shelly Pagliai, 2016, 40″ × 40″

Complete quilt instructions and acrylic templates can be found on my website (page 159).

Thunderstruck Four Block / Victoria Findlay Wolfe, quilted by Liz Haskell, 2018, 88˝ × 88˝

Whirlygig / Victoria Findlay Wolfe, quilted by John Kubinec, 2014, 79˝ × 79˝

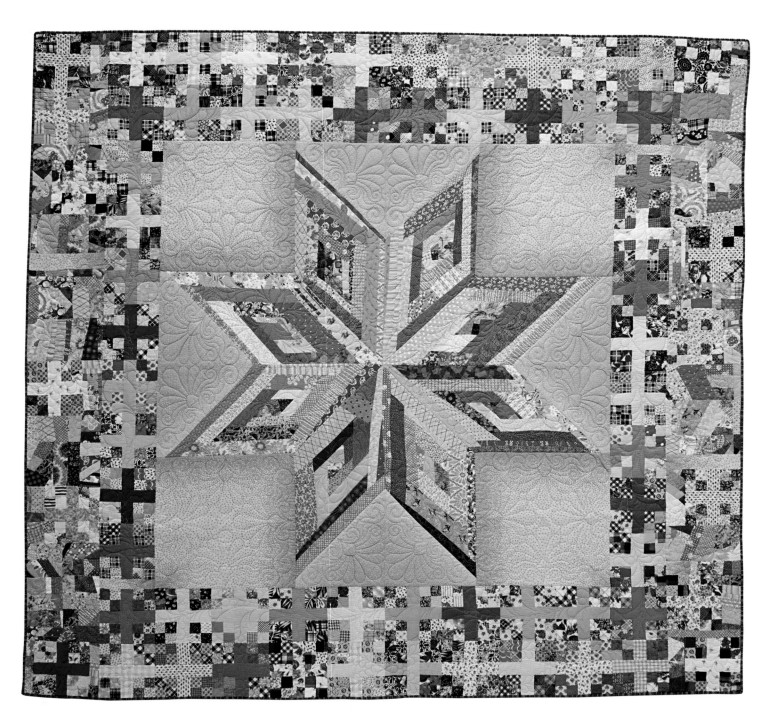

Summer of Stars / Victoria Findlay Wolfe, quilted by Linda Sekerak, 2011, 102˝ × 98˝

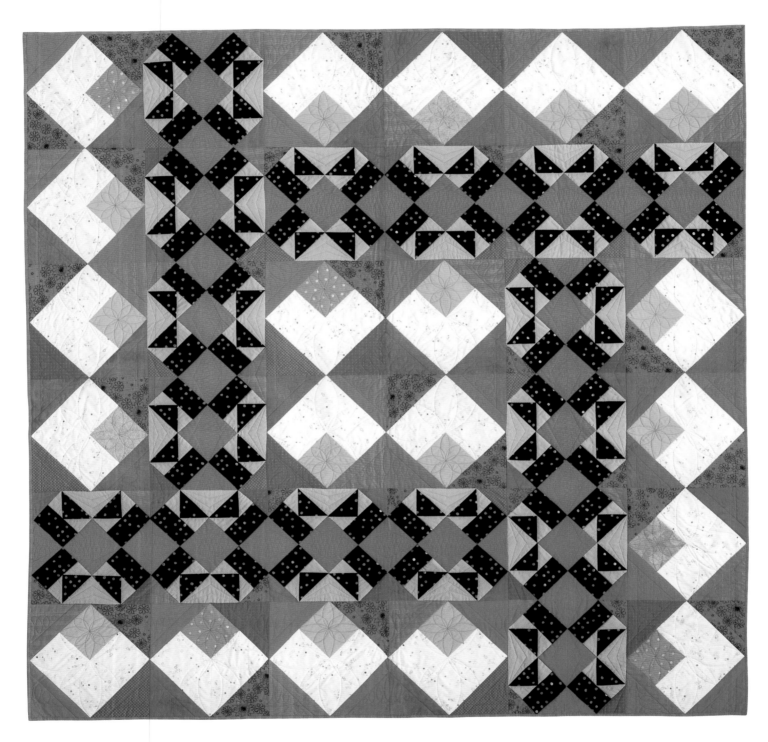

Orange Melange / Victoria Findlay Wolfe, quilted by Shelly Pagliai, 2017, 70˝ × 71˝

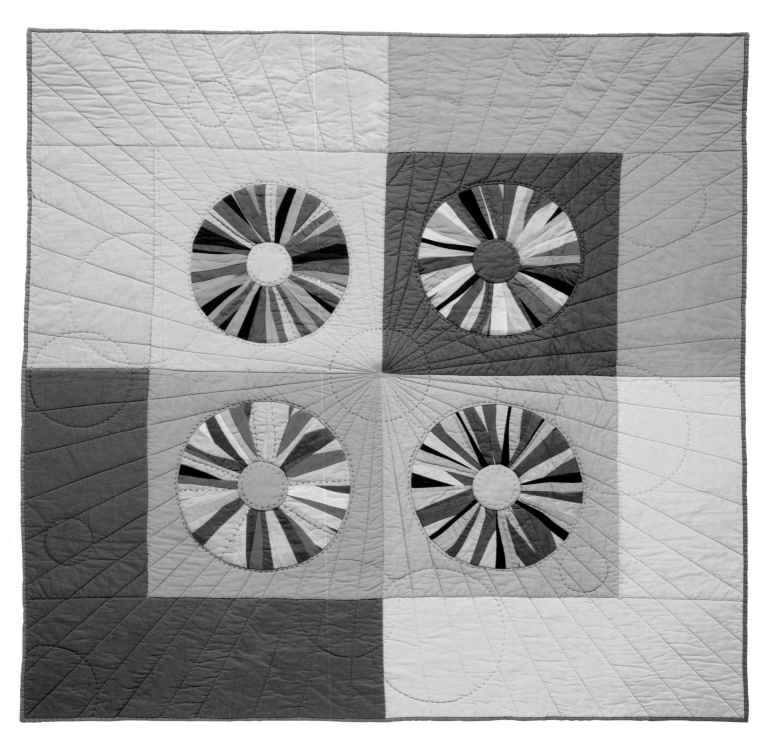

Dropping a Stone / Victoria Findlay Wolfe, 2012, 54˝ × 54˝, hand and machine quilted

No Mistakes

Take negativity out of your creative life.

"It's terrible!" "I don't like it!" Sound familiar? Grumbling away on a project that's not working gets you nowhere! You will never see the project's value if negativity sits in your creative space. It's like someone pointing a finger at you. What do you do? You stop all communication and get defensive. Listening and seeing *stops* when you say, "I don't like it."

IF YOU SAY, I CAN'T. YOU WON'T

IF YOU SAY, I MIGHT, YOU MAY.

IF YOU SAY I CAN, YOU WILL.

Unattained ideas or unfinished projects are not wasted. They are not mistakes. Each one is an experiment where you had the opportunity to learn something. Usually, these projects give your thoughts a pause to sort out why it didn't work. Was it above your skill level? Were there color balance issues? Was there no emotional connection? Is there just a new "shiny object project" that is now catching your eye? Sometimes, it is not obvious at that moment, but something has happened, and you learned that it just wasn't coming together. Instead of going down the negativity rabbit hole and throwing that creative tantrum, open yourself up to a small change in the way you think.

You can have a great idea, attempt to build on it, and stall. It certainly doesn't mean that you just give up! They say the stars have to align, and it's so true. Your talents, ideas, memories and personal experiences— everything you bring to the creative table—have to mesh. That is what it is to be in the creative flow!

Putting a project aside (a day, a month, or even years!) and not fighting it is the perfect way to move beyond the stalled moment. You can continue to work on other ideas and eventually find that the initial idea has come forward again. Now you have the skills you need to finish the thought. It can be better then you originally dreamed! This is not the only quilt you will ever make!

I have many projects that I have started and not finished. I do not get "worked up" about these projects. They are not a burden to my process. I set them aside and I move on. In fact, I start many projects every single day. When I get an idea, I will make a 15-minute sketch of fabric to capture the energy, that spark of an idea that engaged my conscious. I can come back to it. It could be years before I come back to it, and when I do, I may have a whole new set of ideas I can play up on that original idea.

The realization that I may not have the skills I need to fully bring that thought to fruition is okay, because I am not the same quilt artist that I was ten to twenty years ago. Each day I become a new creative human. I have new experiences, new visions, new conversations, learn new skills, and I morph every idea I have in a different way, depending on what the day before has thrown at me. I can go back and revisit old ideas, old projects started and abandoned, and look at them again with new eyes and say, "Wow, let me use this new idea on this piece and see if I can tell the story I want to tell."

So go back, bring new eyes to old projects, and see if anything new has transpired since you saw the project last. Some of my very best quilts started this way. Other quilts just never made the cut. … Some took years to find the solution. What's the rush? Make more quilts, and the rest will fall into place. Stay open to the process.

Detail of *I Am Not Perfect and That Is OK* (page 38)

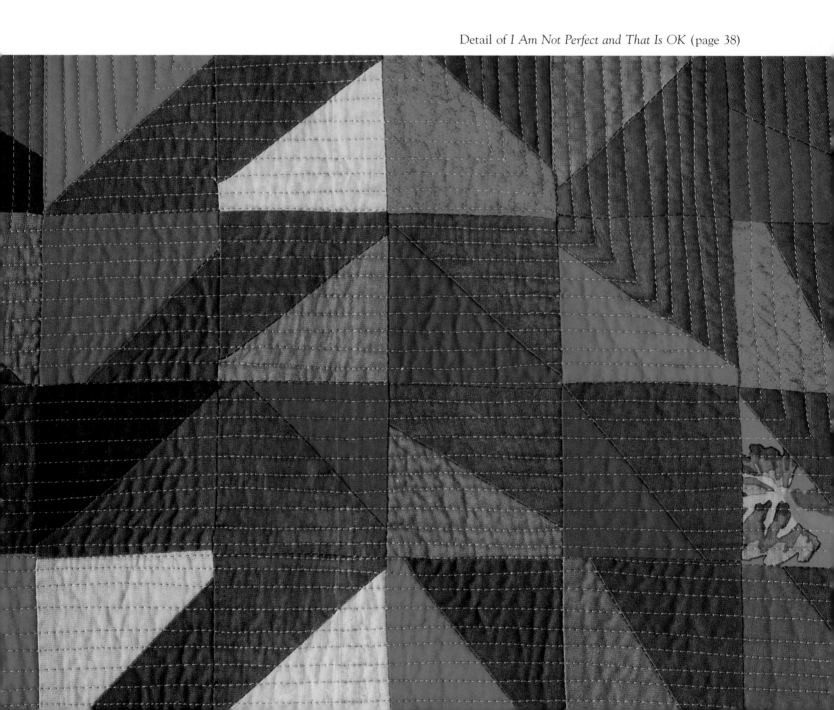

Sometimes, you will see an extended date on my quilts. For instance, I started this quilt in 2008, made the top, started quilting it, and never got around to finishing it. It sat in the back of my brain, saying, "Finish me!" ... and finally in 2018, I did. This quilt excites me now as much as it did when I made it, and I closed the full circle of thought. I completed it when I needed to. The time is right. What project can you go back and bring to the finish line?

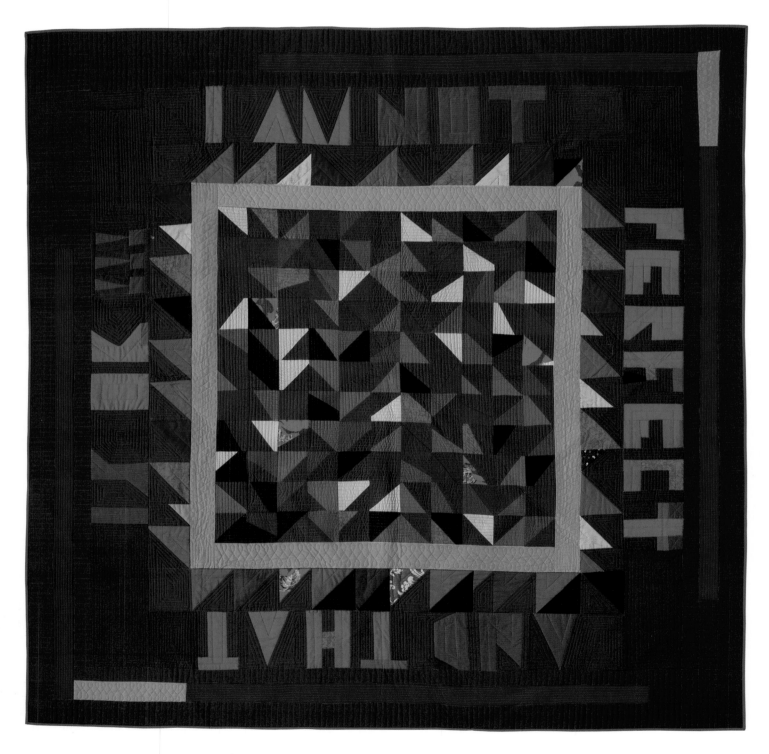

I Am Not Perfect and That Is OK / Victoria Findlay Wolfe, quilted by Victoria Findlay Wolfe and Shelly Pagliai, 2008–2018, 67˝ × 67˝

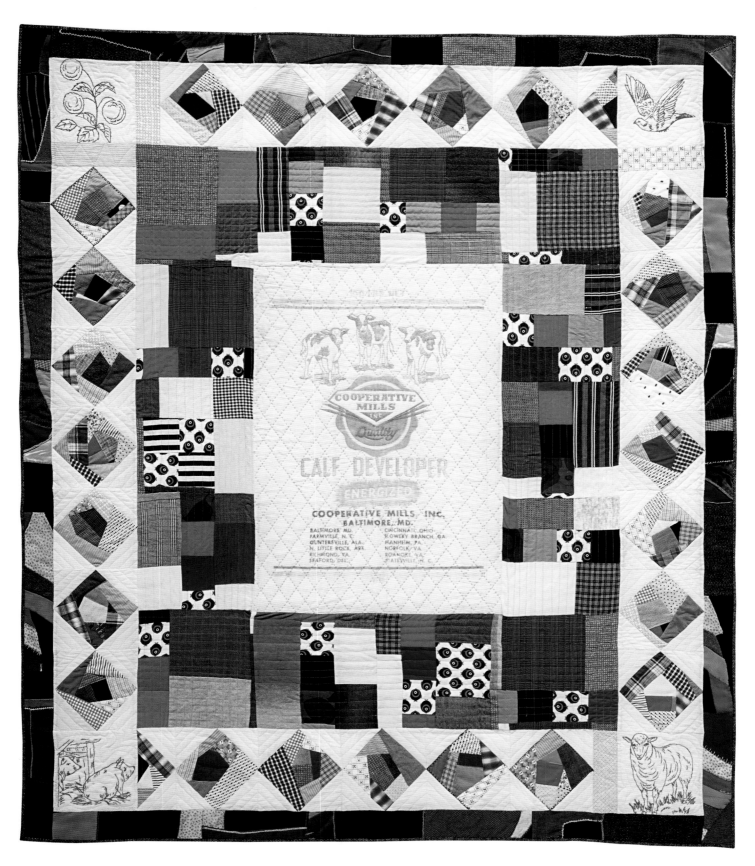

Fresh off the Farm / Victoria Findlay Wolfe, 2013, 79˝ × 82˝, hand and machine quilted

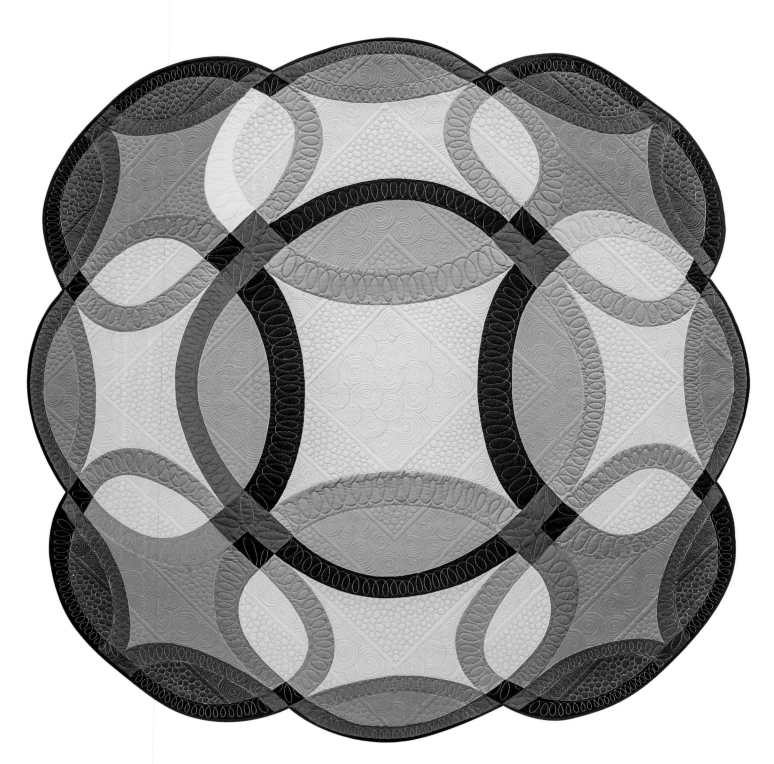

Luminous Views / Victoria Findlay Wolfe, quilted by Lisa Sipes, 2014, 67˝ × 67˝

While I was making *Luminous Views* (previous page), I was so taken with the green portions of the quilt that I thought I needed to make this quilt again but floating in a sea of white negative space. I also decided that I needed to decrease the number of seams, so areas of white would be smooth and seam-free. Basically, this means I was piecing full, oddly shaped ovals, which was really difficult. I do love a good challenge, but afterward I thought, *Why on earth did I bother? Why?* Because it certainly upped my skill set and I'm glad I did it, because it gave me the effect I was looking for.

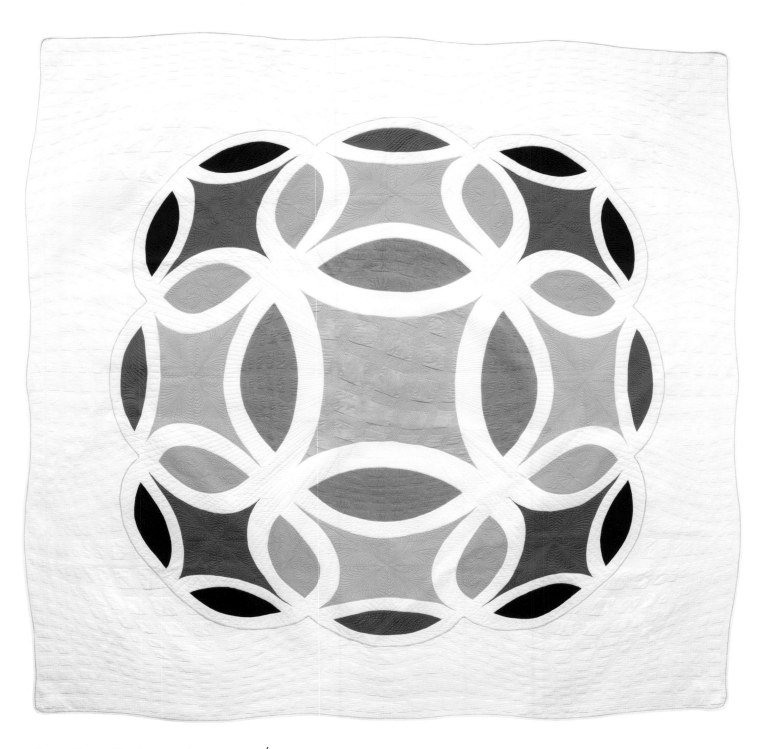

Green Trees, Clouds & Walt Whitman / Victoria Findlay Wolfe, quilted by Karen McTavish, 2014, 82″ × 82″

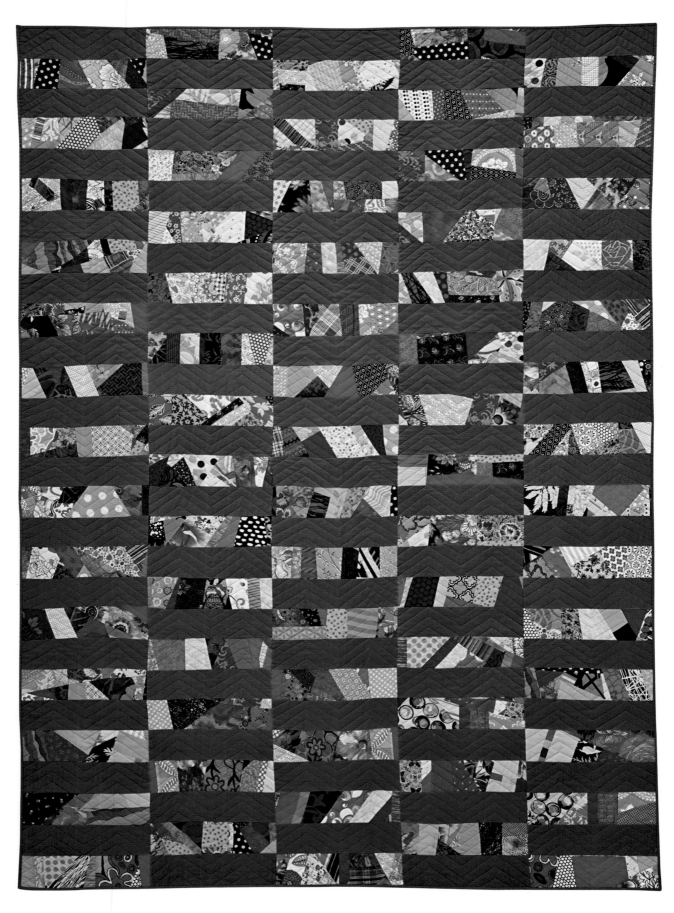

Making Me Crazy / Victoria Findlay Wolfe,
quilted by Shelly Pagliai, 2011, 59˝ × 82˝

Block instructions can be found in my book
15 Minutes of Play—Improvisational Quilts (page 159).

Stellar Fusion / Victoria Findlay Wolfe, 2010, 12˝ × 12˝

Inspiration quilt for *Tiny Dancer* (below)

Tiny Dancer
Victoria Findlay Wolfe,
2012, 59˝ × 71˝,
from the collection
of Susan Wernecke

This quilt was *two* previous quilt tops! Third time was the charm. Dig out your unfinished tops and bring your freshest "quilty eyes" to the game! You are not the same quilter you were years ago! What new skill, color, and technique can you bring to the quilt-top party? Time to step up and take some risks on those old pieces. What do you have to lose? Your creative challenge awaits!

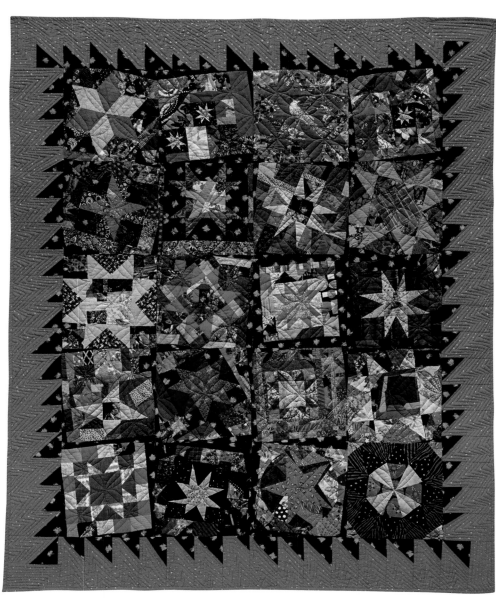

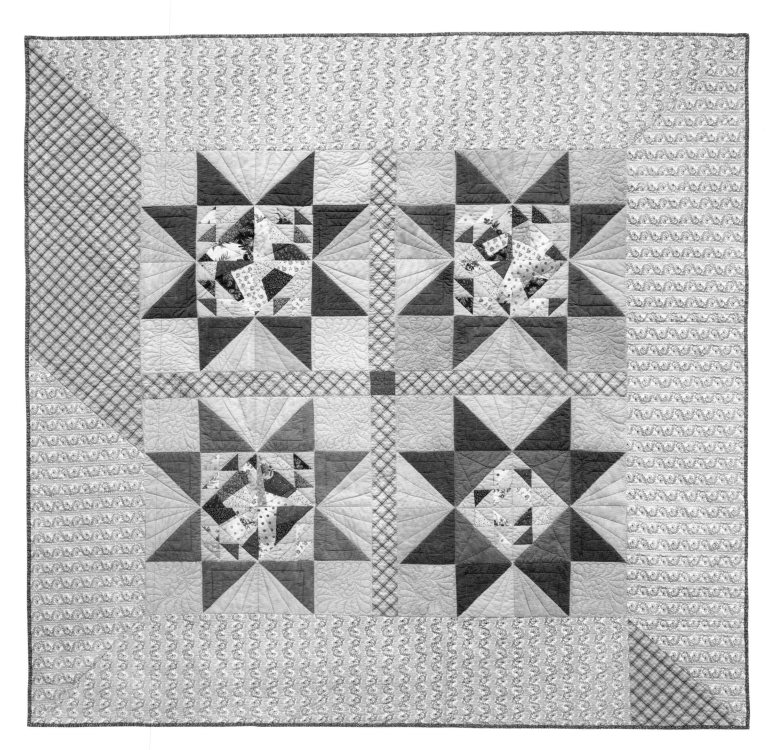

Romeo's Stars / Victoria Findlay Wolfe, 2013, 67˝ × 67˝

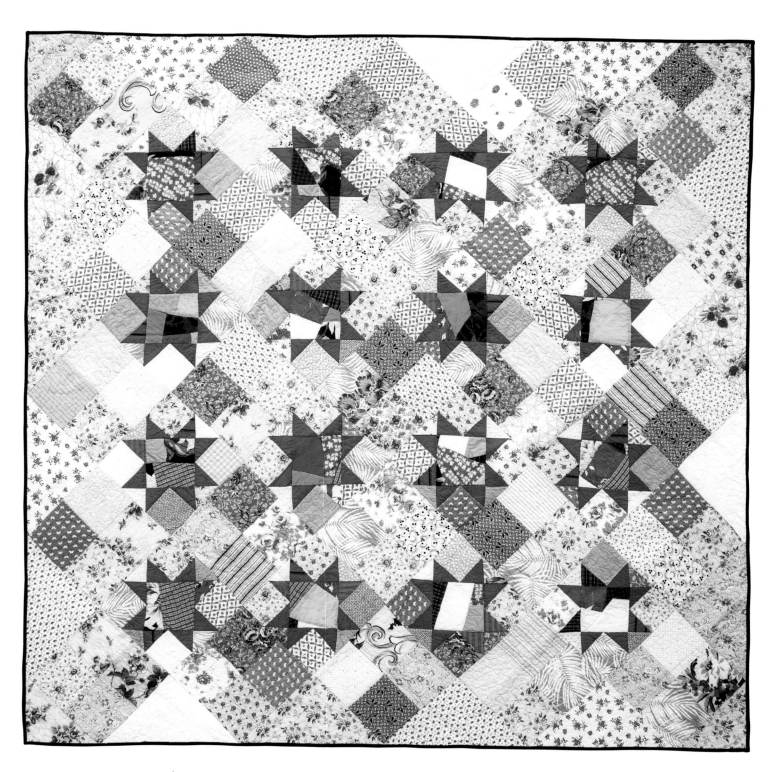

My Good Shirting Stars / Victoria Findlay Wolfe, 2011, 72˝ × 74˝

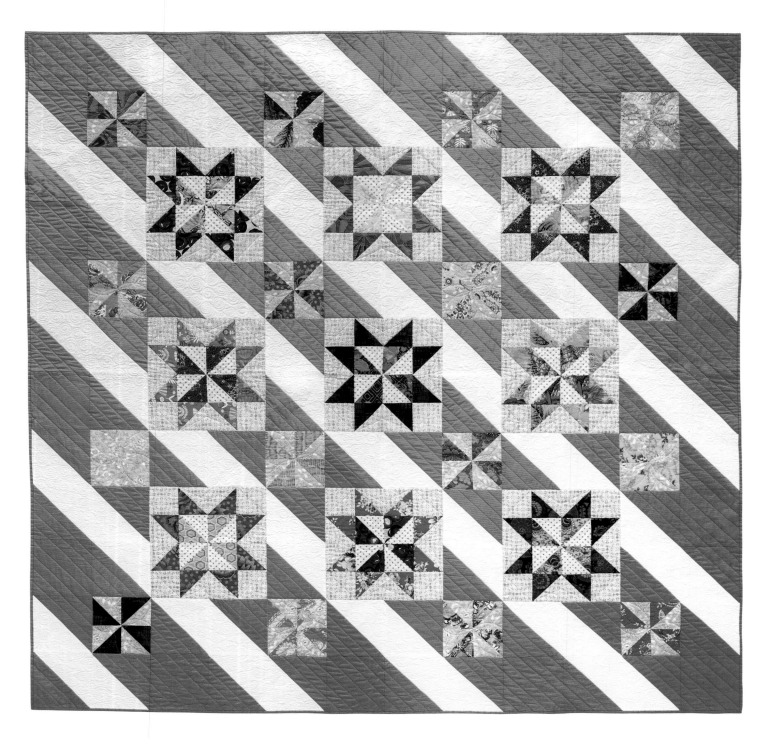

Shine On! / Victoria Findlay Wolfe, quilted by Shelly Pagliai, 2014, 67˝ × 67˝

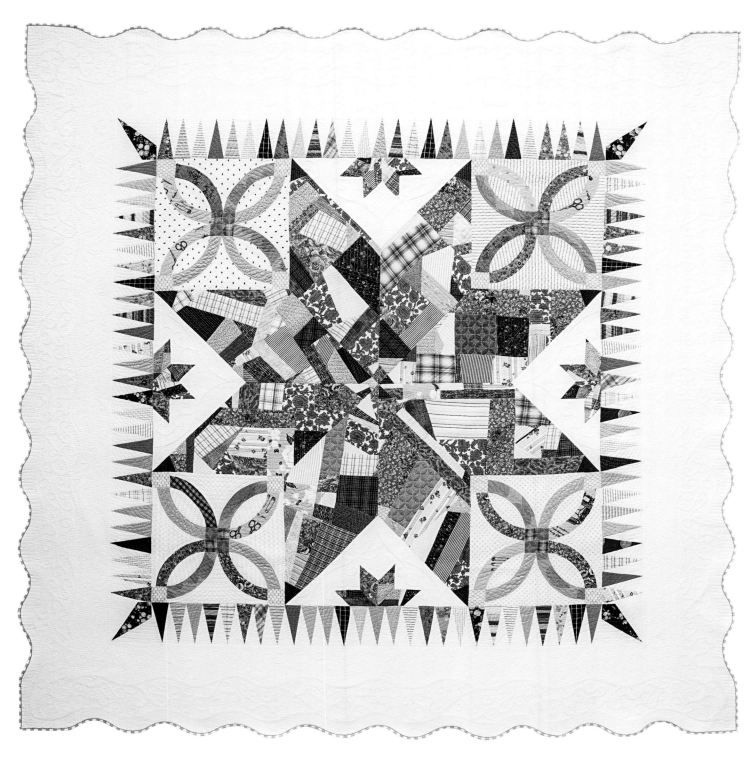

Farm Girl / Victoria Findlay Wolfe, quilted by Karen McTavish, 2011–2014, 98˝ × 98˝

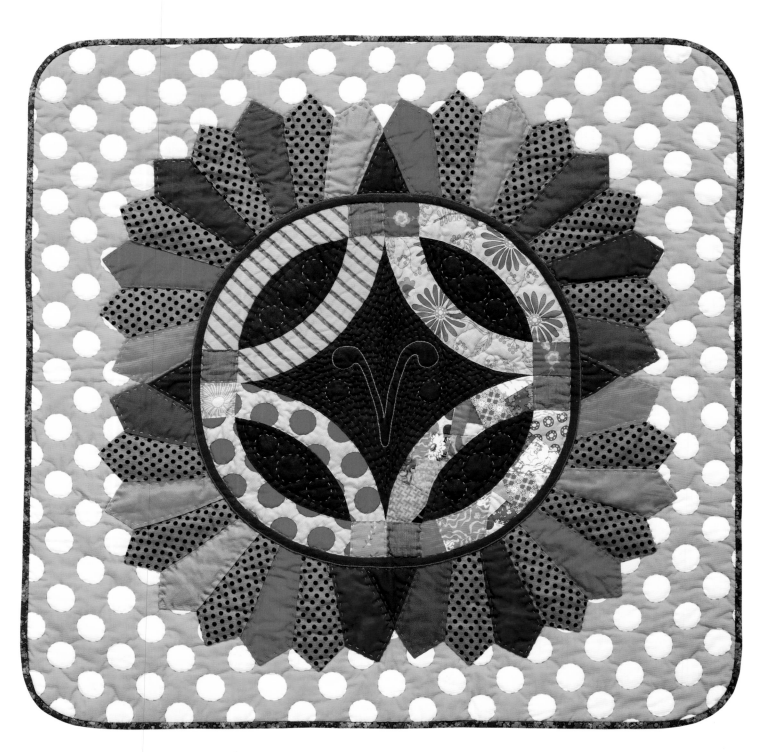

My Personal App Quilt, Spotted Joy / Victoria Findlay Wolfe, 2014, 36˝ × 36˝, hand quilted

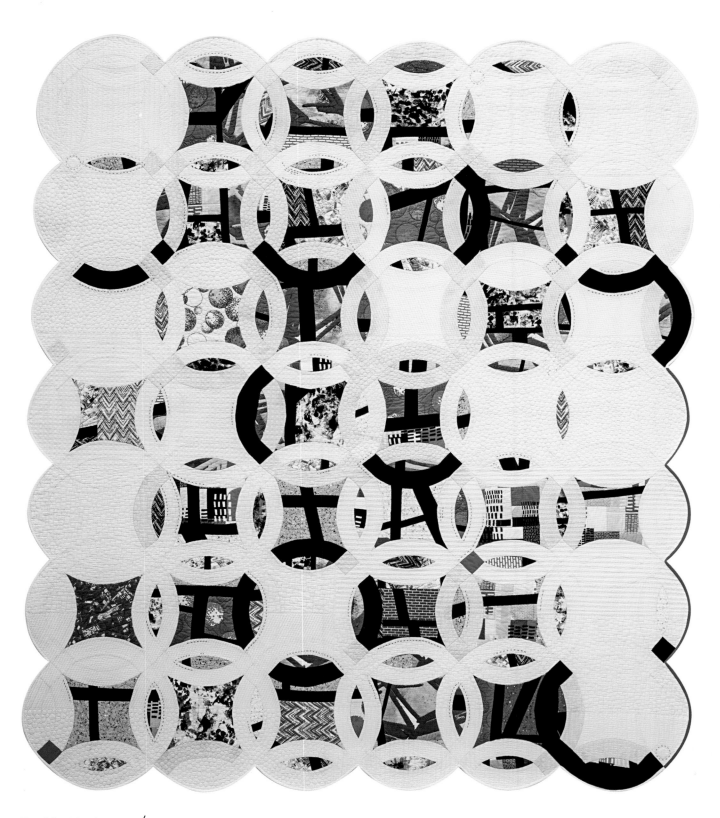

Double-Edged Love / Victoria Findlay Wolfe, quilted by Lisa Sipes, 2013, 66˝ × 77˝;
from the collection of the International Quilt Study Center & Museum, University of Nebraska–Lincoln, 2016.009.0004

Complete quilt instructions can be found in my book *Double Wedding Ring Quilts—Traditions Made Modern* (page 159).

When I first started quilting feverishly, I tried to do what my grandmother did with her polyester scrap quilts, except use cotton to achieve a similar look. Well, my attention span dwindled and I decided I could get a scrappy overall look faster by mashing all my leftover blocks and unfinished quilt tops (cut up and repurposed) and puzzle it all together, so you could not really see the order in which it was sewn. "That's one way to master 'improv and partial seams'!" This quilt was started in April 2000 and finished in 2009. I've made many of these scrappy sampler-style quilts. I love the process of figuring out how to get it all to fit together … play!

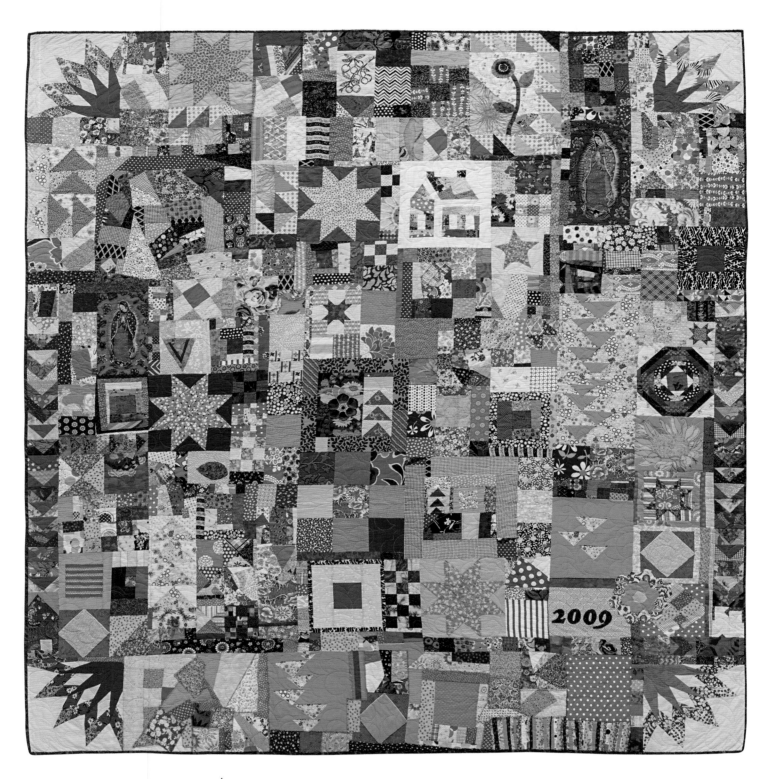

Everything but the Kitchen Sink / Victoria Findlay Wolfe, quilted by Linda Sekerak, 2000–2009, 89˝ × 93˝

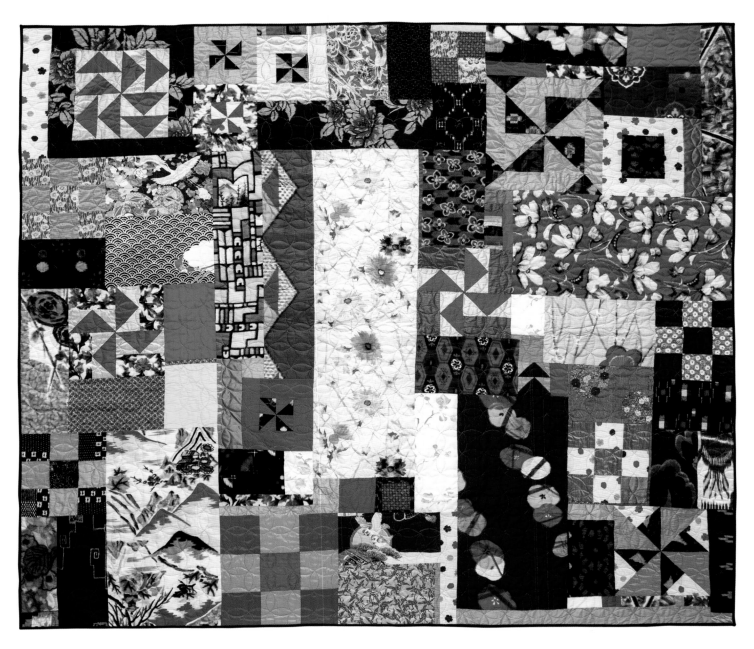

Silk Kitchen Sink / Victoria Findlay Wolfe, quilted by Laura Clark, 2011–2018, 76˝ × 86˝

Permission

I give myself permission to allow the story to change.

I have an idea. I gather my fabrics, I cut a large number of pieces (a "parts department of fabric"), and I play. I push the colors around, I find elements I like, and I give myself permission to look and change my original idea. I don't want to make the same quilt I made before, so I'm looking for elements I can add or use in a different way than before. I ponder where I am going with an idea. I remove something that does not quite work properly, does not fit well, or is not constructed precisely. I give myself permission to make mistakes. I learn by cutting fabric that can give me an interesting effect. I may abandon the original idea, use the newly found idea, and incorporate it into my current stage of the build. I give myself permission to see all the options.

> *I do not want to know what the quilt will look like when I start building a quilt. I do not want to know that it contains 556 half-square triangles. I want to cut, make, add, throw out, remake, take something from another project, and let the story change as I go.*

All the while I am looking to see what I can do next. Is it telling the story I want to tell? Does the scale fit? Is it balanced? What lines am I creating? Where am I telling people to look? All these questions are answered as I add color and shapes to my design wall. I am looking and watching my own process as I work. Is it ebbing and flowing? Will it surprise me in the end and make the hair rise on my arms? Am I getting that intuitive physical feeling while I am working on it? If not, I have not worked it hard enough.

I ask myself more questions. I look to see what is working or not. I take photos to double-check what I am seeing, because our brains like to take over and fill in the visual without actually seeing. I ask others for what they see, but I only take it as their account and not actual fact for my process. I make what I want and need to make. I make to please myself and no one else. I give myself permission to be selfish in my creative process.

As I work, the story could veer into an entirely different conversation. I can accept that or not. I decide very quickly which way it needs to be driven. I hear the questions. I ask the questions. And I move on. I do not dillydally on making choices. I find that the right answer is the one I am faced with at that moment. There will be time to come up with more ideas, more conversations, but at that very moment, my instinct is the only one that is correct. The more I make, the more questions I ask, the more I am driven to finish and create another idea. Once I have made a complete thought—the quilt—I'm over it, and I move on to start the next project.

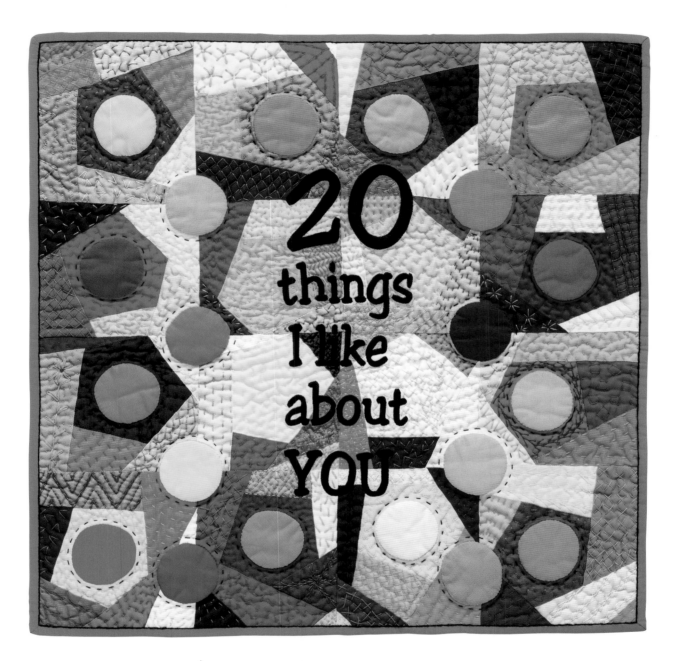

20 Things I Like About You / Victoria Findlay Wolfe, 2013, 20˝ × 20˝, hand quilted, from the collection of Kathy J. Havelka

Staying stagnant in the skill set and idea will not help me grow creatively. I must start the cycle again, allow the process to change again, add new elements, add new skills, and continue to look. Once looking stops, ideas stop. Looking is the adventure and the challenge. You must risk something of your process to grow artistically. Give yourself permission to take those risks.

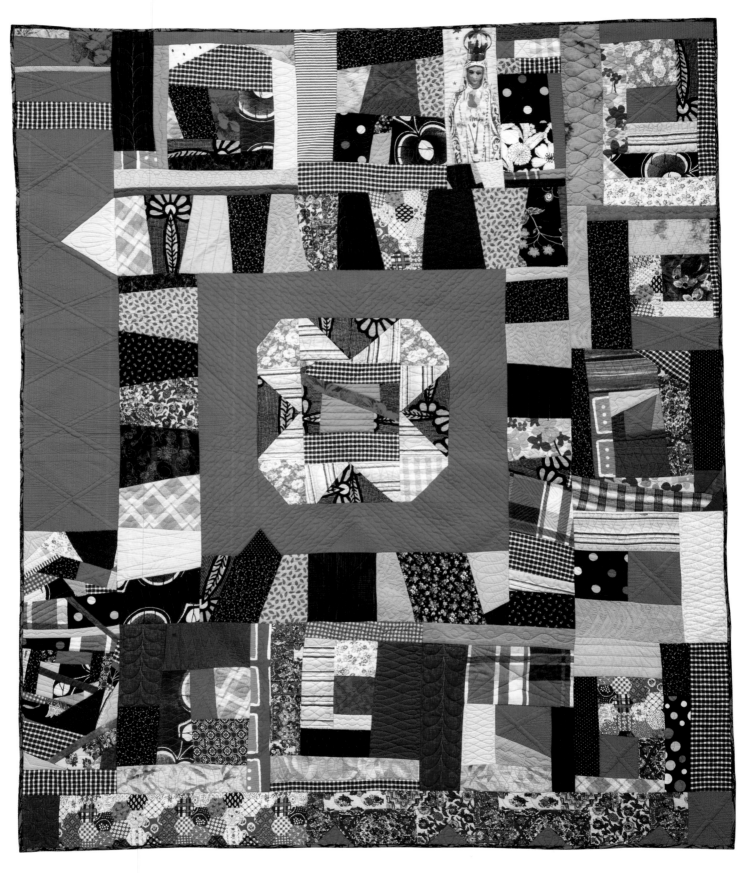

Marriage of Scraps / Victoria Findlay Wolfe, quilted by Shelly Pagliai, 2012–2018, 63˝ × 75˝

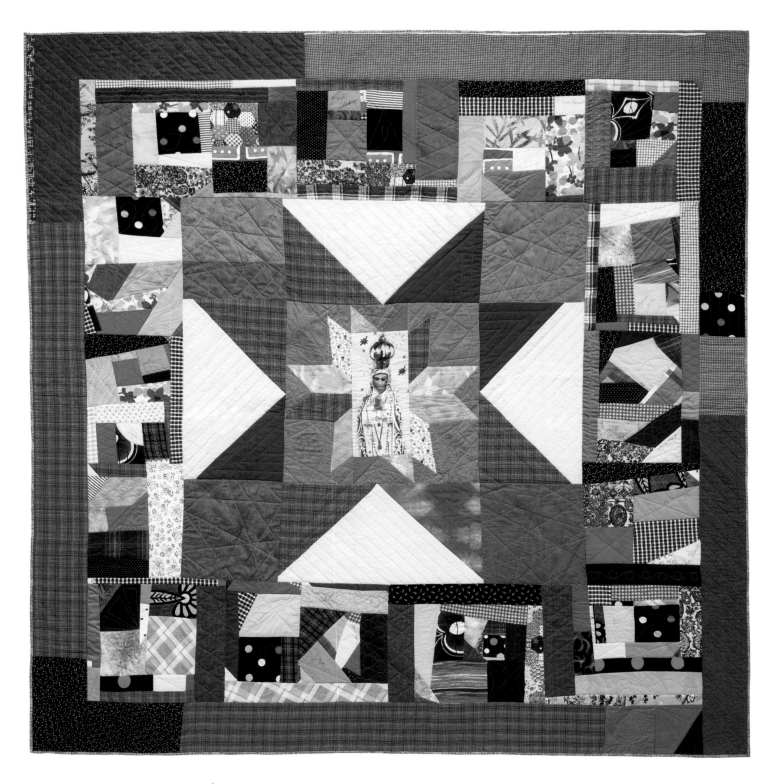

Mary, Mary Ann, and China / Victoria Findlay Wolfe, quilted by Shelly Pagliai, 2012–2018, 72″ × 76″

People bring what I call "color baggage" to their creative path—colors that they may have unfavorable feelings about. I organized a challenge BOM quilt where participants had to use these colors. They would be forced to look at the color, let go of what they disliked about it, and find a way to mix colors they do like with it, to make something they are satisfied with. When I make a quilt, I want *all* colors at the design party. This is one more step in the process of keeping an open mind. I want all the options, colors, and techniques available to me to make the best quilt I can. Let go of color baggage. All colors can play nicely with each other.

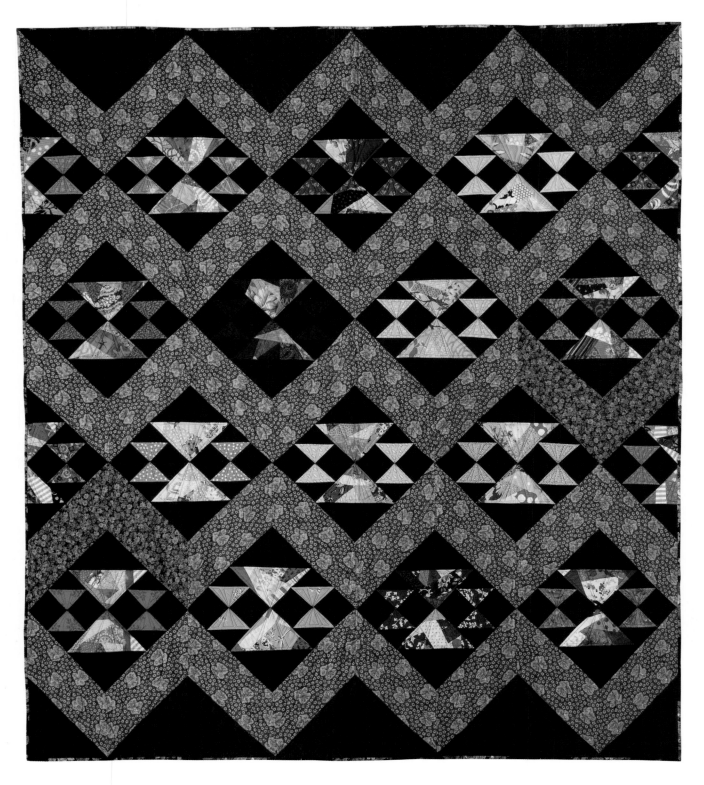

Color Baggage / Victoria Findlay Wolfe, quilted by Shelly Pagliai, 2012, 66˝ × 76˝

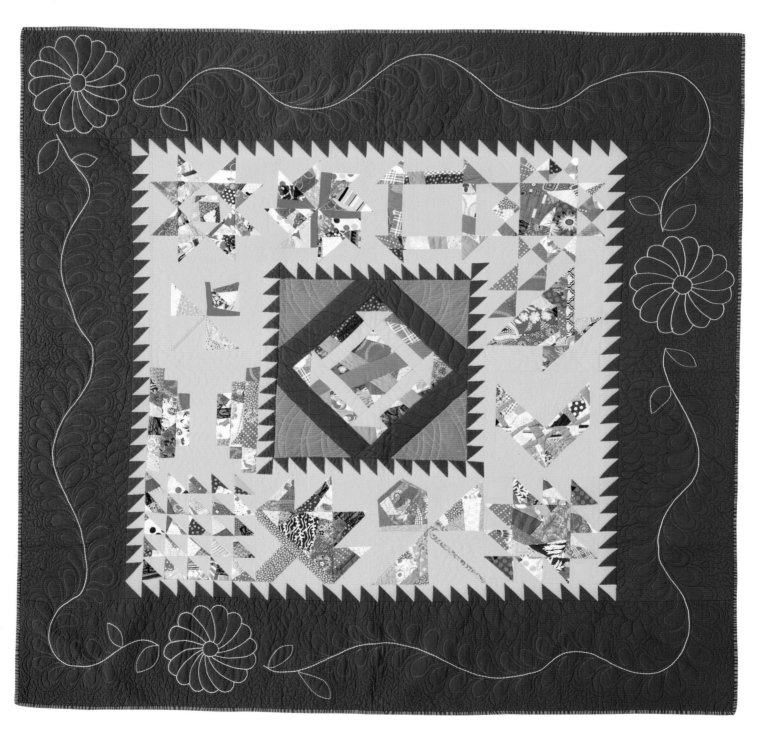

Goodnight My Fancy / Victoria Findlay Wolfe, 2012, 72˝ × 75˝

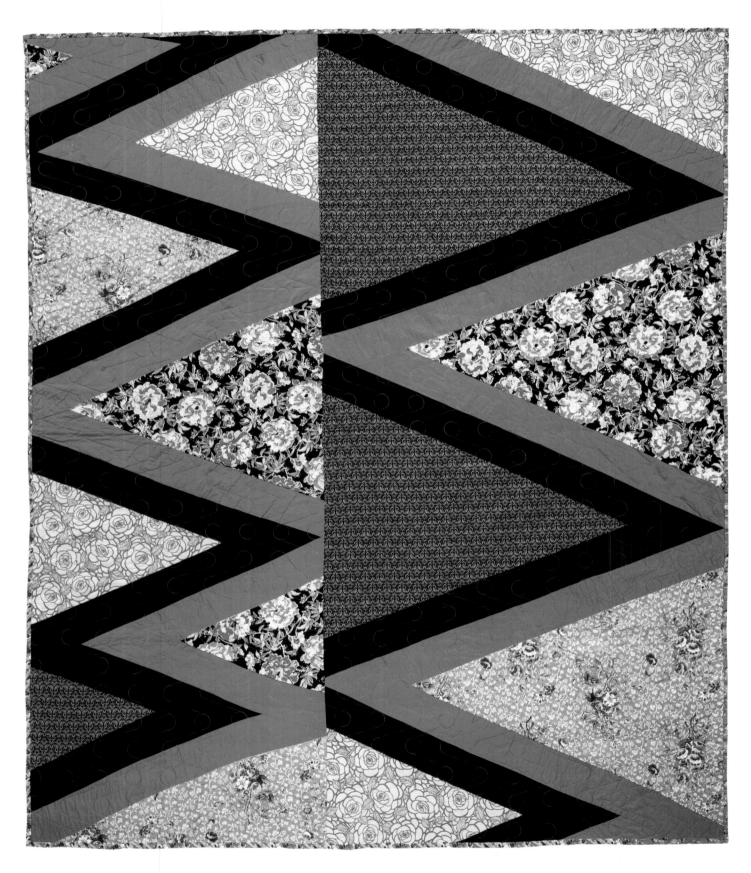

ZigZag / Victoria Findlay Wolfe, quilted by Jackie Kunkel, 2009, 74˝ × 87˝

This was a quilt top that went unfinished for many years. I liked it, but I always thought it had the potential to be much better. After digging through a bunch of leftover quilt blocks, I came across the vintage stars and thought the colors looked a lot like this old quilt top I had started. I found the top, played with options for placement of the stars, and finished the quilt! Sometimes the stars need to align for success, and this time, it literally happened! Go back and visit your old quilt tops and blocks and see if any new connections can be made to complete the creative conversation with the project.

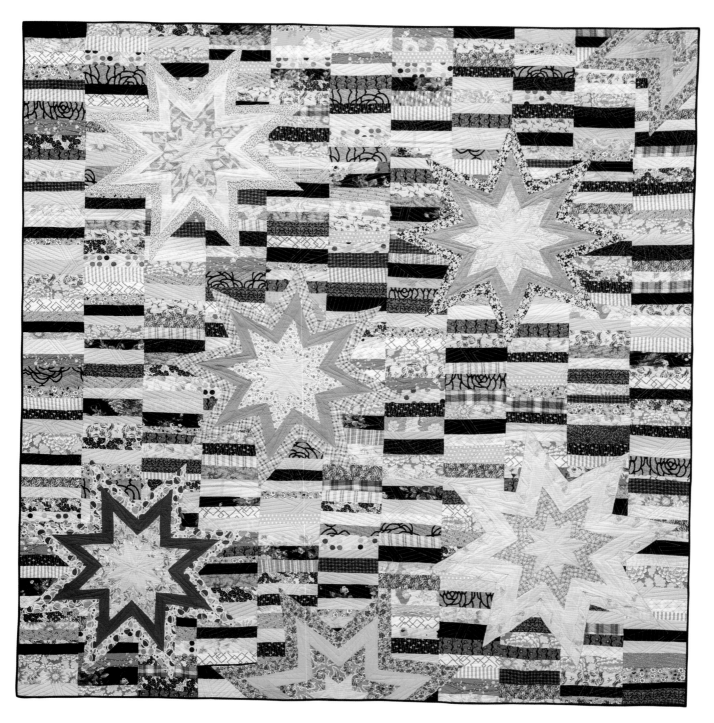

POW! / Victoria Findlay Wolfe, quilted by Frank Palmer, 2010–2016, 84˝ × 88˝

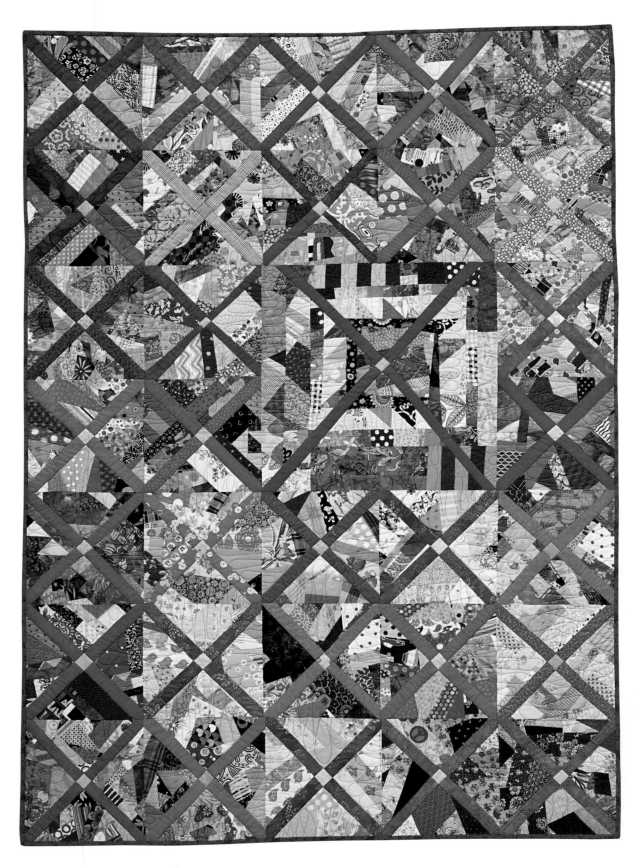

Flowers in Elda's Garden / Victoria Findlay Wolfe, quilted by Shannon Baker, 2010, 46″ × 64″; from the collection of the International Quilt Study Center & Museum, University of Nebraska–Lincoln, 2016.009.0003

Block instructions can be found in my book _15 Minutes of Play—Improvisational Quilts_ (page 159).

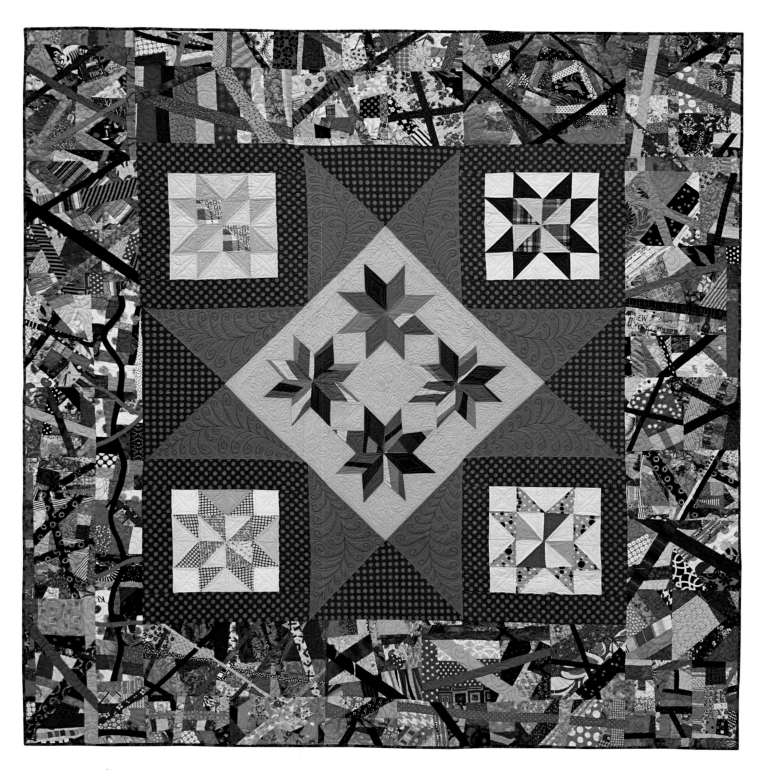

True North / Victoria Findlay Wolfe with 15 Minute Scrap Bee Block contributors: LeeAnn Decker, Glenda Parks, Sujata Shaw, Margaret Cibulsky, Shelly Pagliai, Charlotte Pountney, Mary Ramsey Keasler, Helen Beall, Brenda Suderman, Lynn O'Brien, and Beth Shibley; quilted by Shannon Baker; 2010; 73˝ × 75˝

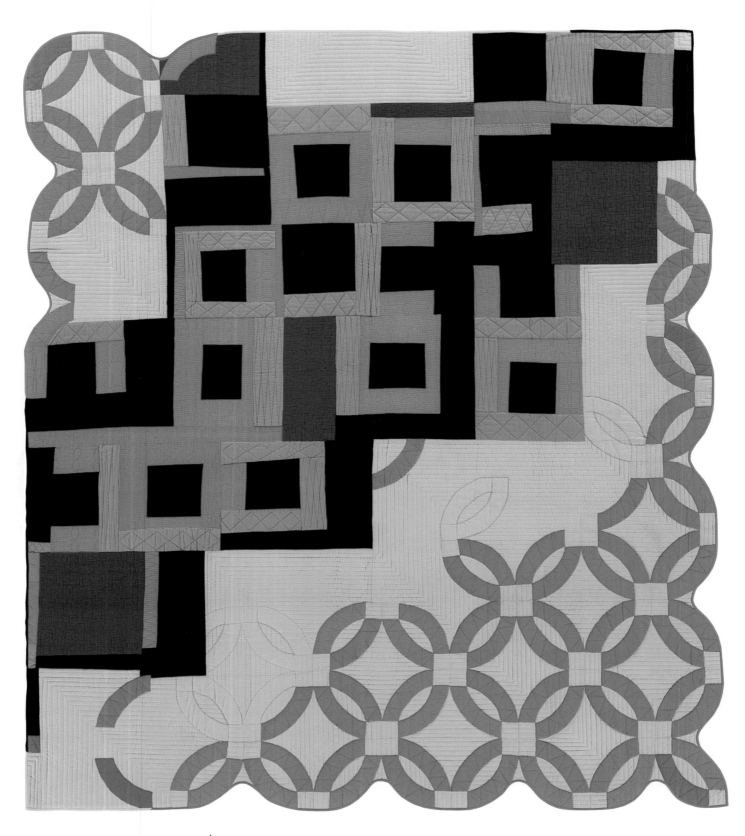

Lost and Found in Translation / Victoria Findlay Wolfe, 2014, 88˝ × 76˝; from the collection of the International Quilt Study Center & Museum, University of Nebraska–Lincoln, 2016.008.0007

Photo by Thomas L. Hauder

My purpose to always seek the joy in what I do never wavers, but my process does ebb and flow. Sometimes I am working so hard at the construction of something that once I finish, I need to loosen my creative reigns. Building an improvisational quilt is a great way for me to refocus. I can work constrained, but afterwards I need to build without a concise plan. Here, techniques, skills, and improvisation are like old friends having a conversation. ... Think. See. Feel. Make. *Joy.*

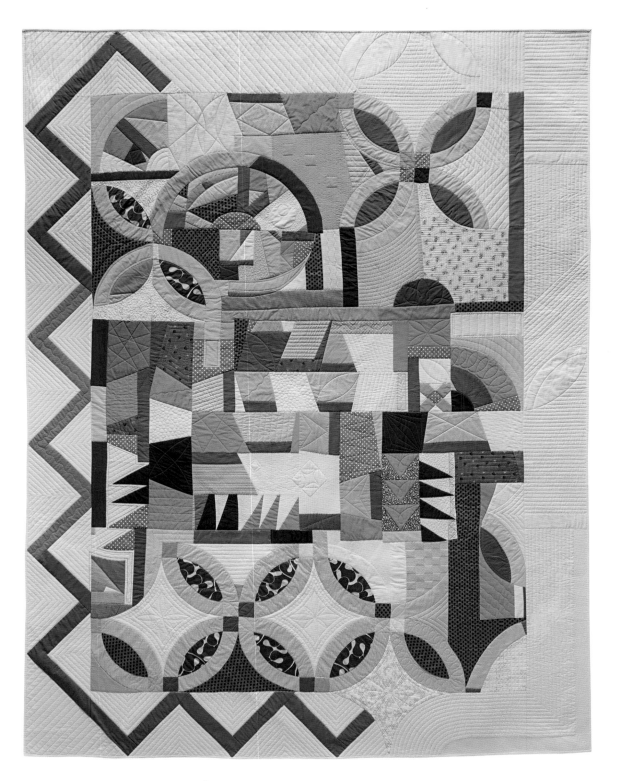

Conversations Among Friends / Victoria Findlay Wolfe, quilted by Shelly Pagliai, 2017, 71″ × 94″

Be aware of what you do and don't do in your creative process. Think you are already "outside the box"? What quilt skill do you avoid or have you not tried? This quilt is me pushing my own creative comfort zone. What other joys do I have that I can incorporate into a quilt? Using photography, taking photos in my Times Square "hood" to make my own fabric shows how small you can feel in a mass of people, yet the next moment, have a spotlight on you. NYC is very much like a small town, in many neighborhood-y ways. It can swallow you up, or you can join in the chaos. Using several techniques—"Made-Fabric," double wedding ring, hand and machine quilting, painting on fabrics, and an "NYC" color palette—I played with more techniques in one quilt than I normally do. What "trick" can you add to your next quilt that pushes you outside your comfort zone?

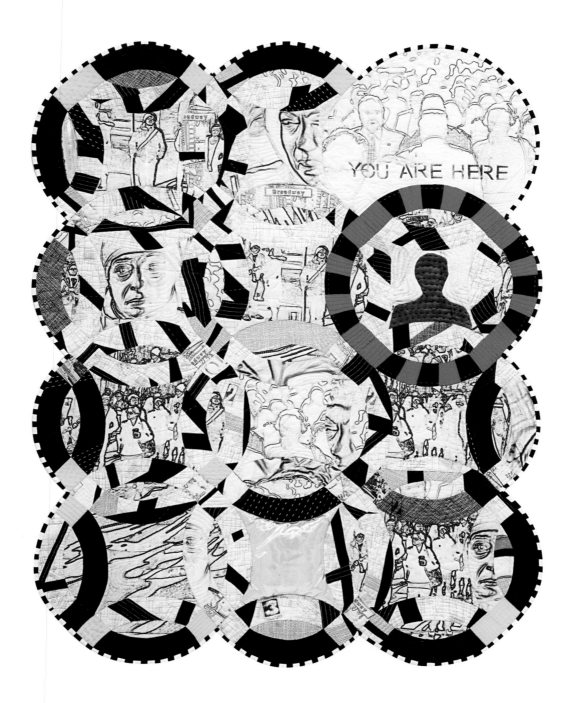

You Are Here / Victoria Findlay Wolfe, 2012, 38″ × 48″, hand and machine quilted

Complete quilt instructions can be found in my book *Double Wedding Ring Quilts—Traditions Made Modern* (page 159).

Making the personal connection. ... What if my grandmother and I had gotten to make a quilt together? What might it look like? This quilt tells the story of my roots, traditionally based, with modern twists: where I came from—*the country*—and where I live now—*in the city*. This quilt fuses as much of my story and techniques that relate to both my grandmother and me. I hope Grandma Elda approves!

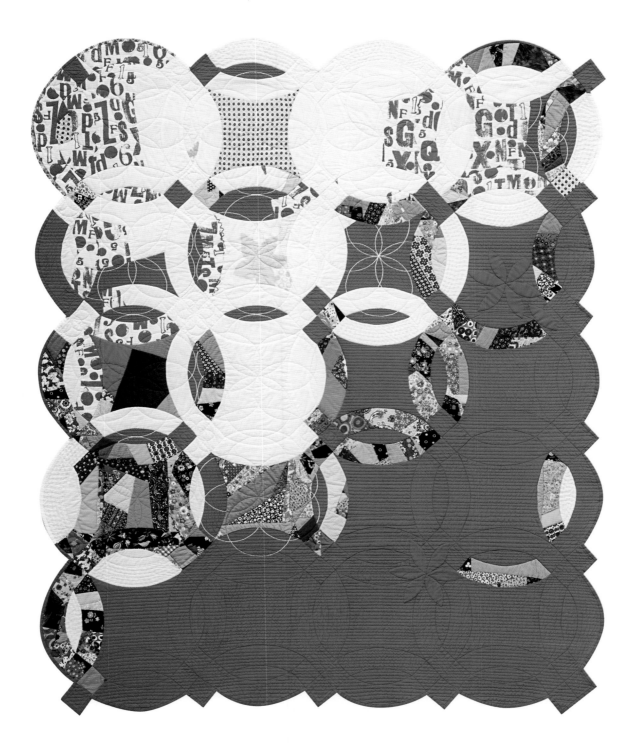

Greatest Possible Trust / Victoria Findlay Wolfe, 2013, 47˝ × 57½˝, hand and machine quilted and embroidered; from the collection of the International Quilt Study Center & Museum, University of Nebraska–Lincoln, 2016.009.0001

Complete quilt instructions can be found in my book *Double Wedding Ring Quilts—Traditions Made Modern* (page 159).

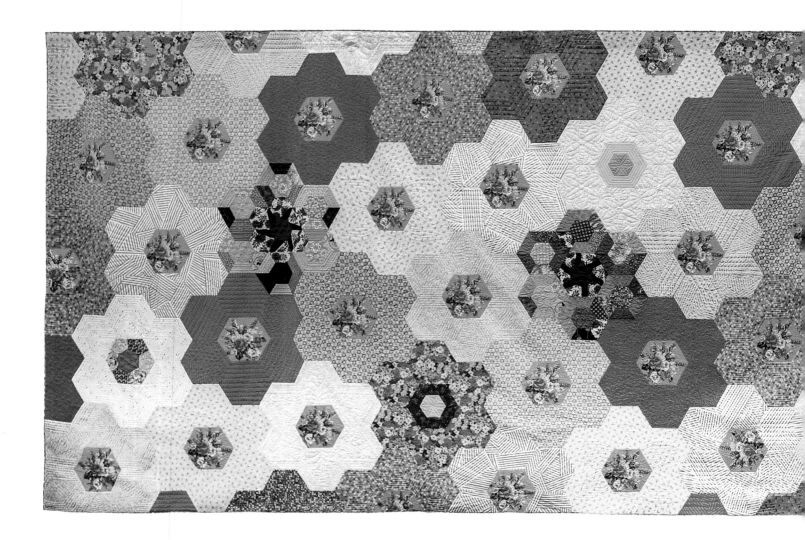

I wanted to make a piece of art for a public art display in NYC, inspired by my renovated bank building. I had to have the art piece to submit it for acceptance, so as I was finishing this quilt, I received a call from Simplicity Pattern Company, saying they were moving their offices and they were wanting quilts to hang in the new offices. ... Their dilemma was they had a 40-foot wall. ... I said, "Well, I have a 30-foot quilt." It hung on display in their offices, and best part was, I did not have to do the paperwork! Did I mention that their new offices were in my bank building that inspired me to make it in the first place? Crazy, right?

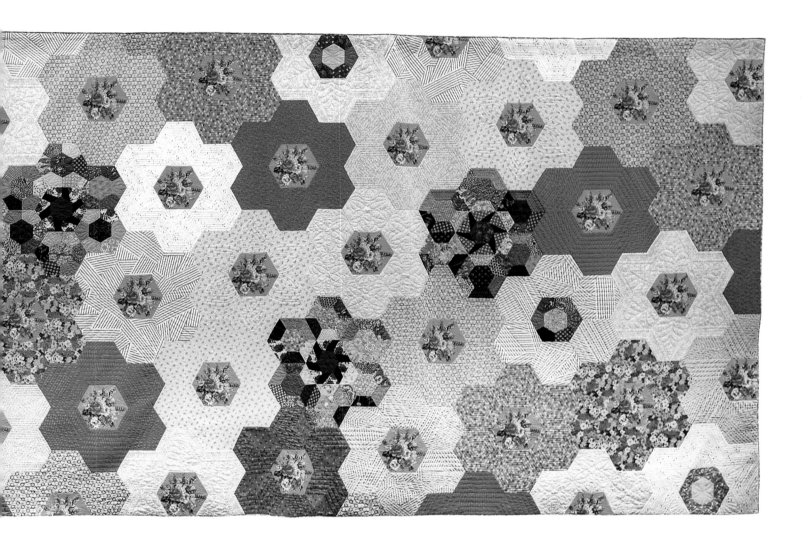

A Garden for All Seasons / Victoria Findlay Wolfe, quilted by Shelly Pagliai, 2017, 9´ × 30´

Photo by Charley Lynch

Being Aware of Your Process

I am hyperaware of my creative process. I spend hours thinking about the way I work. This is key in pushing me outside of my own creative box. Once I know what I do over and over, I can then tweak my ways, a little here and there, to give me the jolt I need to keep creating.

Understanding my process includes everything I do to make a quilt: from the way I buy my fabrics, gather supplies, and find my inspiration.

I am searching for something that keeps my interest! I don't want to make the same quilt over and over; I want to try something new. I have a lot of ideas for quilts I hope to make in my lifetime, I can't just make pattern quilts. Heck, I can't even make my own pattern quilts without changing something up each time!

The idea must be of value to me. It must take me on an interesting journey. It must have purpose in my journey of searching for joy. All these tools we have to play with—from fabrics, to paints, to tools and techniques—should be fun. Ask yourself what's one thing you can do with this quilt that can shake up your process?

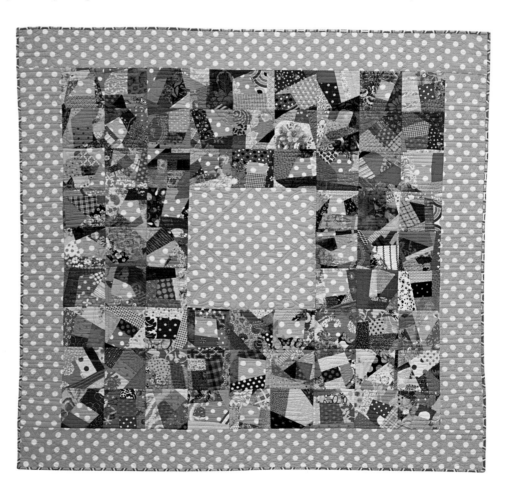

Polka Dots Squared / Victoria Findlay Wolfe, quilted by Angela Walters, 2011, 57˝ × 59˝

Block instructions can be found in my book
15 Minutes of Play—Improvisational Quilts (page 159).

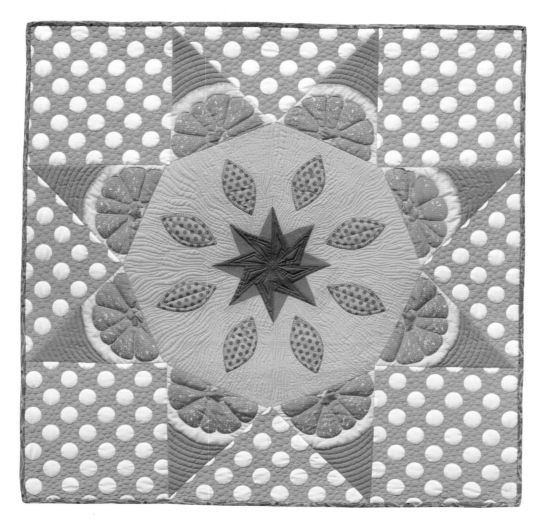

Orange Loving Twin / Victoria Findlay Wolfe, quilted by Jolene Knight, 2015, 39½˝ × 39½˝, from the collection of Bill Volckening

Photo by Bill Volckening

I can look back on my journey and see that there are certain elements I can't seem to get away from, even when I think I'm doing something unique in my process! I can look through these pages and see how I can go from very traditional, to improvisational, to something more artistic, and then circle back and make something that incorporates all of those aspects. Yes, my process is cyclical. My attention span changes, my patience changes, and my focus changes depending on where I am at the given moment—I have to also be aware of that. I try very hard not to be bogged down by labels. I make the quilts that I want to make. I need that fluidity in my creative process to keep me connected. I don't make excuses for my work; I do my very best each time I make a quilt. My best is what I can push myself to do on that day. Then I jump in and make another quilt.

The final object is not as important to me as the process. Of course, it's lovely to make nice quilts, but I'm always thrilled to start a new quilt! I want to see what I can learn the next time, and I revel in the discoveries along the way. I am all about the process. As I've written in these essays, it's exciting to me, it's healing to me, and it fills me with joy. That is all I can ask for.

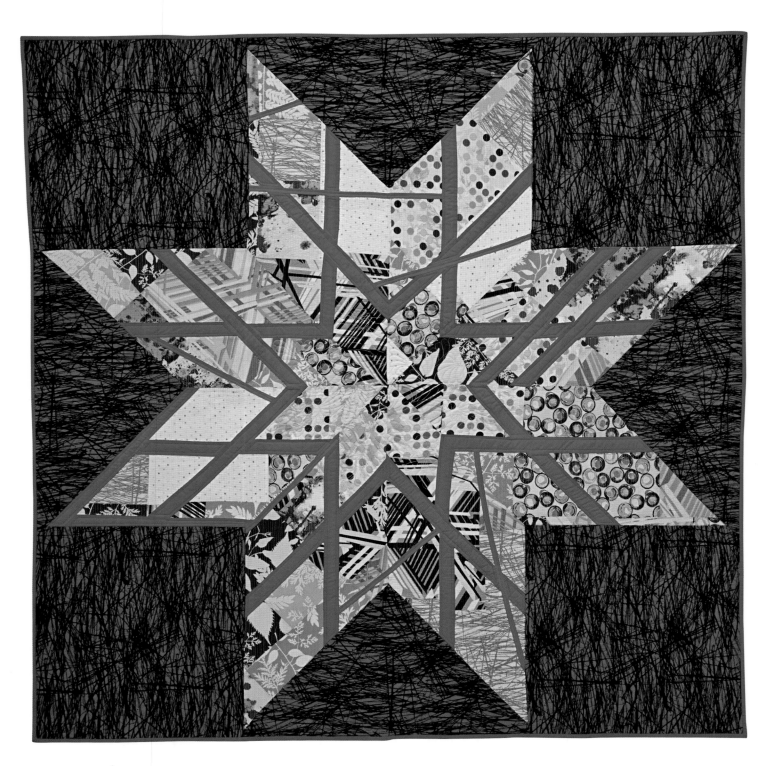

J Rock Star / Victoria Findlay Wolfe, quilted by Jackie Kunkel, 2011, 65˝ × 66˝

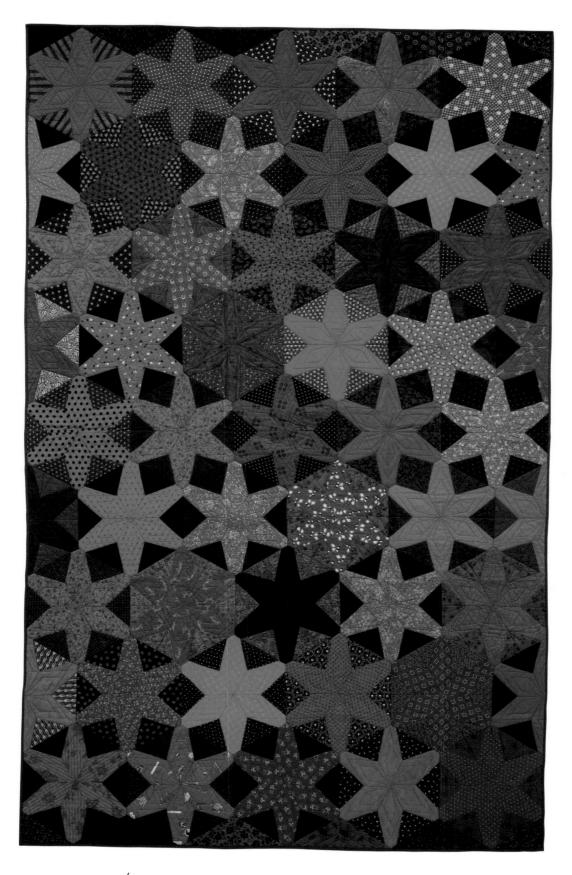

Classic Hex Star / Victoria Findlay Wolfe, quilted by Shelly Pagliai, 2016, 58˝ × 95˝

Complete quilt instructions and acrylic templates can be found on my website (page 159).

Another example of evaluating and taking risks in my journey to shake up my creative process was when I asked my friend Janet, whose work I admire, to play along on an experiment. The challenge was to make two improvisational quilts at the same time, knowing that the two quilts would be similar but not exact. You had to be hyperaware of what you did each step along the way, so that you could duplicate it. It definitely gave me a new perspective on the way that I work. That sort of challenge is great for shaking things up! It's also a great way to learn from others' techniques when working together on a project.

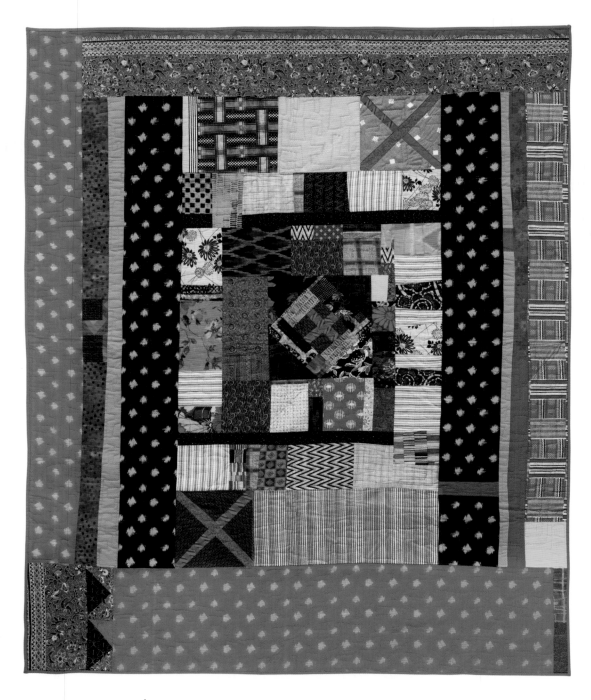

Twin Improv Quilt / Victoria Findlay Wolfe and Janet Hopkins, 2010, 51˝ × 63˝

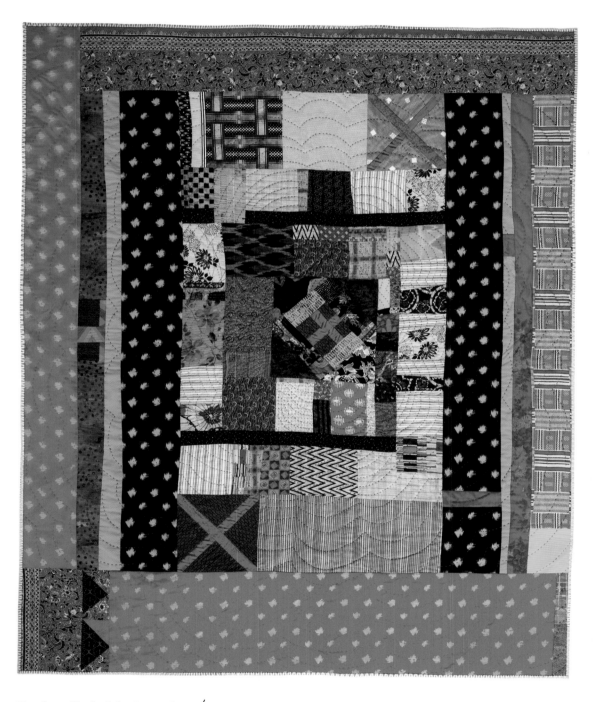

Finishing Each Other's Stitches / Janet Hopkins and Victoria Findlay Wolfe, hand quilted by Janet Hopkins, 2010–2018, 52˝ × 62½˝

A friend sent me a bag a scraps and asked what I could do with them. I chose to use the pieces as I found them, no cutting, but puzzling them together. This was an interesting skill-builder challenge using Y-seams, appliqué, tricky piecing, balance of colors, and fabrics that were not my choices. It's an amazing way to push you outside your comfort zone. Be open to the challenge!

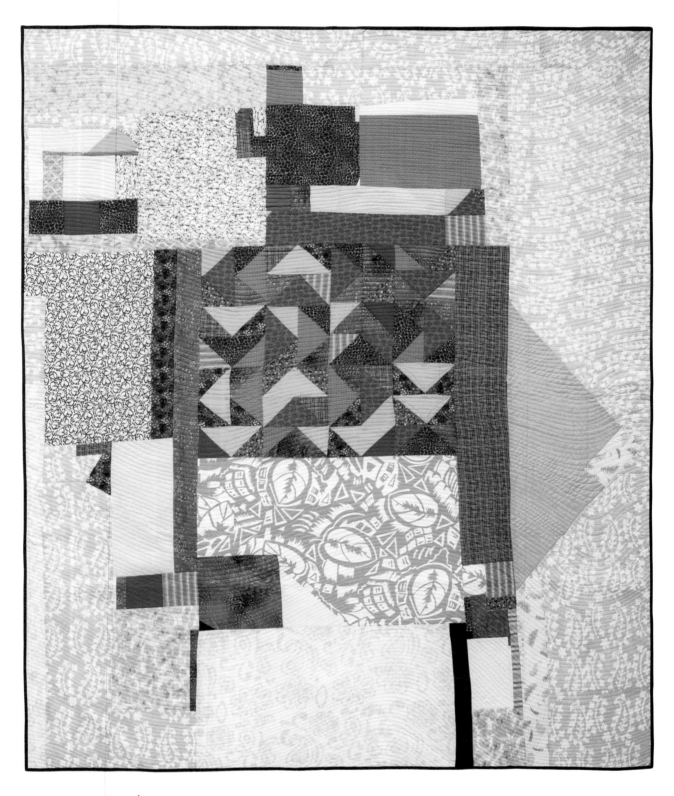

Scrappy Bee Quilt / Victoria Findlay Wolfe, 2010, 60˝ × 73˝

I am a collector of items that bring me joy! I collect chalkware carnival dolls. They make me think of the prizes I would get at the fair as child that I could then paint—another creative outlet. I decided one day I'd design fabrics using images of the dolls and then make a quilt from them. Once I received the fabrics, I started to build the quilt around various ideas; one was the circus tent, another was the birds that fly around eating up all the dropped food on the ground, which made me think of old church revivals. How very random, right? The journey can change, depending on what I am seeing on any given day. That is the part of the creative journey I love. The discoveries feel like an extreme sport sometimes. Risk-taking is always part of designing. Where will my ideas and thoughts take me next?

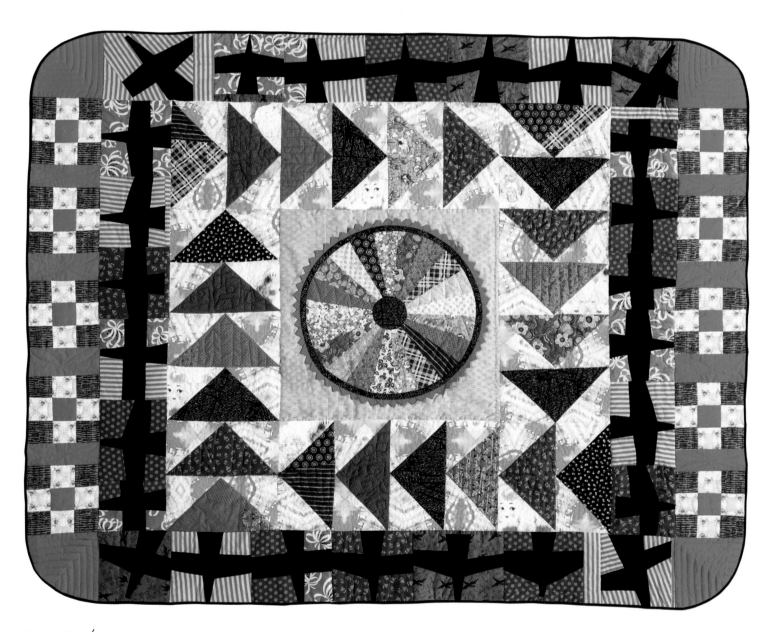

Carnivale / Victoria Findlay Wolfe, 2009, 62˝ × 76˝

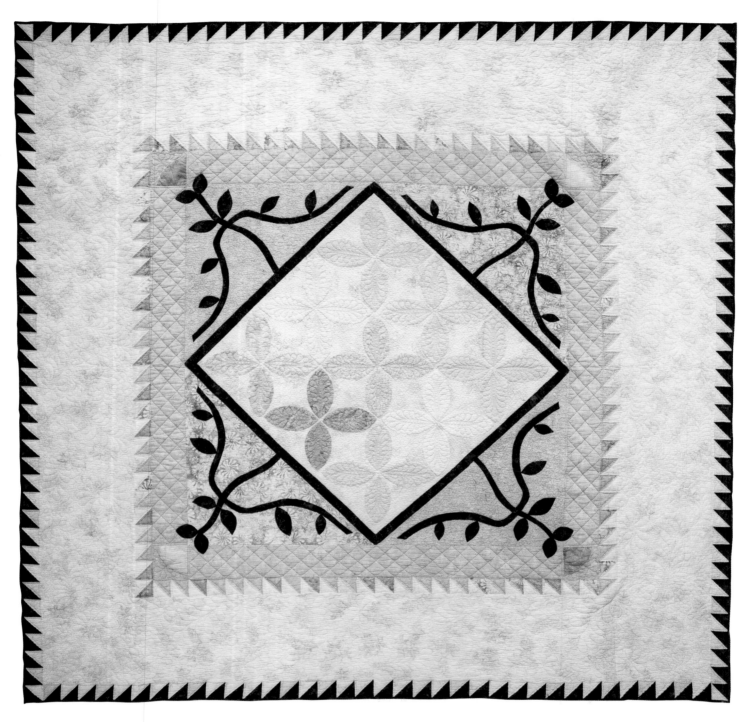

Made for Adele Klapper / Victoria Findlay Wolfe, quilted by Linda Sekerak, 2010, 105˝ × 105˝, from the collection of Adele Klapper

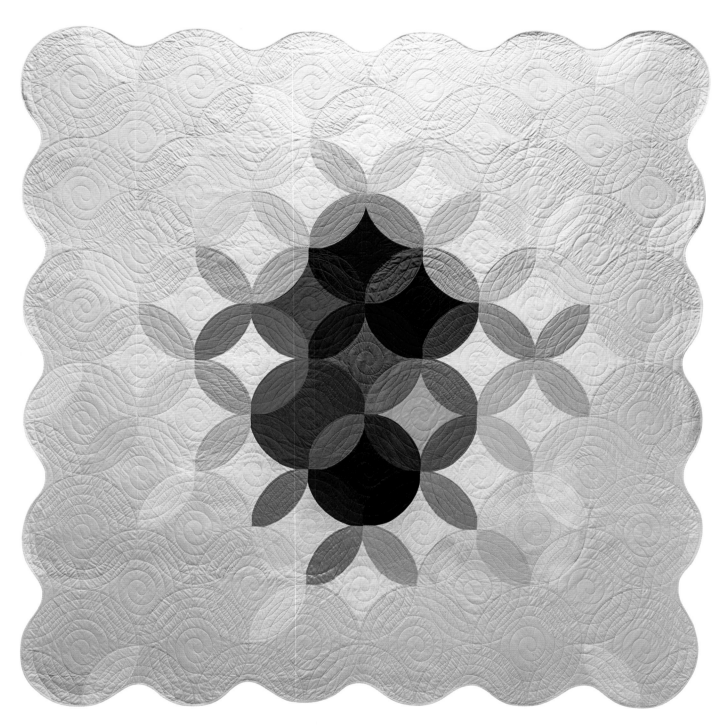

Color Play / Victoria Findlay Wolfe, 2015, 96˝ × 104˝

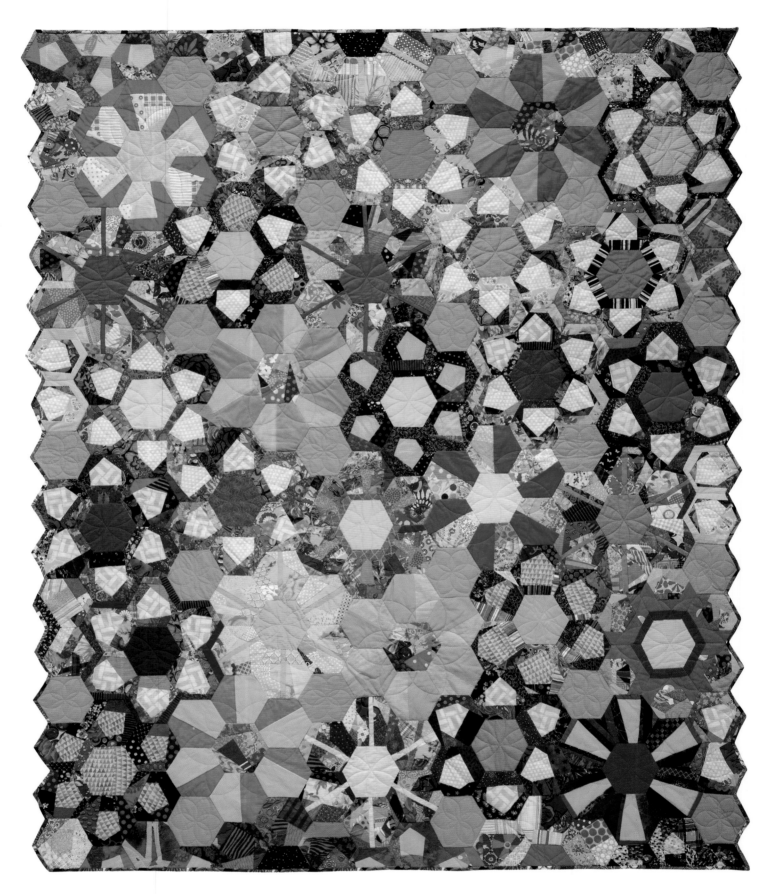

Hex Flower Garden / Victoria Findlay Wolfe, 2015, 69˝ × 84˝

The middle blocks of this quilt were made using solids and striped fabric. I lost my focus with the pieces, and I put them away in a bin with the striped fabrics I was using, for over a year. Later, when I revisited the unfinished project, I looked at the stripes and thought, *What if I just cut all those stripes up, make 15-Minute "Made-Fabric"—would it work?* In my head I thought, *No.* But when I cut it up and looked at it, I was pleasantly surprised that my answer had been right there in front of my eyes from the start. Stop thinking so much. Cut that fabric (you have more) and look at it. What's in your brain and what's visually in front of you are *two different things.* Cut, look, trust your instinct, make.

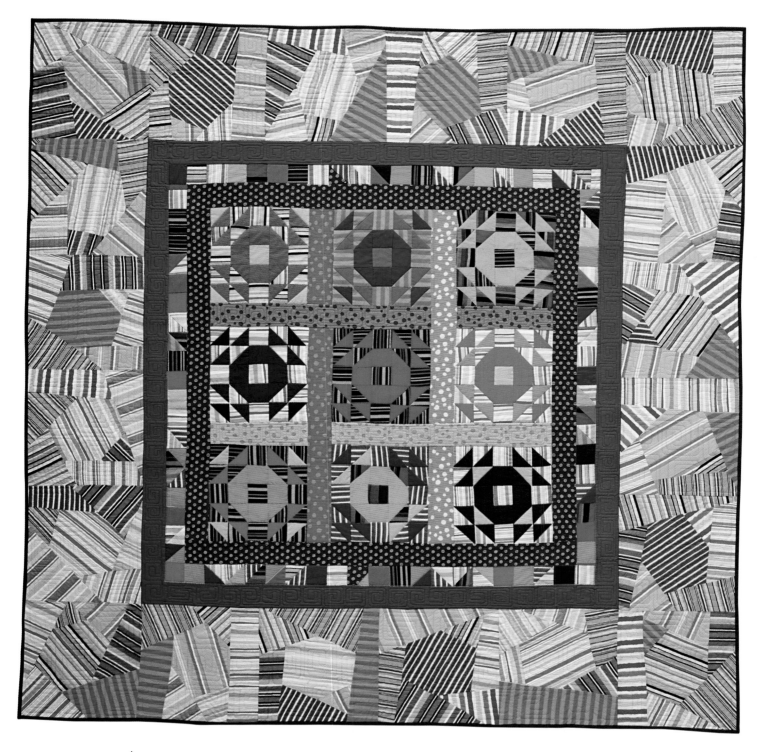

Crown of Thorns / Victoria Findlay Wolfe, quilted by Linda Sekerak, 2011, 71˝ × 71˝, from the collection of Ricky Tims and Justin Shults

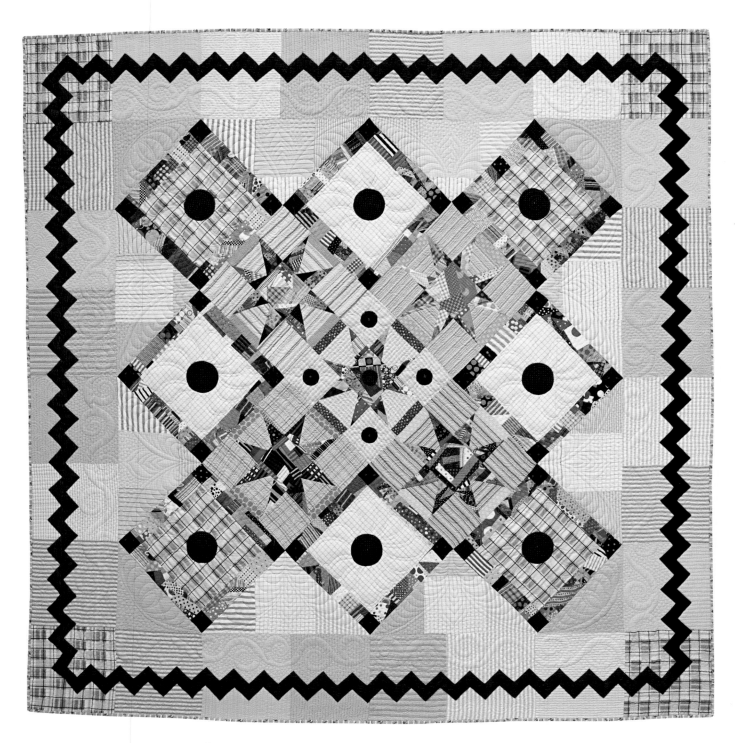

Stripes, Plaids, and Polka Dots / Victoria Findlay Wolfe, quilted by Angela Walters, 2011, 86˝ × 91˝;
from the collection of the International Quilt Study Center & Museum, University of Nebraska–Lincoln, 2016.009.0006

Making Dresden plates are a really fun and easy way to make a complicated looking quilt! Look at each of your shapes to see how you can fill it with pattern. Here, stripes and chevrons make for some exciting motion, just by fussy cutting from the print.

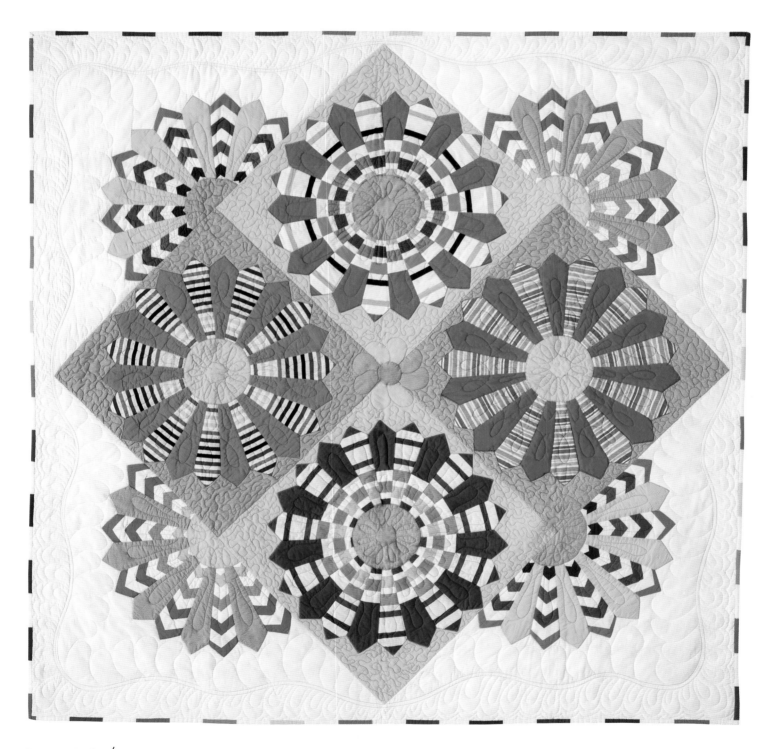

Stripe It Rich / Victoria Findlay Wolfe, 2012, 59″ × 59″

This is a version of my *Bright Lights, Big City* (next page). When working on a busy colorful quilt, you can get stuck balancing color, so think of it this way—color needs to come *out* of the quilt. This time, I wanted to focus on doing just that. Playing with low-volume whites and lights and adding pops of color within the pattern, then adding interesting quilting to mimic elements in the quilt, is a good way to retrain your eyes to look at the space between, instead of the obvious visual path.

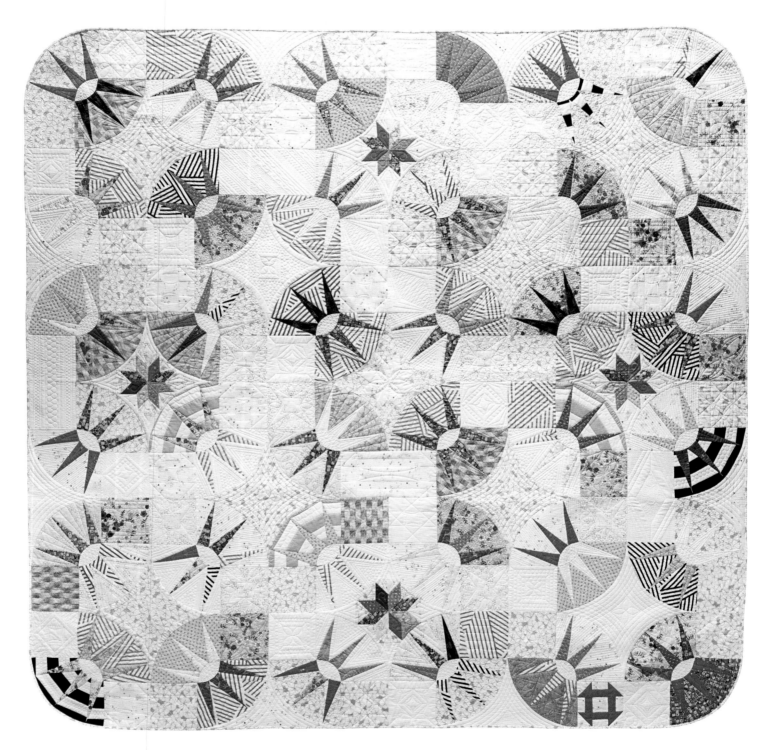

Clear View / Victoria Findlay Wolfe, quilted by Shelly Pagliai, 2017, 87˝ × 87˝

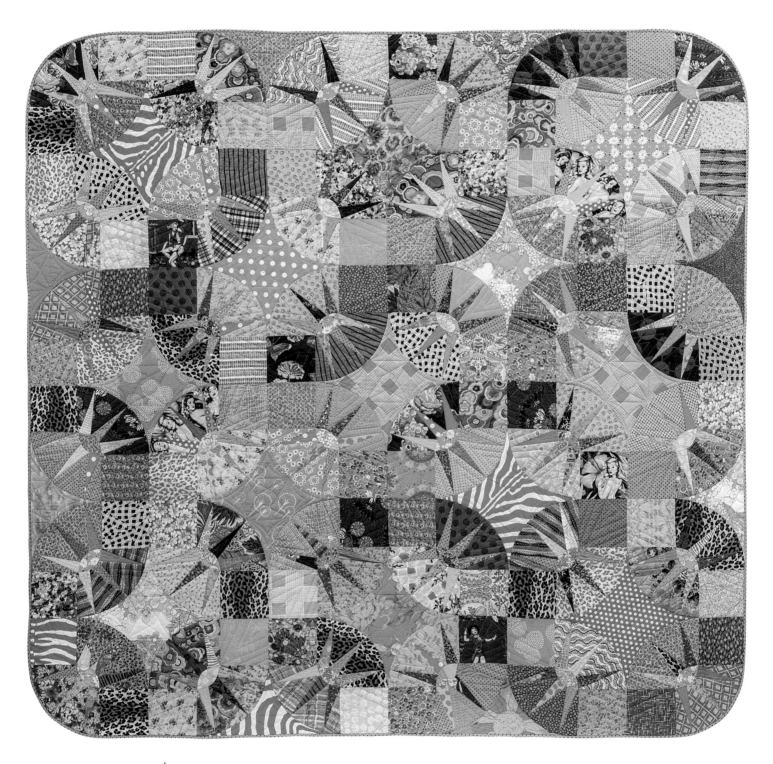

Bright Lights, Big City / Victoria Findlay Wolfe, quilted by Shelly Pagliai, 2013, 90″ × 90″

Complete quilt instructions can be found in my book *Double Wedding Ring Quilts—Traditions Made Modern* (page 159).
Acrylic templates can be found on my website (page 159).

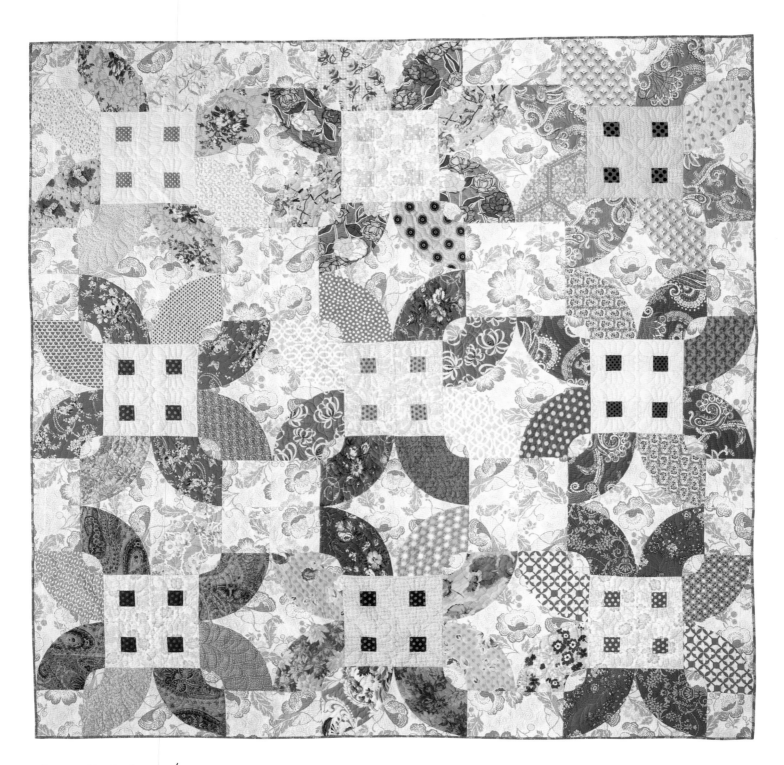

Flowery Florid Blooms / Victoria Findlay Wolfe, quilted by Shelly Pagliai, 2017, 87˝ × 87˝

Complete quilt instructions for this variation of my *Strings of Florid Blooms* quilt can be found
in my book *Double Wedding Ring Quilts—Traditions Made Modern* (page 159).

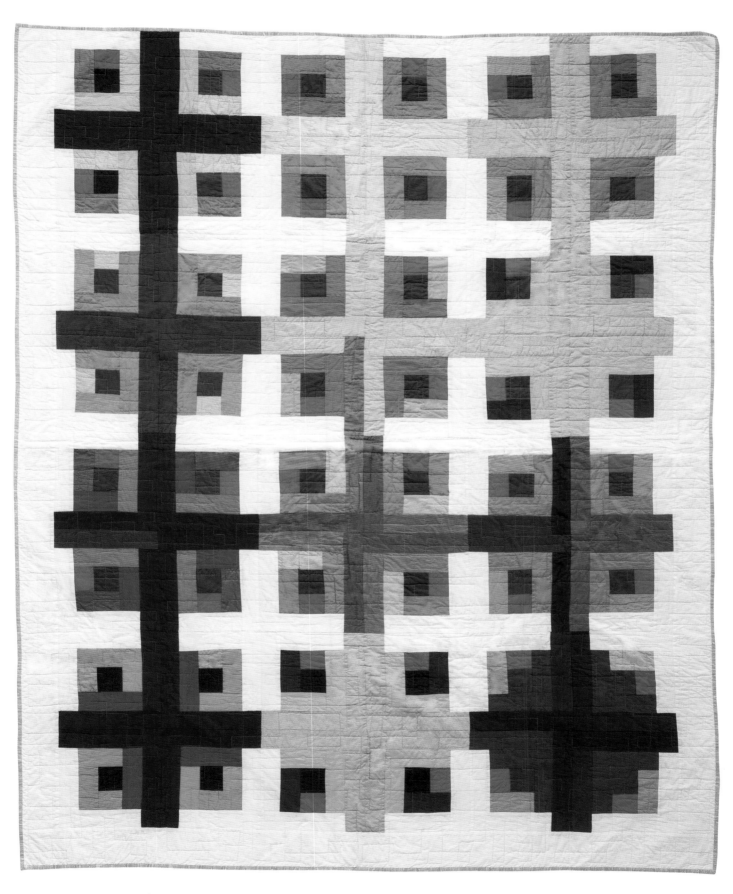

Color Study Crosses / Victoria Findlay Wolfe, 2011, 65″ × 80″

Storytelling

I have always tried to make a quilt that told a story or captured memories of events in textiles.

I need that aspect to make a successful quilt. I rely on my intuition to tell me that I have captured something of myself within the work. That part is what I enjoy the most about quilting.

Finding that "moment" is also a great way to search for inspiration. It's part of understanding why you create.

Sometimes the story is about a personal event, sometimes it's a feeling for a particular person or my mood on that given day. I can look back through these works, and although they may not look super-exciting to the viewer, there is significant purpose within the quilt for me to hold it as a powerful object in time.

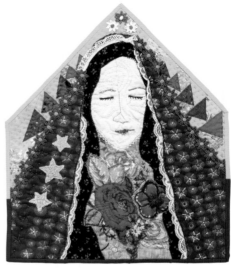

Quilted Mary, Watches Over Those Who Quilt / Victoria Findlay Wolfe, 2012, 16˝ × 19˝, hand quilted, from the collection of Jamie Fingal

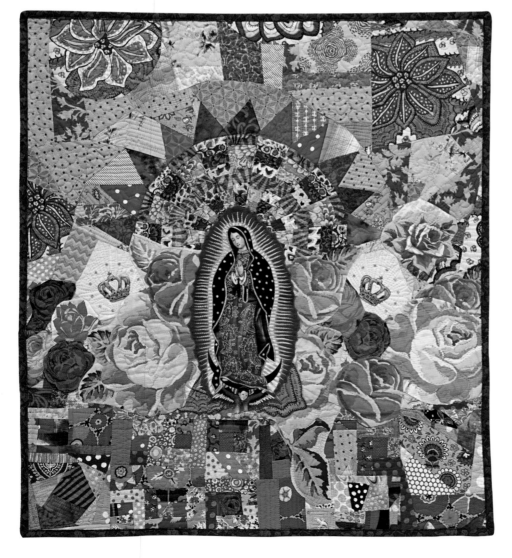

Mary in the Garden
Victoria Findlay Wolfe, 2011, 29½˝ × 33½˝

Having that moment can sometimes be just about me working through a new idea to get ready for the next big project. Not every quilt needs to be big, complicated, and over the top. In fact, my most favorite-quilt-ever took me about two hours to make. Honestly, I cannot even tell you what it is about that quilt that holds that power for me. Maybe that is why this one quilt holds such joy for me. Maybe I am still searching and trying to figure it out.

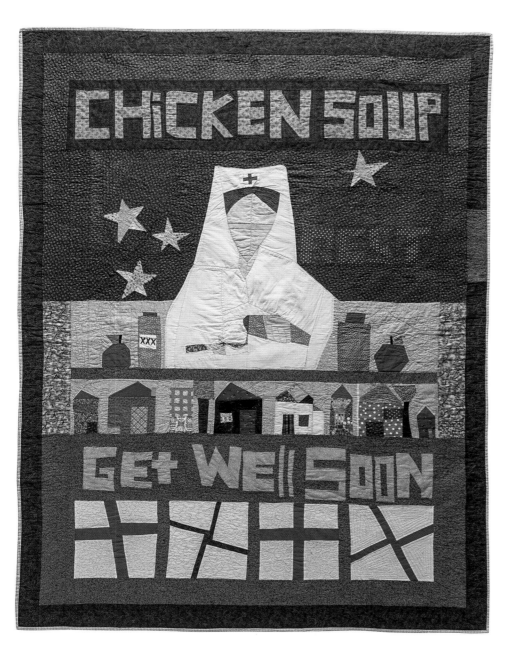

Chicken Soup, Rest, Get Well Soon / Victoria Findlay Wolfe, 2008, 61˝ × 81˝

This is one of my favorite story quilts. When I was growing up, we had a quilt we called "The Sick Quilt." It was red corduroy with Indian cotton and fluffy cotton batting. The quilt was soft, warm, and super snuggly, and we only used it when we had to stay home from school because we were sick. When I started my family, I asked my mother if I could have The Sick Quilt, so I could use it for my daughter as well. My daughter decided she needed to sleep under it every day and did for a long time, even as that poor quilt was deteriorating before our eyes. I had patched it over and over and finally I thought I'd better make a new one, because soon, there would be nothing left.

This quilt started because of a challenge, through Tonya Ricucci's blog, to make a house, home, or pantry quilt. The idea was to use either free-pieced words, wonky houses (inspired by Gwen Marston), bottles, or jars. I was so excited by the idea, that I included everything in one quilt. I remember feeling like every light bulb was lighting up in my brain as I worked all these ideas into one improv-based quilt. No pattern was used; I free-pieced the entire quilt. And wow, it was so satisfying! It was not until I was finished that I realized I was only meant to use one of the ideas to make a quilt. (I do get a little over-excited sometimes!) It was such an inspiring process, and I was hooked. The energy that process gave me is now what I look for in every quilt I build. It should always feel that good, or I'm not doing something right.

A "cousin quilt" to *A Cloudy Day* (next page), this is a great example of ideas reoccurring in your process. Four years before it became this quilt, it started with a leftover quilt block that was pretty but not pieced well. I cut and spliced, and it grew to the center medallion before I abandoned the piece. I didn't know where it was going, I didn't have a story connected to it. Four years later, I was shown another quilt made by my grandmother, and instantly a light bulb lit up. It immediately reminded me of the piece I had made and I knew then exactly how to finish it! Having a quilt finally come to completion, no matter how long it takes, is such an exciting moment. I made sure to add the element I found in my grandmother's quilt, into the bottom right corner of mine, to show what inspired me to finally finish the journey. A happy ending!

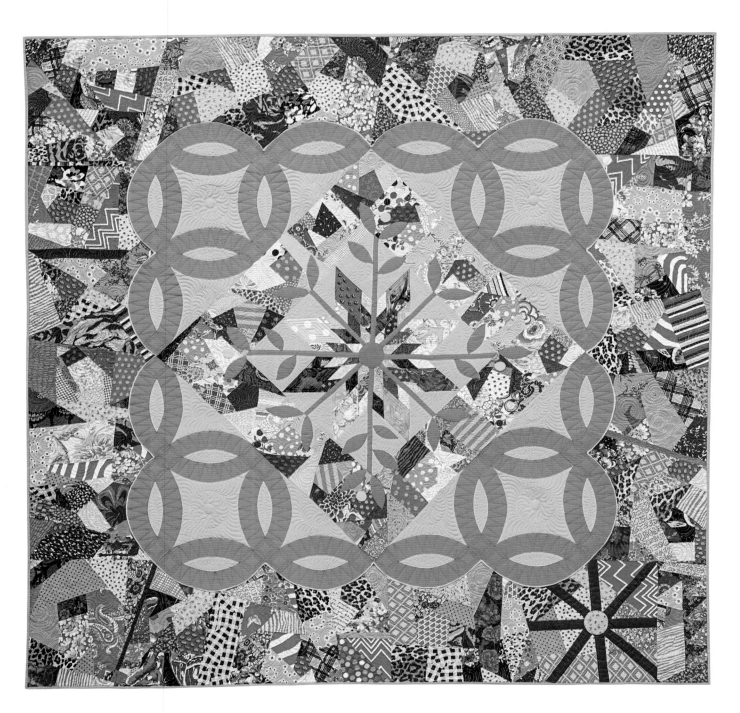

A Summer's Day / Victoria Findlay Wolfe, quilted by Debby Rittenbaugh Brown, 2010–2014, 68″ × 68″

Complete quilt instructions can be found in my book *Double Wedding Ring Quilts—Traditions Made Modern* (page 159).

This quilt is a mixture of using whatever fabrics I had to find the composition. Limiting your palette—finding fabrics you might not normally use (double gauze, linen, batik, cotton)—in one quilt is certainly a challenge! Find the elements you enjoy in the quilt and highlight them—such as adding appliqué to draw your eye around the quilt, using prints to point in the direction you want the movement to go, and combining hard and wavy edges to the complete design, not just within its borders—having fun with all aspects of the quilt. Limits are as good as options. They make you *look* harder! Think. Look, Feel, Make.

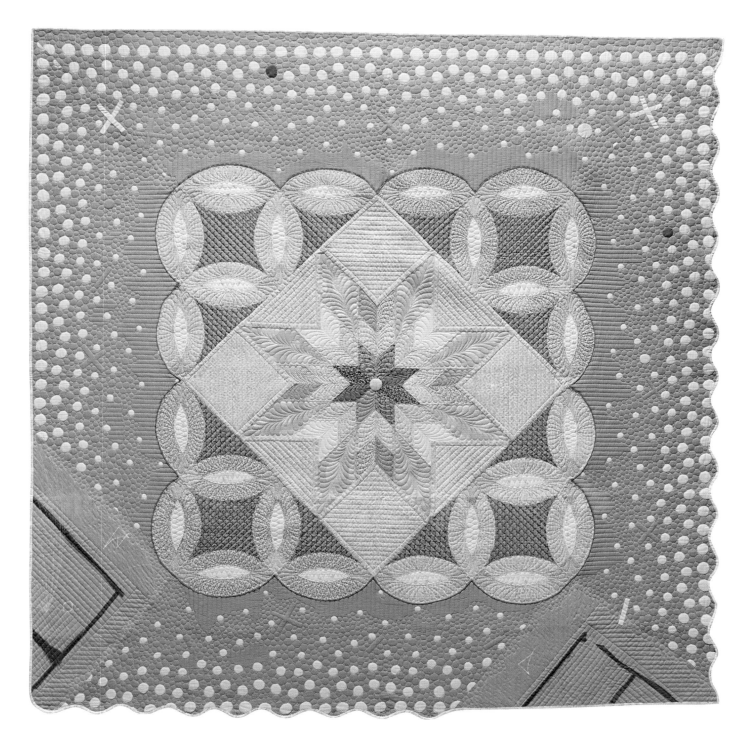

A Cloudy Day / Victoria Findlay Wolfe, quilted by Frank Palmer, 2015, 73˝ × 73˝

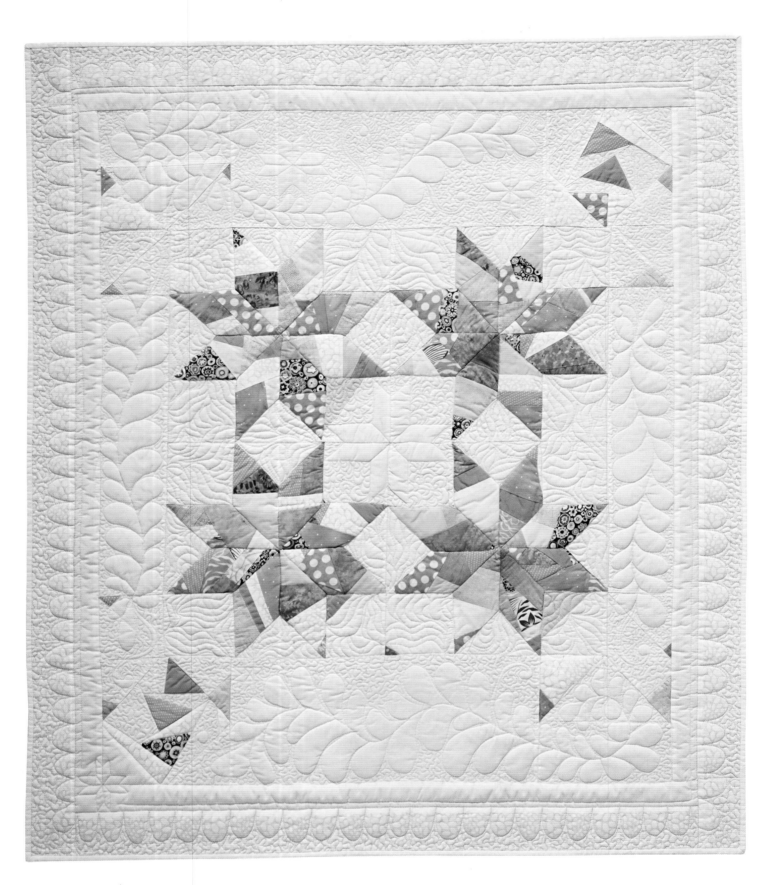

Lucky's Cloud / Victoria Findlay Wolfe, 2011, 39˝ × 44½˝, from the collection of Andy and Kate Bellin

Block instructions can be found in my book *15 Minutes of Play—Improvisational Quilts* (page 159).

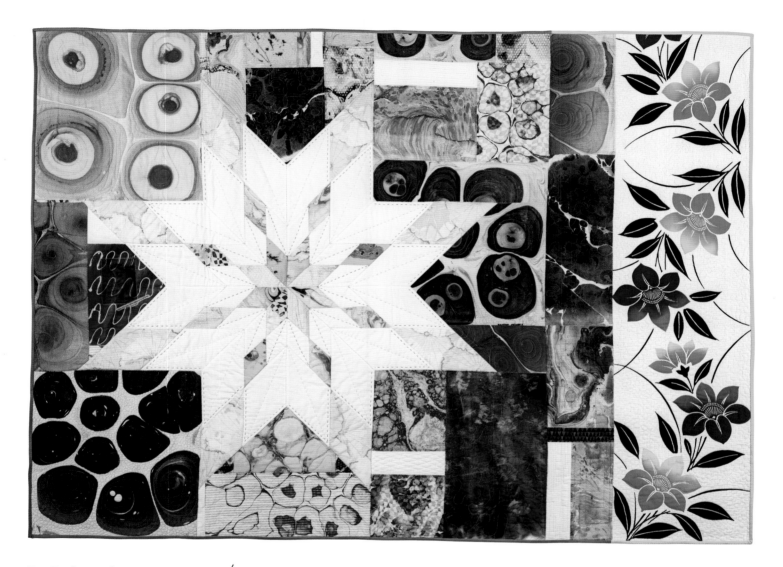

For Barbara, Shine on Bright Star / Victoria Findlay Wolfe, 2016, 51″ × 68½″, made in memory of Barbara Feinstein, from the collection of the Schweinfurth Arts Center

Photo by Schweinfurth Arts Center

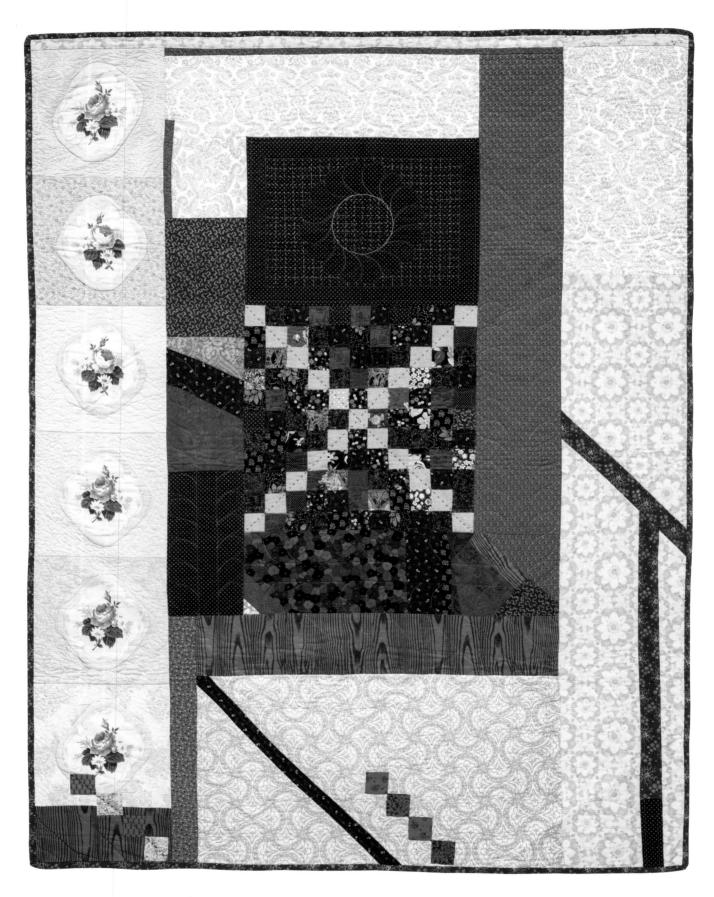

Grandma's Rocking Chair / Victoria Findlay Wolfe, 2010, 46˝ × 59˝, hand and machine quilted

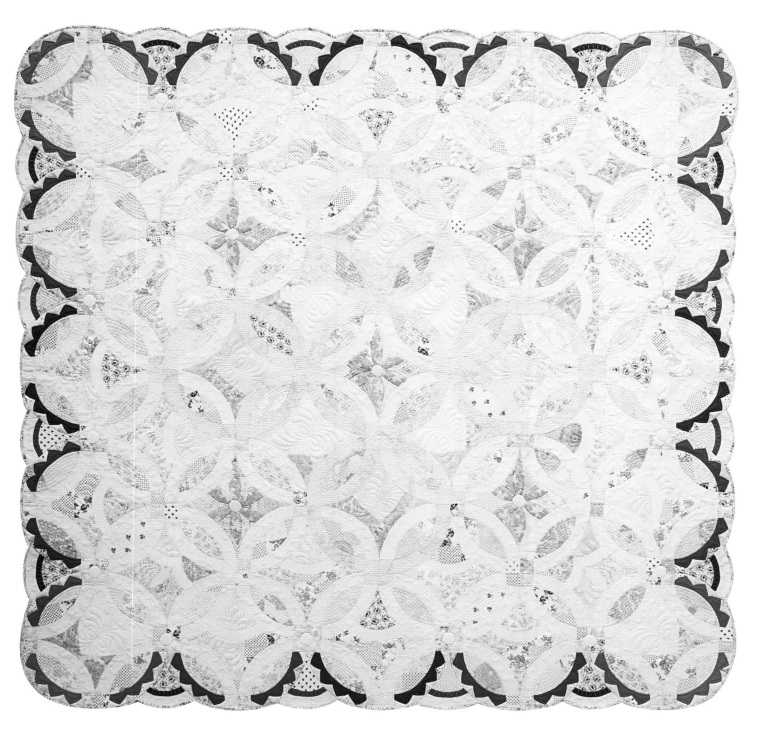

Lace / Victoria Findlay Wolfe, quilted by Lisa Sipes, 2014, 83˝ × 83˝

A personal favorite of mine. This quilt was made from a classmate's fatigues after he retired from the U.S. Air Force. I figured a traditional eagle quilt fit the bill, with the Air Force star in the middle. Camouflage service fatigues is not the easiest fabric to use for appliqué, but the impact was worth it.

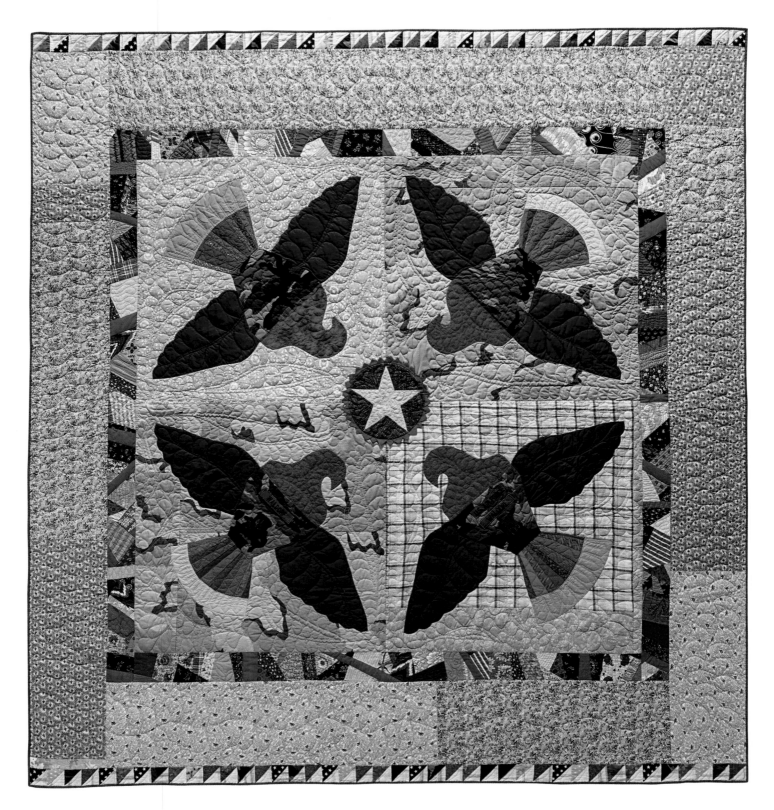

A Quilt of Camo / Victoria Findlay Wolfe, 2011, 86˝ × 91˝, from the collection of Bob and Jennifer Waldorf

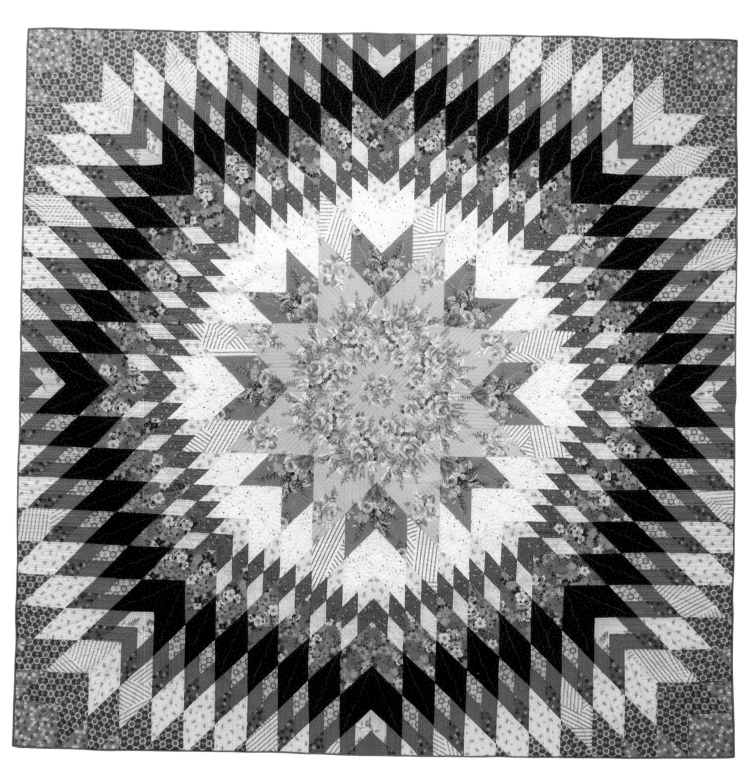

Family Album / Victoria Findlay Wolfe, Kim Hryniewicz, and Margaret Cibulsky; quilted by Frank Palmer; 2016; 91˝ × 91˝

Complete quilt instructions and acrylic templates can be found on my website (page 159).

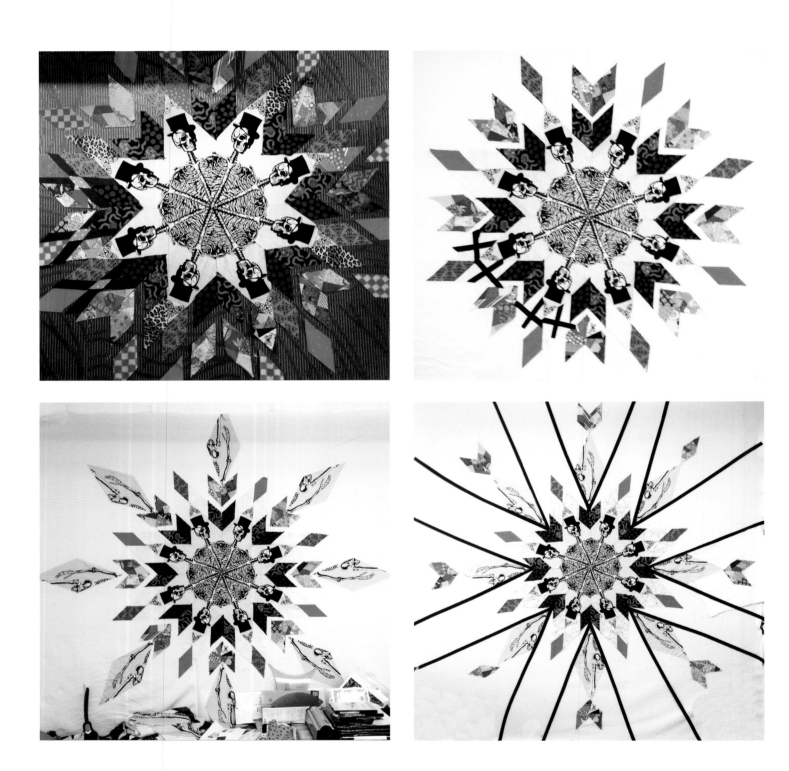

Mr. Swirl E. Bones (next page) took me a few years to decide where and how he needed to "Be." Here are a few photos of his journey, which started on the floor of my hotel room in Lawrence, Kansas, when I was teaching there. The photos show how busy he started out and how the design thinned out for graphic punch.

Photos by Victoria Findlay Wolfe

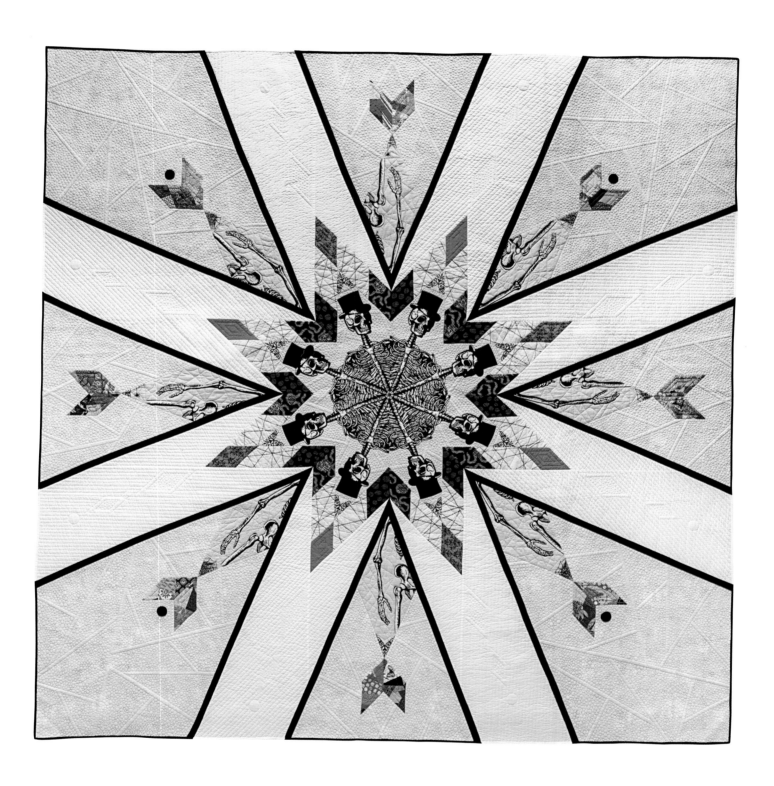

Mr. Swirl E. Bones / Victoria Findlay Wolfe, quilted by Shelly Pagliai, 2015, 96˝ × 96˝

Looking

Looking involves being aware of what has been done traditionally and open to what can be done going forward. Defining a traditional block, understanding its construction, and how to master the skill are all parts of the equation. As a teacher, I love to give students the power to add new skill sets. I also tell them that it's up to them to decide where the importance of perfection falls in their work. It is one small step in the process of the build. Improv piecing has the same value as a traditional, technically pieced block, as long as it adds to the visual effect.

> *Redefining the shapes by looking, taking the name off each particular part, and filling that shape with many colors, or with negative space is the next crucial part of the process. It's where you tell your story with the textile and colors you choose to create visual expression.*

Understanding construction allows you to create easily without having to think about it. This can seem overwhelming if you think, *I have to create a king-size quilt.* But if you break it down to *I need to fill this two-inch space with color,* the task of building becomes so much more achievable.

Try to stop thinking about the final vision of the quilt. Think about each small part, as being a part of the bigger story. Often, I will have an idea, and as I build, the story changes and is often better than I could have predicted. It doesn't need to look like what I initially set out to make.

I work with a parts department; meaning, I select a large group of fabrics and cut a large number of shapes I'm working with, just to get started on an idea. I cut way more than I need of any given shape. I have to have parts to play with and really look at or I can't make any decisions.

Find your intuitive nature and pull what you like. You can make choices, you do it all the time. Don't waste time making these choices. Pull a large pile of fabric, choose one piece and keep making choices based on whether it has any relation to the previous one. Or perhaps just choose it because you like it. Why not? You have nothing to lose.

Limiting choices is also a way to look differently. Becoming comfortable making these choices and being aware of what you are choosing and discounting is very important information. Why aren't you choosing some? If you say, "I just don't like it," be more specific: Is it the color, the scale of print, too dull, or too bright? Putting language to your choices when asking questions is what it's all about when it comes to enhancing creativity. These questions lead to you make choices based on textiles you may not have tried and pushes you toward a new reality!

I continue this process as I evaluate the shapes I want to cut. Start asking questions: What is the block called? What do we know about the block? Is it within your skill set, or is there something you need to learn before you can proceed? How is the block generally constructed? How does it repeat? What secondary patterns are made when the blocks are placed next to each other? Am I focusing on the traditional aspect of the various shapes? How do the shapes connect when the blocks are next to each other? Do I need to enlarge or shrink the block for effect? Can you change it from a block into a completely different shape?

Asking some of the questions ahead of time gives me a place to start to cut. Perhaps I need to make the block as it usually appears, so I can explore the options of filling spaces further. Can I fill the negative spaces with the same color or multiple colors? Can I take information out of the block to create something entirely different? Can the seam allowance represent lines I need to tell another story? Being active in the process of exploring is what will guide you to your next steps.

Detail of *Fade to Purple* (page 113)

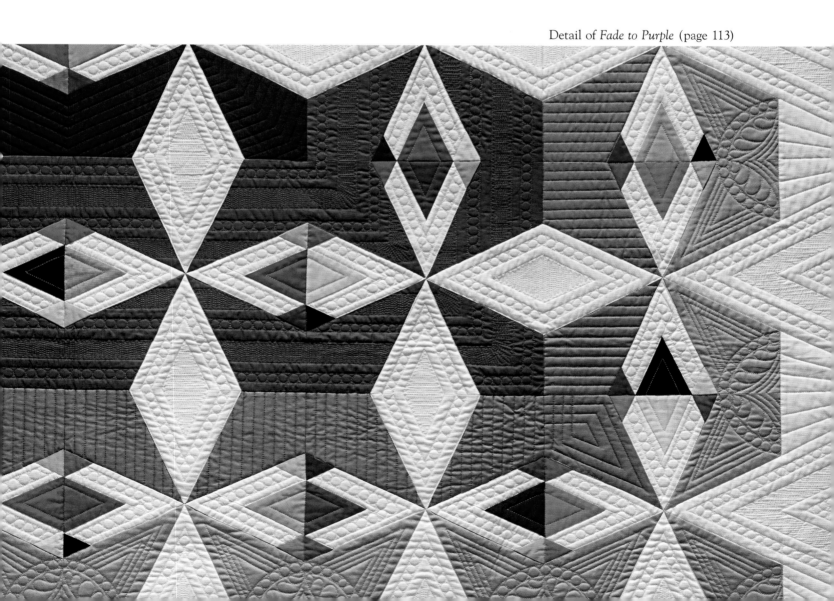

Deconstruction / Victoria Findlay Wolfe, 2015, 62˝ × 62˝

When looking at an individual shape, think about the negative space. Should your focus be on the traditional sense of the block or can you play/ adapt/ change the background to become foreground? Playing and considering each space as individual to the process lets you decide what depth and movement you can add. You will then make purposeful decisions for the next steps of your story/design.

Be conscious about the questions, and trust your eye and instinct as to what is working and what is not. Step back after each adjustment you make, and get perspective on the choice, again, taking photos with each change, so you are really seeing what is happening and not what your brain thinks.

Get in touch with your intuition. Feel the choices and continue to ask more questions. Does this stand on its own? How does it relate to the fabrics around it? Is it telling me anything about the composition, about where it sits, or does it need to be in a different position? Balance is an ongoing set of questions when designing. For example:

- Overthinking is the biggest problem that can arise in your creative process. Working something to death, until it has no life visually, is a place many people get "stuck." Being mindful of that can bring you to a wall, where you have to decide if you need to look at it differently. Often, this is a great time to take information out of the quilt and focus on negative space, because often, less is more.

- Busy compositions are satisfying, too, and must balance well with color, light and dark, places of visual rest, and contrast. A couple very good examples of that are *Clear View* (page 82) and *Bright Lights, Big City* (page 83).

- Get involved in cutting, experimenting, and looking. Don't stand to the side and wait for inspiration to hit you. You have to be involved and work hard to make it happen. You have to focus, so you can enjoy the ride.

- Adding new elements is not just about adding technique. Improv work is a brilliant way to test your eyes. It can push your drive to let go and ask questions. I start my days by sewing scraps of fabrics together for several reasons: I don't want to overthink. I want to allow color combinations to happen, I want fabrics to be cut up to give me unexpected patterns and effects. I want to give permission to my eyes to see something I cannot label with words but feel that it is something I can work with and build on.

- Once you can label something with words, it's hard to break free of that thought. Working in abstract can stop the words from forming and push your eyes to see what is in front of you. If you find that you exclude colors, say brown, and you randomly sew brown, green, and pink together, and you realize you like it, then you can quit saying, "Oh, I never use brown!"

Allow your eyes to see, allow them to find things you like. We are so trained out of using our intuition, that sometimes we don't even know what we like anymore. We buy the pattern, we buy the fabric to make the pattern, and we have no choices left to make. We are not using our creativity when we make that quilt, we are being a machine, to make someone else's vision.

Say Cheese Bumble Beans / Victoria Findlay Wolfe, 2010, 28˝ × 24˝, hand and machine quilted

Never say *never* ... because you will ...! (It's also a very good challenge to get creative, figuring out how to make the process enjoyable, while making the thing you said you would never make!)

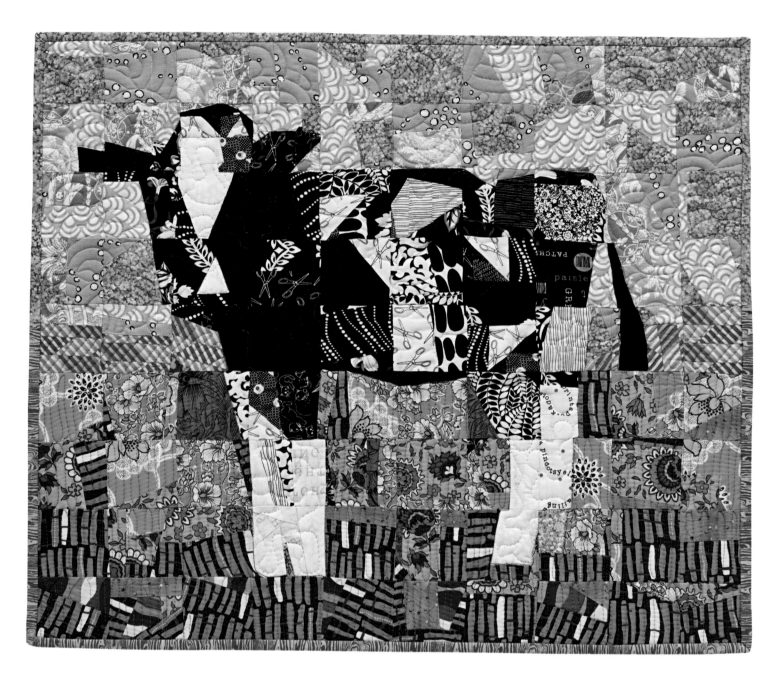

I Will Not Make a Cow Quilt / Victoria Findlay Wolfe, 2011, 25˝ × 22˝

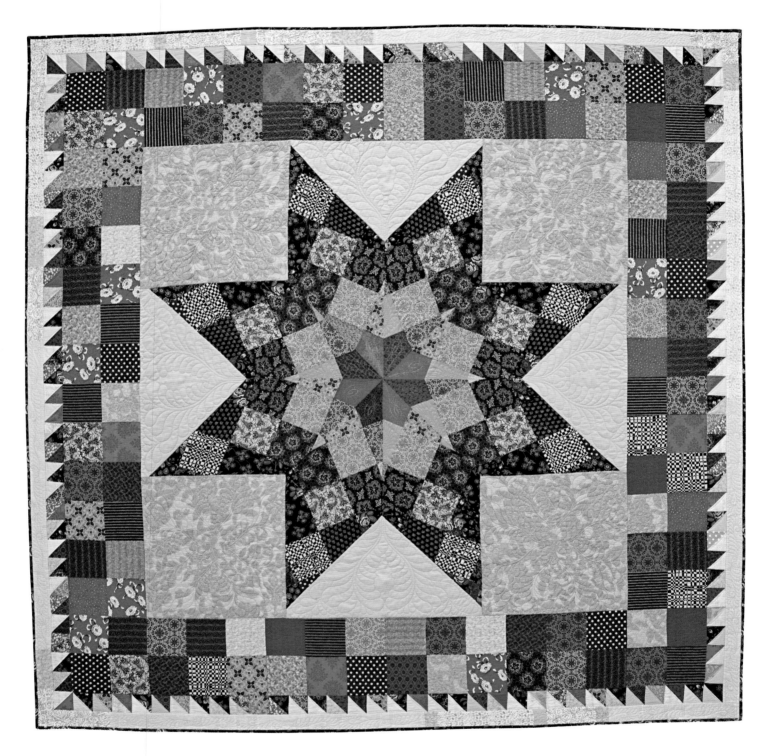

Barn Star / Victoria Findlay Wolfe, quilted by Jackie Kunkel, 2011, 95˝ × 95˝

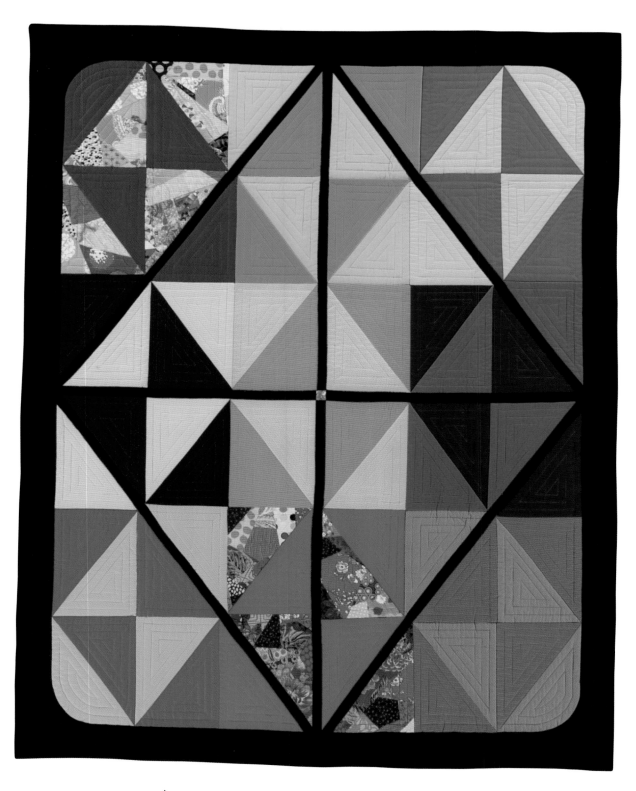

Stained Cargo Windows / Victoria Findlay Wolfe, quilted by Shelly Pagliai, 2015, 69˝ × 54˝

Inspired by an Yvonne Wells quilt, circa 1980–1985; from the Robert and Helen Cargo Collection, International Quilt Study Center & Museum, University of Nebraska–Lincoln, 2016.009.0005

Photo by Thomas L. Hauder

Looking at how blocks repeat and what happens in the spaces between the obvious placement of color is a way to boost your design sense. This traditional square dance block is *exactly* the same block as I used in *Modern Square Dance* (next page). Think about the power of negative space!

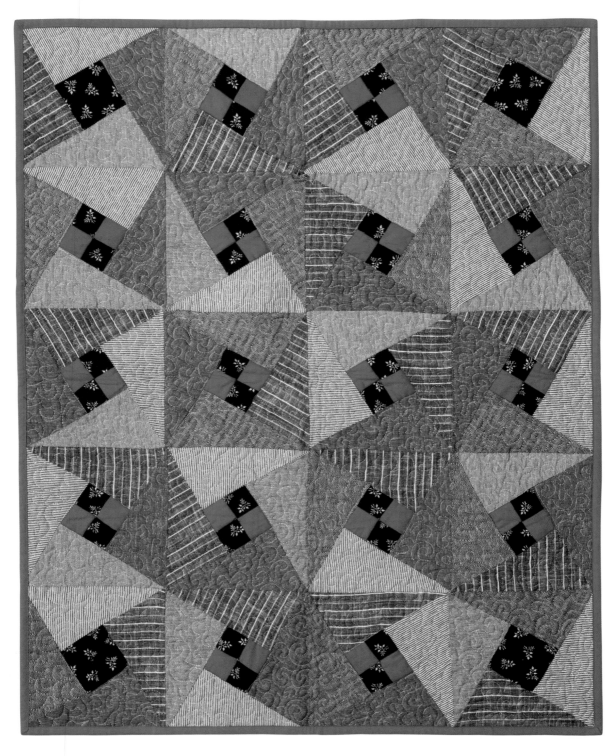

Traditional Square Dance / Victoria Findlay Wolfe, 2016, 23˝ × 27˝

Photo by Mike McBride, Sizzix

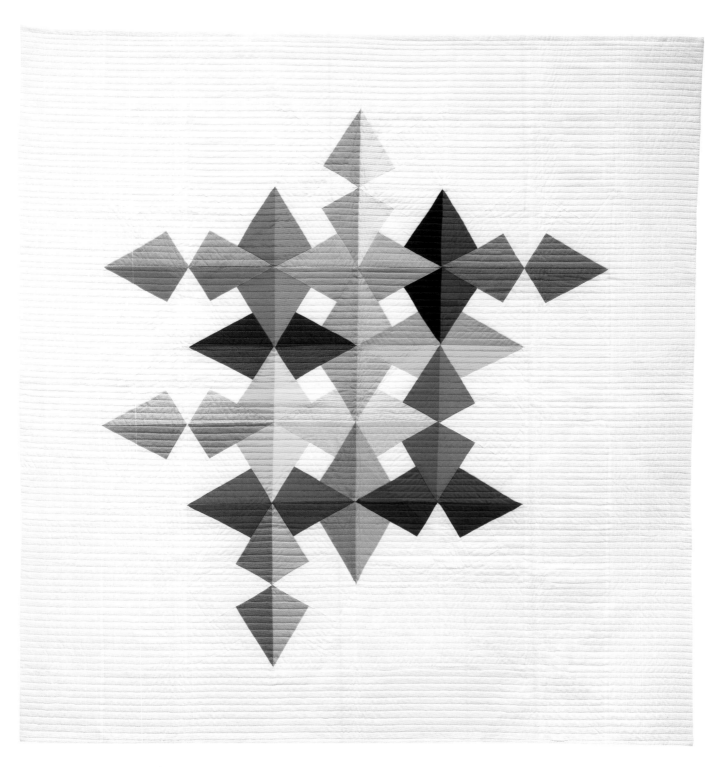

Modern Square Dance / Victoria Findlay Wolfe, 2015, 54˝ × 58˝

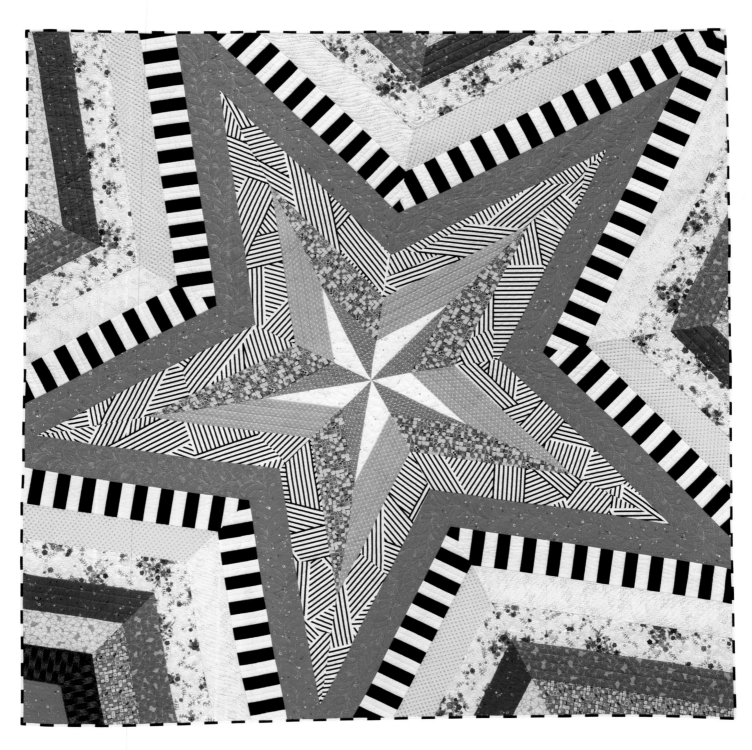

Star Storm / Victoria Findlay Wolfe, quilted by Shelly Pagliai, 2017, 78˝ × 78˝

Complete quilt instructions can be found on my website (page 159).

My perfect T-shirt quilt! I used my Harley T-shirts, added stabilizer to them, cut them up, and cut my strips to make this quilt. Looking at the shapes of a design to find ways to fill the spaces with more than one fabric is what I am looking for when I make a quilt. I don't always need to reinvent the pattern, but I can change the look of the quilt by filling the space with different combinations of pieced elements.

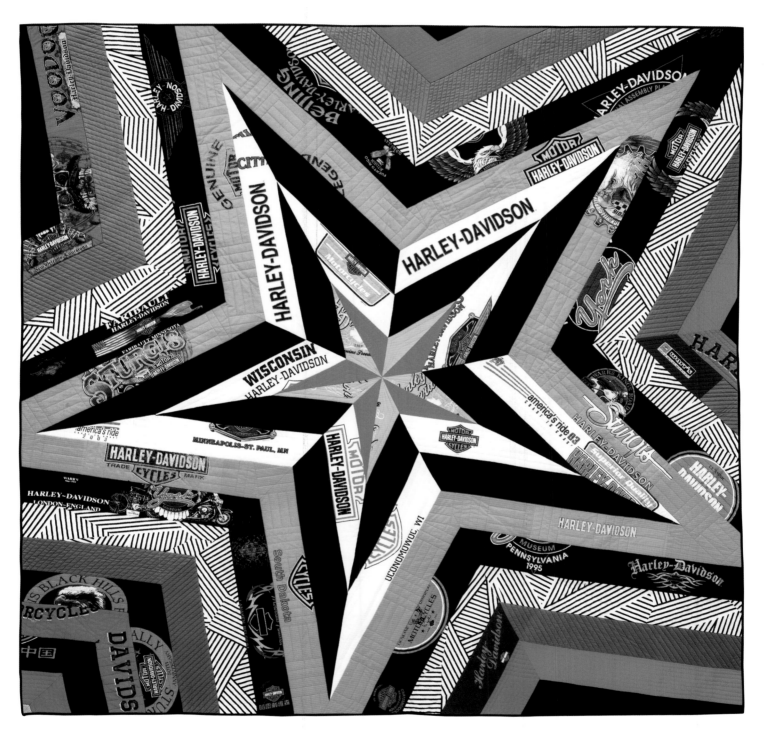

Harley Storm / Victoria Findlay Wolfe, quilted by Shelly Pagliai, 2017, 78˝ × 78˝

Complete quilt instructions for this variation of my *Star Storm* quilt can be found on my website (page 159).

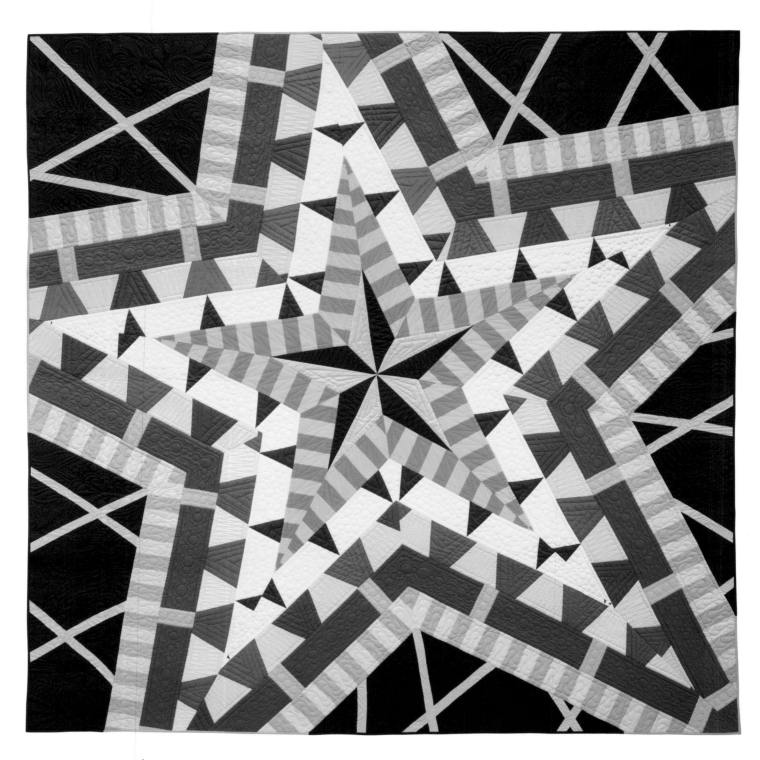

Improv Star Storm / Victoria Findlay Wolfe, quilted by Karlee Porter, 2018, 78˝ × 78˝

Complete quilt instructions for this variation of my *Star Storm* quilt can be found on my website (page 159).

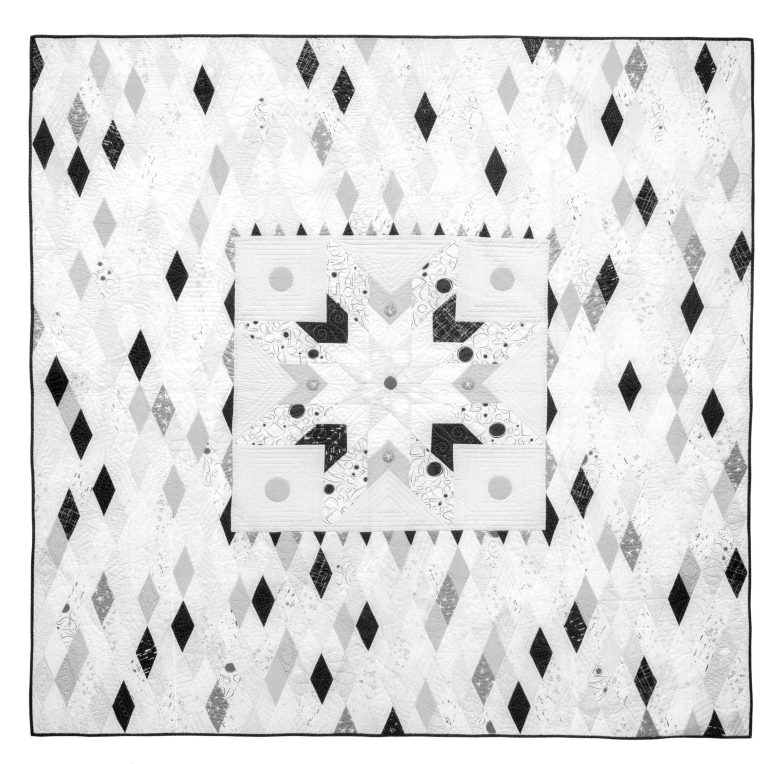

Diamond Work / Victoria Findlay Wolfe, quilted by Shelly Pagliai, 2016, 71˝ × 71˝

Complete quilt instructions and acrylic templates can be found on my website (page 159).

I love looking at a traditional quilt block and figuring out how I can use the same block in several quilts that look nothing like each other. This one and the next three quilts (pages 113–115) were all made using the Victory block. Notice the color placement and how different the design can look without changing the block construction—traditional to modern!

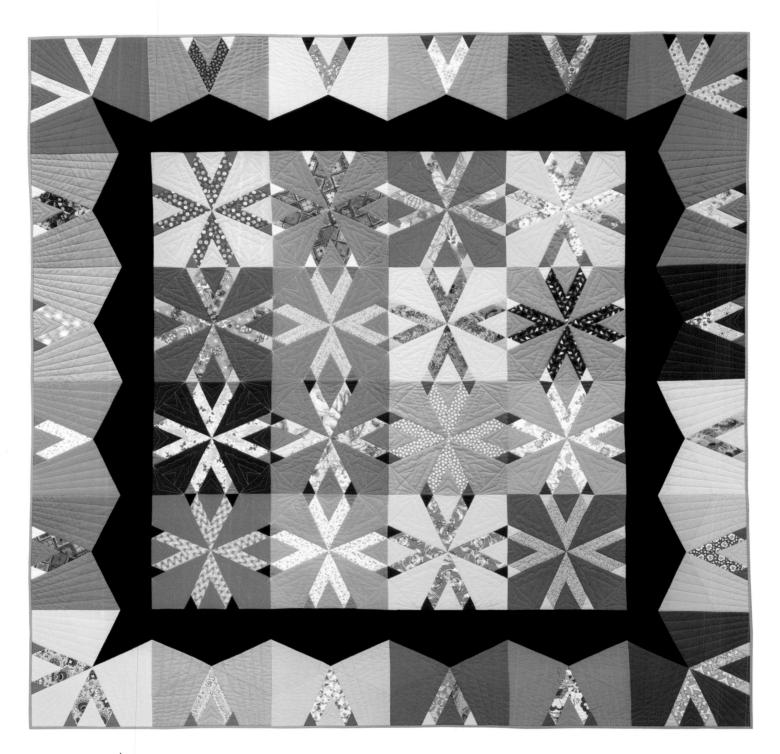

Dancing Legs / Victoria Findlay Wolfe, quilted by Shelly Pagliai, 2016, 72˝ × 72˝

Complete quilt instructions and acrylic templates can be found on my website (page 159).

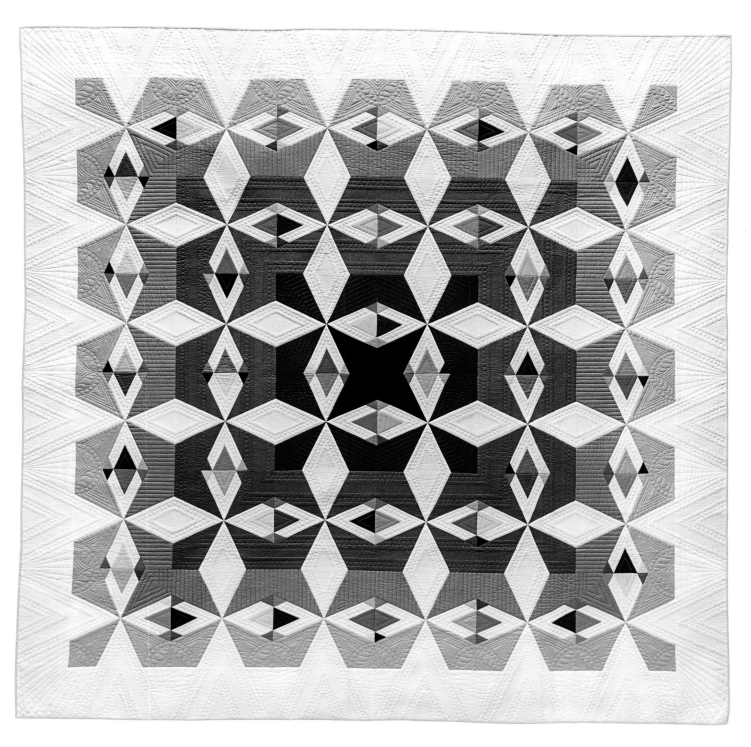

Fade to Purple / Victoria Findlay Wolfe, Kim Hryniewicz, and Laura Clark; quilted by Shelly Paglia; 2015; 84˝ × 84˝; group quilt

Complete quilt instructions and acrylic templates can be found on my website (page 159).

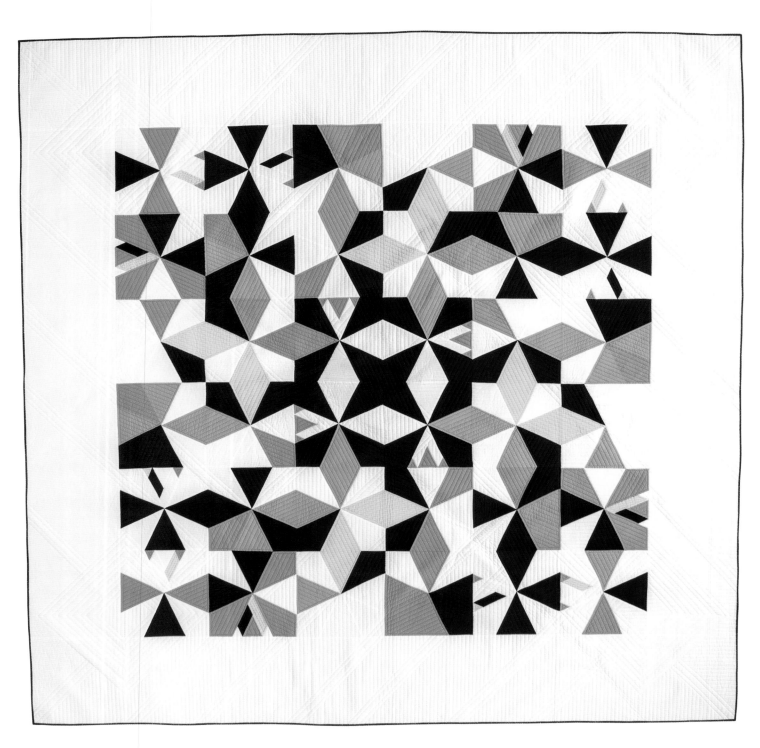

To the Nines / Victoria Findlay Wolfe, quilted by Frank Palmer, 2017, 92″ × 92″

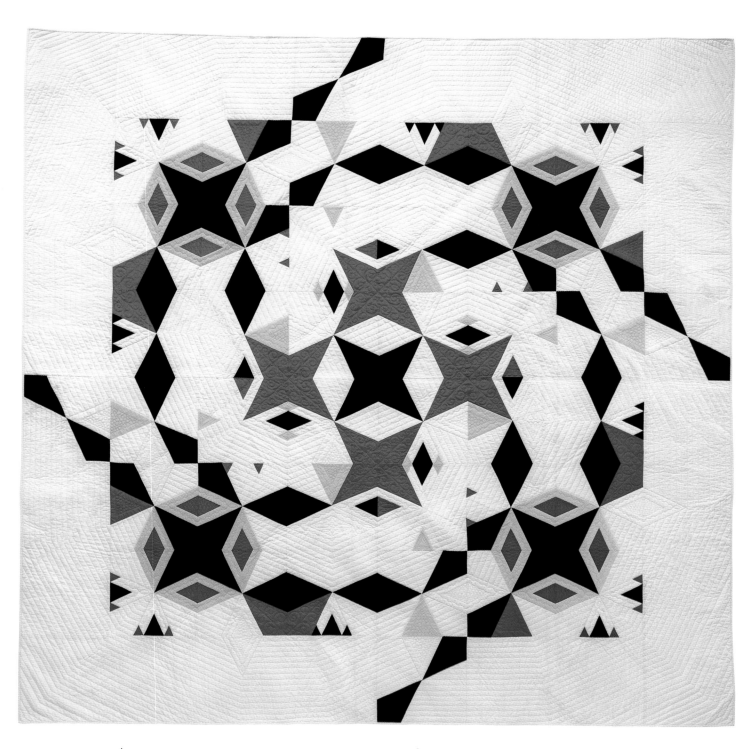

Rose in a Storm / Victoria Findlay Wolfe, quilted by Shelly Pagliai, 2017, 96˝ × 96˝

This one and the next three quilts (pages 117–119) were made using a stretch hexagon and tumbler shape to get a variety of looks. I find discovering the different patterns very exciting. Look beyond the obvious.

Garden Variety / Victoria Findlay Wolfe, 2016, 70˝ × 84˝

Complete quilt instructions and acrylic templates can be found on my website (page 159).

Stretched Hex / Victoria Findlay Wolfe, quilted by Shelly Pagliai, 2016, 70˝ × 84˝

Tumbling Arrows / Victoria Findlay Wolfe, 2016, 71˝ × 80˝

Complete quilt instructions and acrylic templates can be found on my website (page 159).

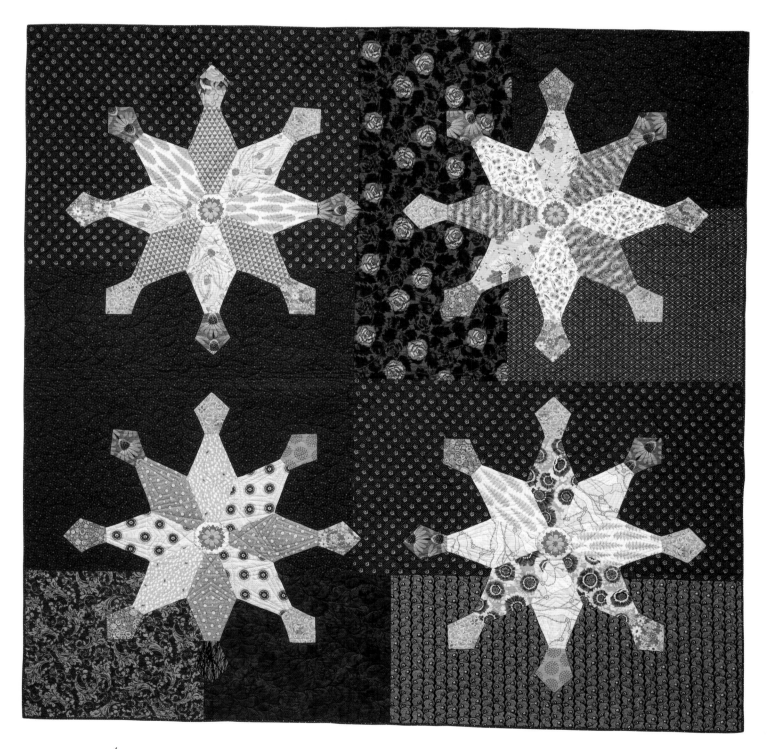

No Two Alike / Victoria Findlay Wolfe, quilted by Shelly Pagliai, 2016, 80˝ × 80˝

Complete quilt instructions and acrylic templates can be found on my website (page 159).

Sometimes, when Shelly and I talk about how she will quilt the quilt, we have deep conversations about my ideas and thoughts about making the quilt. (We had a week's worth of conversations about this quilt.) She then takes that info and decides how we can merge our ideas into quilting. Sometimes I leave it up to her, sometimes I have an idea, most of the time it's a conversation to see if we both agree, and often, we quickly move forward with trust. Lucky for us, we work well creatively this way.

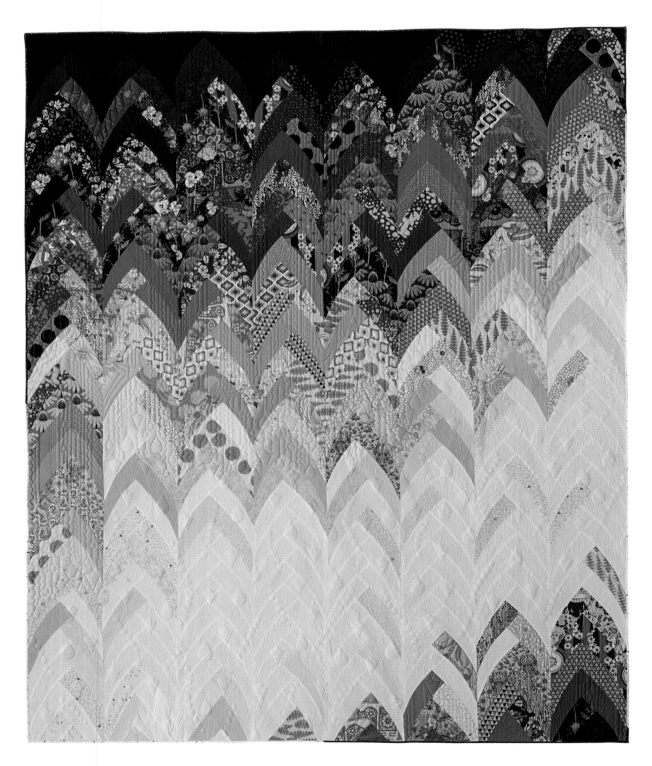

Cascade / Victoria Findlay Wolfe, quilted by Shelly Pagliai, 2016, 74˝ × 90˝

Complete quilt instructions can be found in my book *Modern Quilt Magic* (page 159).

The curved-braid template that I used to make *Cascade* (previous page) is the same shape I used to make *Flatliners*. The idea that one simple shape can produce such a completely different design is what keeps me making quilts. It's all an adventure and keeps me excited.

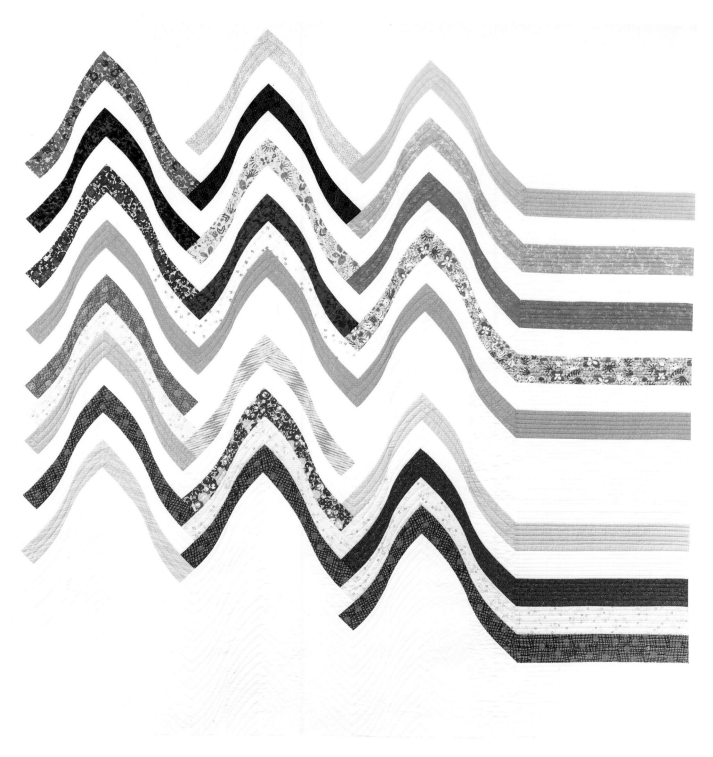

Flatliners / Victoria Findlay Wolfe, quilted by Shelly Pagliai, 2018, 83˝ × 87˝

Photo by Alan Radom

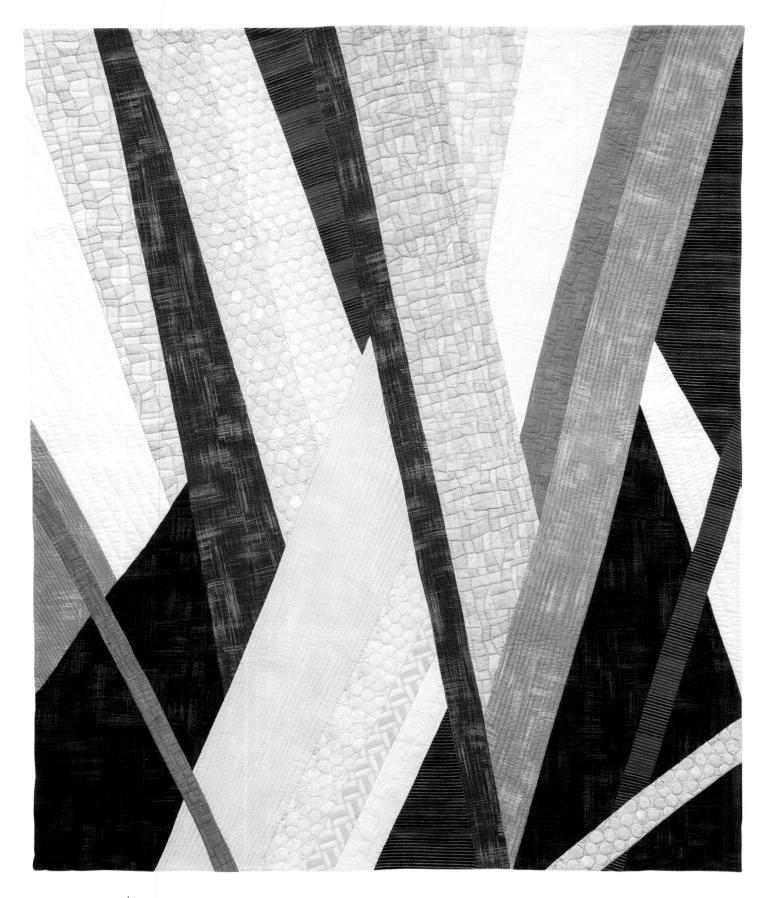

Modern Views / Victoria Findlay Wolfe, 2013, 49˝ × 60˝

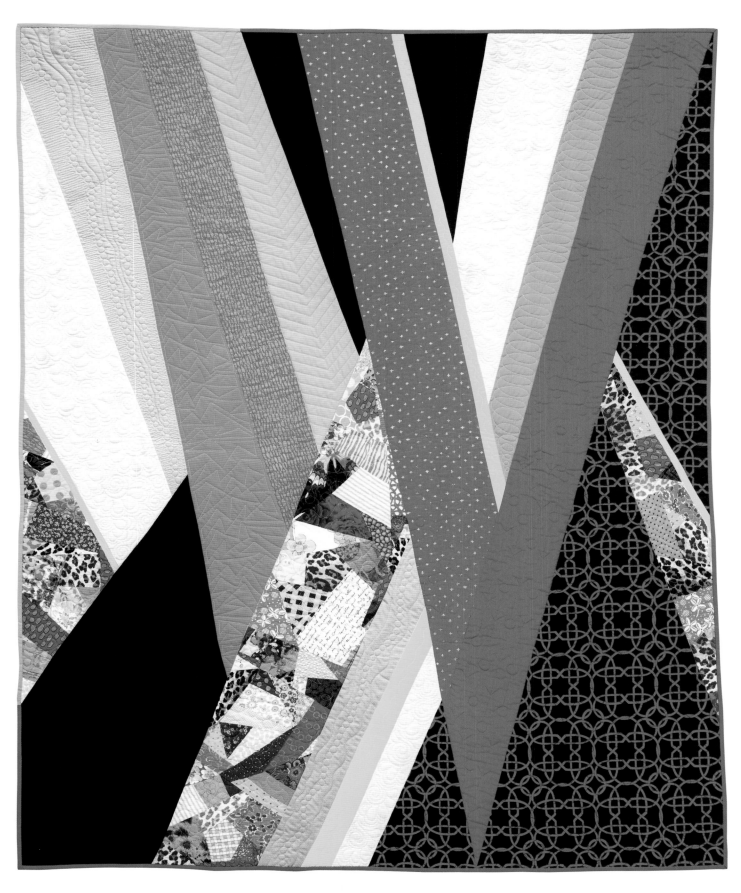

Modern Views II / Victoria Findlay Wolfe, quilted by Shelly Pagliai, 2014–2015, 50″ × 63″

Healing: Giving Joy

Being an artist/maker has given me a way to physically put my feelings out into the world in a tangible way. During a "Save Our Stories" interview with Meg Cox for the Quilt Alliance, Meg asked me, "Would you tell me if you've ever used quilts or quilting to get through a difficult time in your life?" It was early on in my career and I answered, "Not specifically. ... It's mostly joyous times. Anytime there is a baby in the family there is a quilt being made."

That is mostly true! Anytime I can make and give a quilt, it is a joyful experience, both in making it and making someone feel loved when I share it. But really, every quilt I make is part of my own healing process as a human. I make quilts because they make me happy, I make them because I can be very angry and sad at the loss of a dear friend or at one more person getting cancer or any other illness. I can work through the sadness of watching families struggle to find their way out of homelessness and help give them strength by making something for them with my hands. I can share my joy in threads, while making that quilt to congratulate a new life. I can heal by making something that helps me focus on the joys in my life rather than the sad or hard times. I can share my happiness in textiles as I celebrate adding another trip around the sun, by using my favorite colors.

Quilting pulled me out of my shell. I am an introvert. Speaking in front of groups or to people in small meaningless conversation does not come naturally to me ... it's difficult. But creativity, quilting in particular, has given me something I can speak passionately about. I found my voice and confidence by standing in front of a guild and showing my work. What happens when you take a chance, stand up, and say, "I made this, and I'm proud of it"? People who also like it, come to you and ask you about it. By doing that, I have found my people.

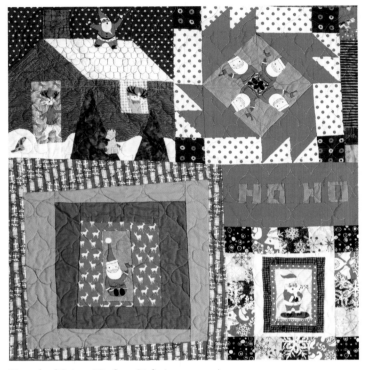

Detail of *Santa Kitchen Sink* (next page)

My closest friends in the quilting world have come from the very first quilt meetings I attended. The beauty in our creative community is that the quilters I met at the very first quilt guild meeting are still my closest sewing pals. I've made friends with people online, back when people thought that was "odd," and I've done block exchanges with people from all over the globe for myself and for others who were in need.

I've reconnected with family through quilting and friends from long ago through quilts. I've learned and taught through quilting, and I've mourned and celebrated lives who have touched my soul. I've soul searched and healed through constantly challenging my creativity through quilts. It's been a surprising and joyful journey that I have gently embraced, and am thankful each and every day that I have a something to do with my days that fills me and feeds my self care.

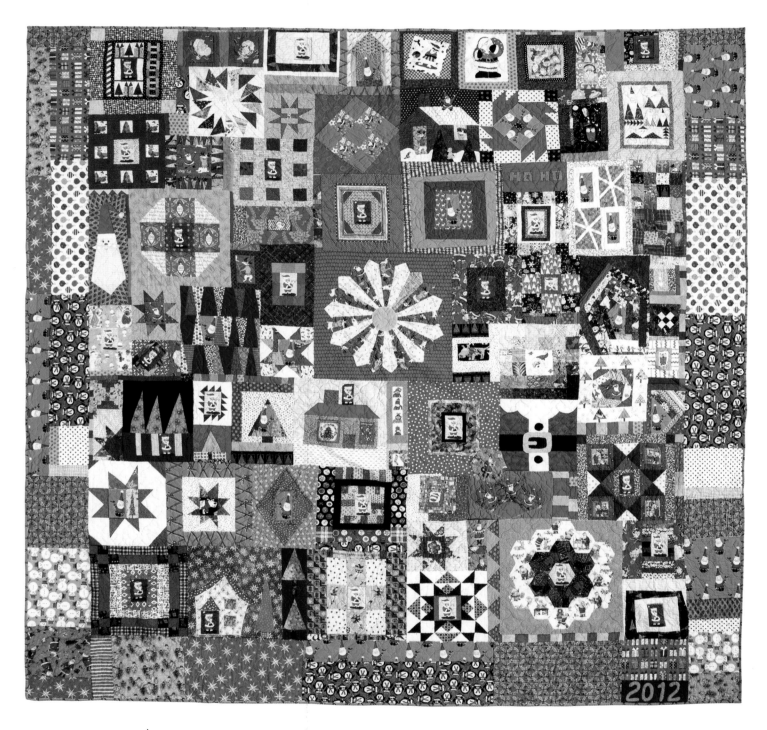

Santa Kitchen Sink / Victoria Findlay Wolfe, quilted by John Kubinec, 2012, 104˝ × 100˝, blocks contributed by friends across the internet

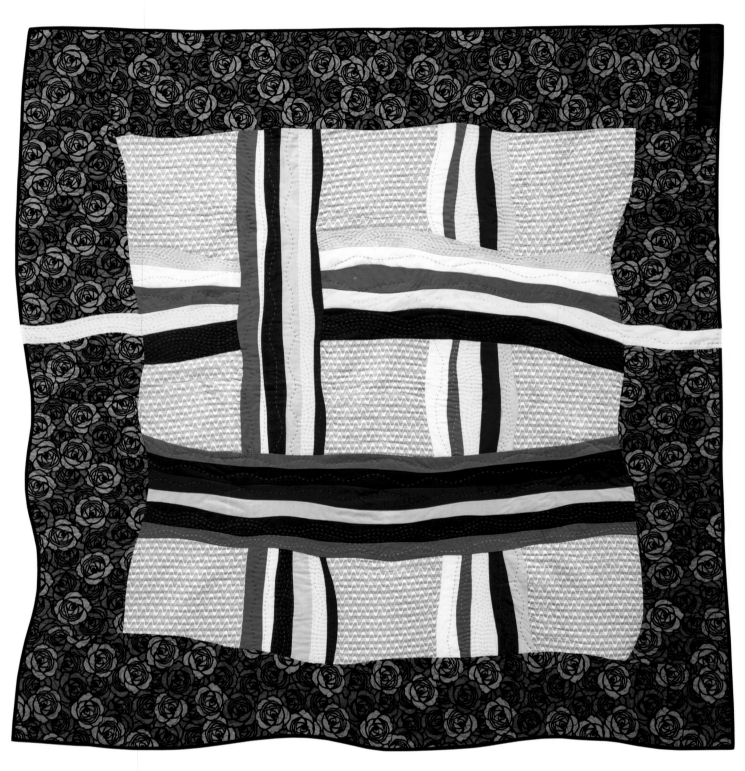

Minnesota Waverunner / Victoria Findlay Wolfe, 2009, 58˝ × 62˝, hand and machine quilted

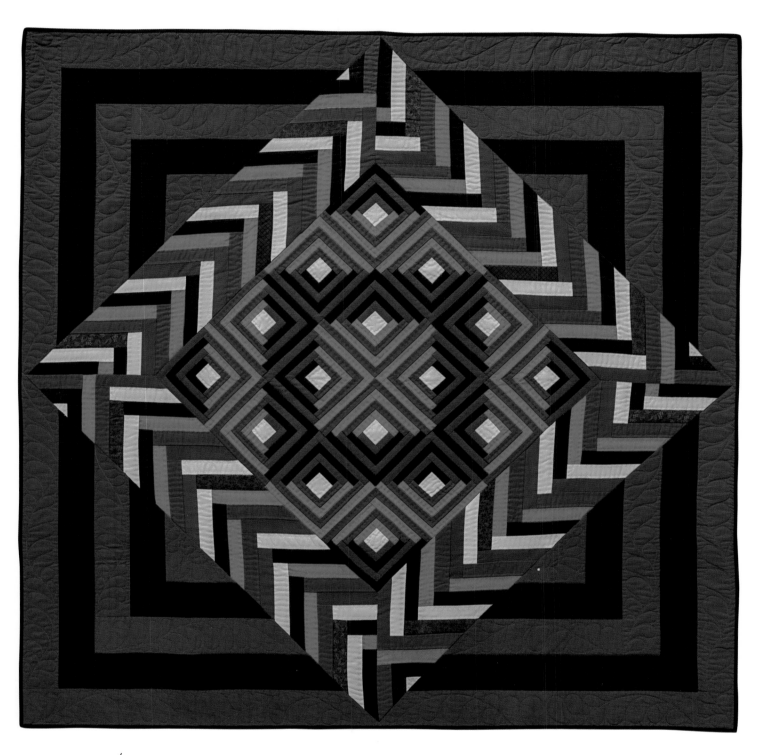

Polished Timber / Victoria Findlay Wolfe, 2015, 58˝ × 58˝, hand and machine quilted;
from the collection of the International Quilt Study Center & Museum, University of Nebraska–Lincoln, 2018.053.0001

Contemplating life's blessings, what I've done,
and where I'm going is a way to heal, grow, and
push my creativity! Put your thoughts into fabric,
build it, make your feelings physical. We are lucky
to have something we are so passionate about.
Quilting is very healing to make, share, and
document that reflective process.

Reflect Upon Your Blessings
Victoria Findlay Wolfe,
2014, 23˝ × 58˝

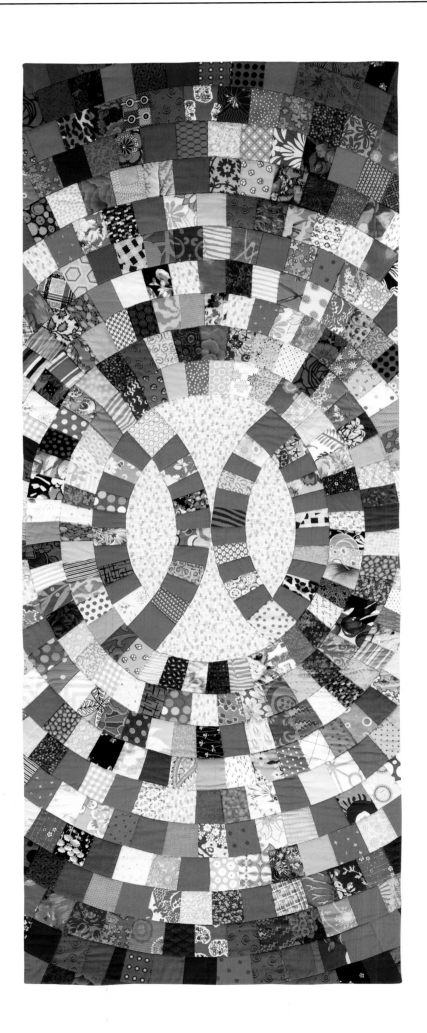

Sitting at home behind my sewing machine might sometimes feel small and singular ... but asking friends (and strangers) from all over the globe to make you a block certainly makes your life seem better and your world a bit bigger! Many of the strangers who submitted blocks to this project have become friends. Pure magic.

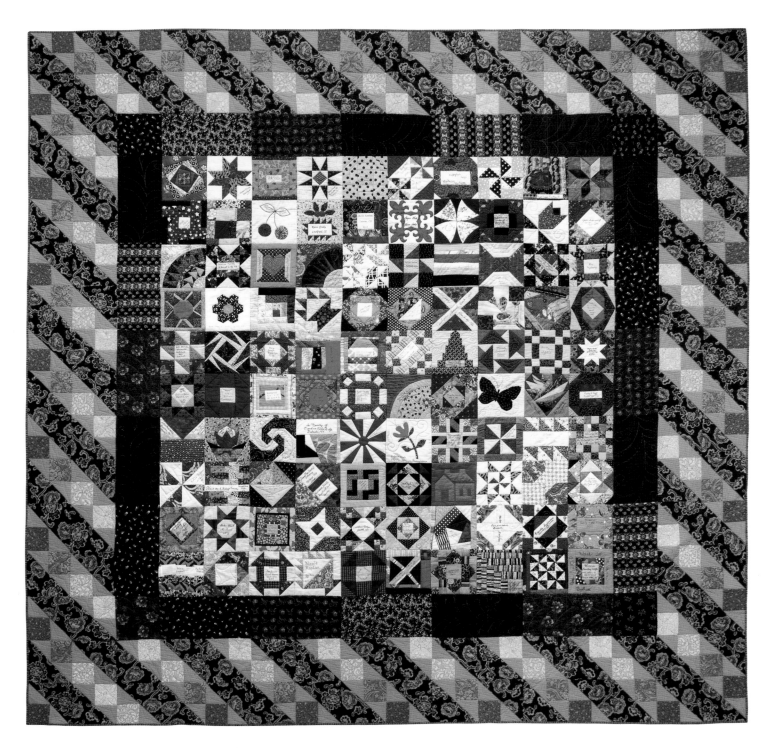

Bloggers, Family, and Dear Friends / Victoria Findlay Wolfe and friends, family, and internet friends; quilted by Shelly Pagliai; 2011–2017; 94˝ × 93˝; signature quilt

I definitely make a lot of Christmas quilts. They bring me joy—and I choose to stay connected to my joy. Making what you love keeps the joy near.

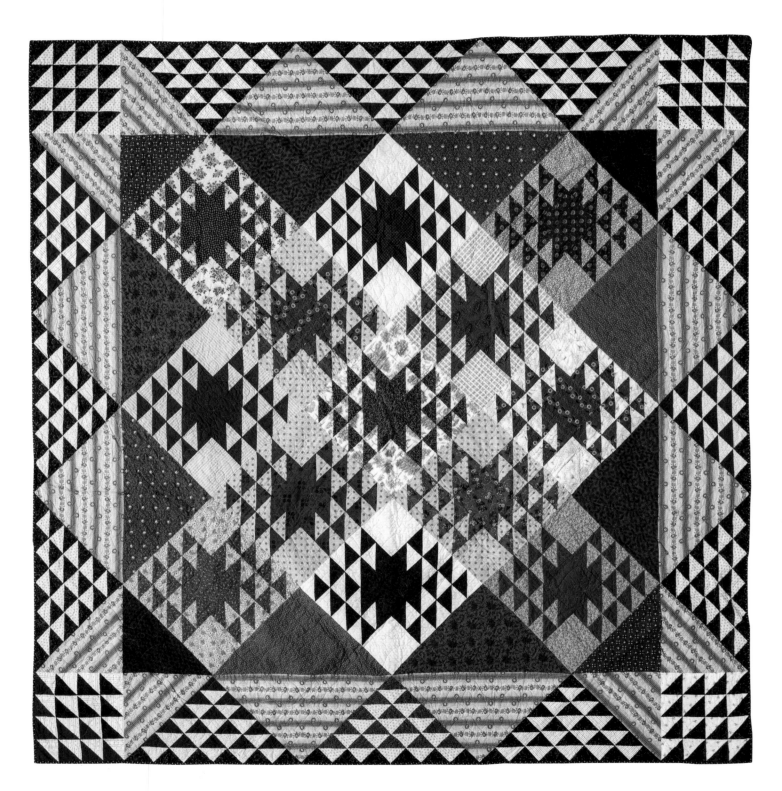

Comfort Christmas / Victoria Findlay Wolfe, 2015, 82˝ × 80˝

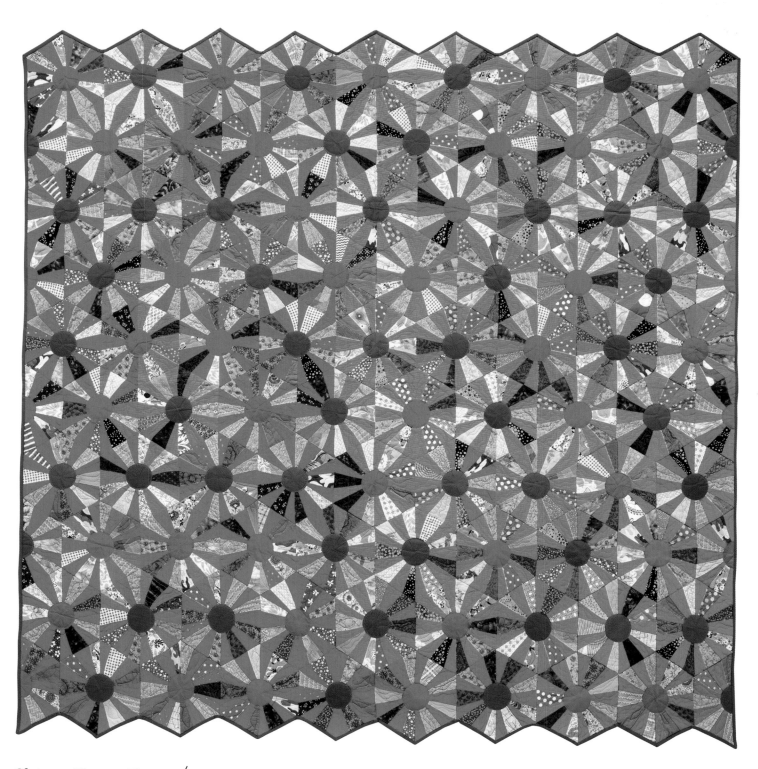

Christmas Hexagon Flowers / Victoria Findlay Wolfe, 2012, 77˝ × 77˝

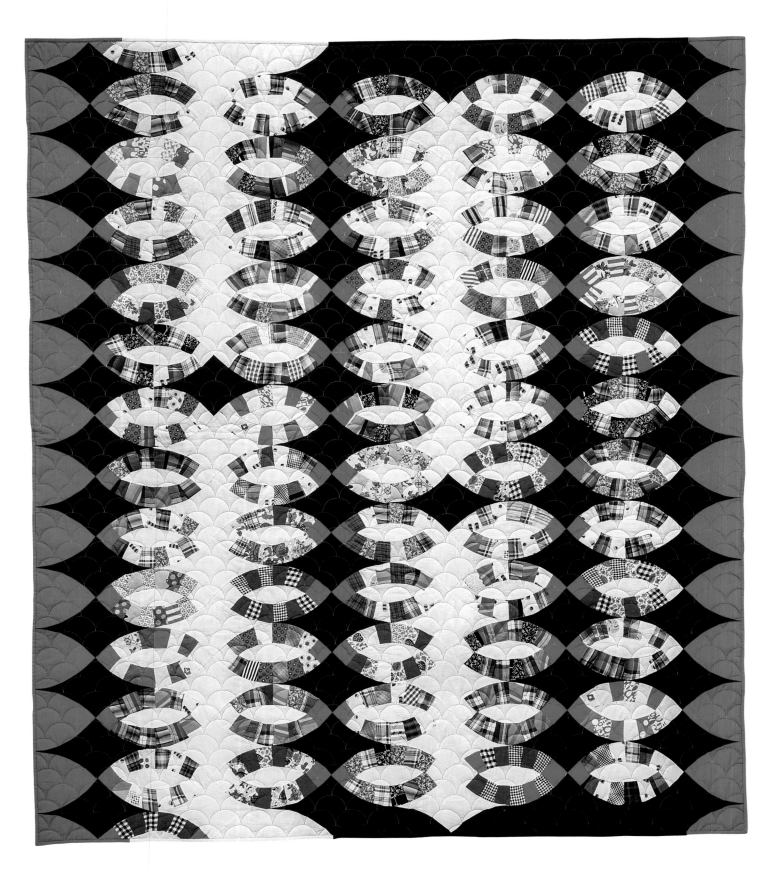

Leona / Victoria Findlay Wolfe, 2013, 67½˝ × 77½˝

Complete quilt instructions can be found in my book *Double Wedding Ring Quilts—Traditions Made Modern* (page 159).

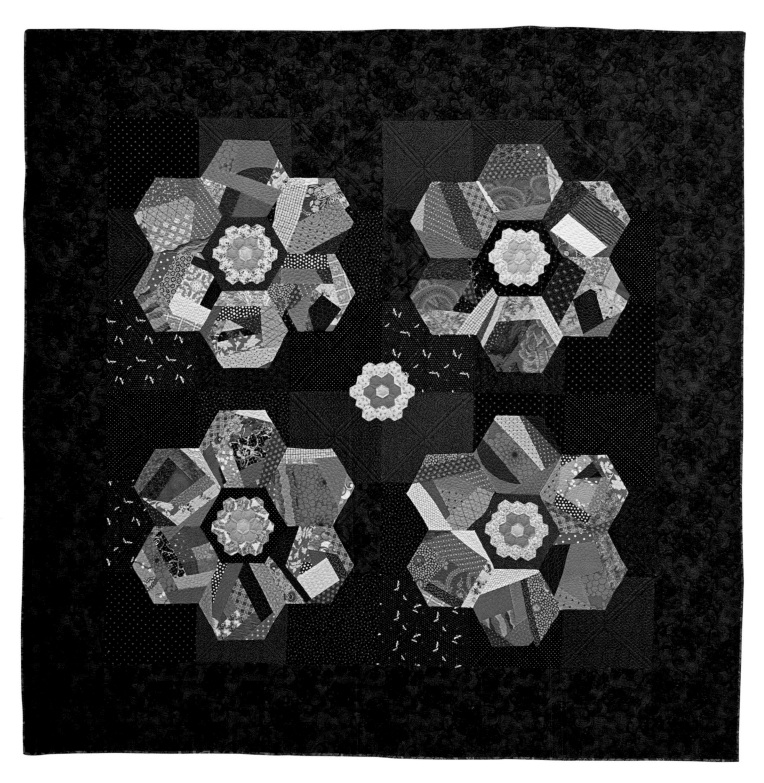

Something Old, Something New / Victoria Findlay Wolfe, quilted by Angela Walters, 2011, 87˝ × 91˝

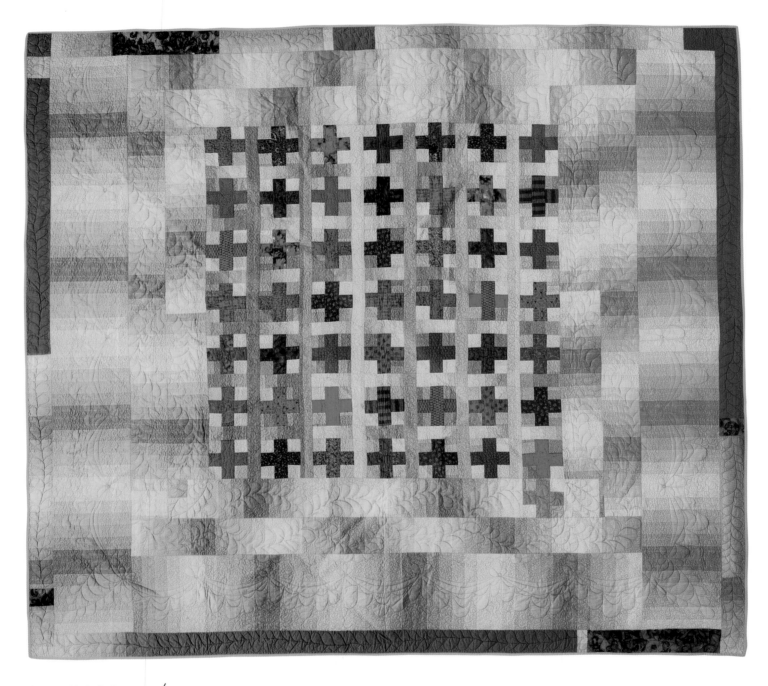

Green & Red Crosses / Victoria Findlay Wolfe, 2010, 97˝ × 88˝

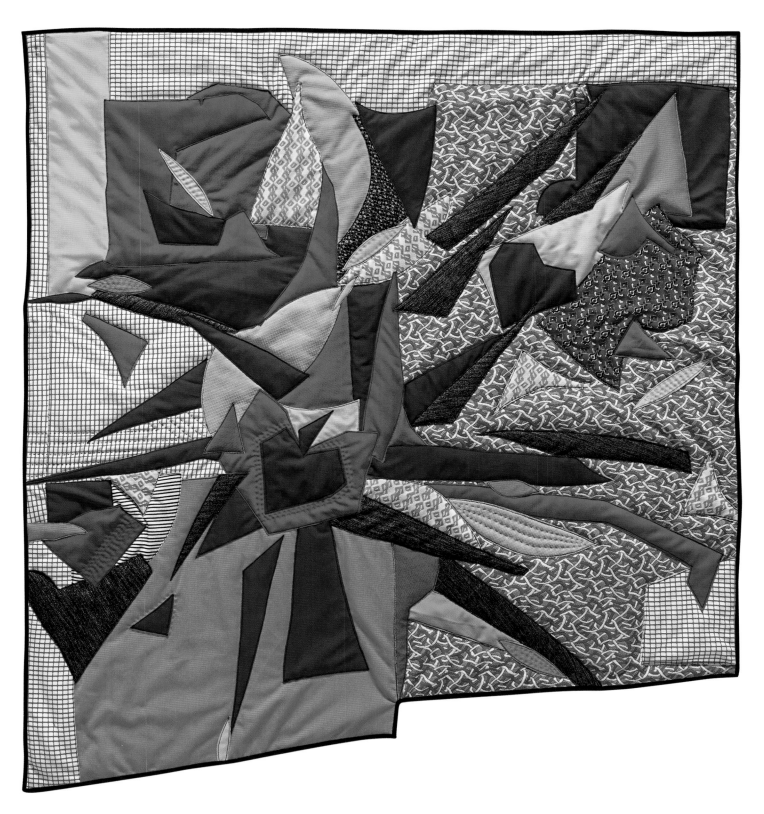

Raw Emotion / Victoria Findlay Wolfe, 2016, 58½″ × 63″, made in memory of Michael C. Meier, hand and machine quilted

New Challenges: What's Next?

As I look back at this body of work, I can see where and how I have changed and grown as an artist. I can also see how I've never been able to waver from some forms of my designs. Mostly, that comes from not being able to see over 100 of my quilts at one time! (It's certainly a humbling experience. ...) But the patterns I see in my work, the square-in-a-square sense or quilts without borders, I think are my "comfort food" style. Some designs just feel good to me. But now, looking over the expanse of work, I can clearly see where and what I want to try now, and that excites me!

The beauty in looking back at my work (or your work) or thinking about my process, is that I realize I am not the same quilter I was a year ago, or five years ago, or ten years ago.

My color sense has changed, my skill sets have changed, my level of techniques has changed and developed, and best of all, my patience level has changed. I can always feel when a shift in my process is about to occur. I feel unsteady about projects, or not as interested, so I sit in that weird headspace to see what comes of it.

When I was first making quilts obsessively, heavily into improv, I enjoyed the rush of making quickly, working in gestural movements, just to make and see what happened. Next came learning to sit longer with my thoughts and process, as I made my first double wedding ring quilt. After making more than 70 double wedding ring quilts, I can tell you my process was something totally new, and my patience had grown, working on the complete thought of a quilt. Again, I felt a shift. Quilts that I always loved, but found repetitive and boring, are just the kind of quilts I find intriguing.

By the time this book comes out, I will be rooted in my next creative phase, which I feel I am just settling into—repetition of small pieces with loads of color and pattern. ... I am still fascinated by color, pattern, and design, just as I was as a small child. And I am still convinced that sleeping under double-knit polyester scrap quilts indelibly set my sense of color.

I can tell you I never thought I'd say: Who knew the fabrics of my youth could be threaded so deeply into my veins! ... But you can already see here in my current works that it is, and it is feeling really, really good.

Somehow, the joy keeps getting greater, not just in my creative life, but in my personal life as well. Getting older and wiser has its benefits! Keep seeing, keep your options open, let in the opinions from those who matter most, and let the other stuff go ... and keep making *joy*! Tell the quilt police (in your head and outside) where to go. It's your fabric, your time, your memories, your joy. Just make!

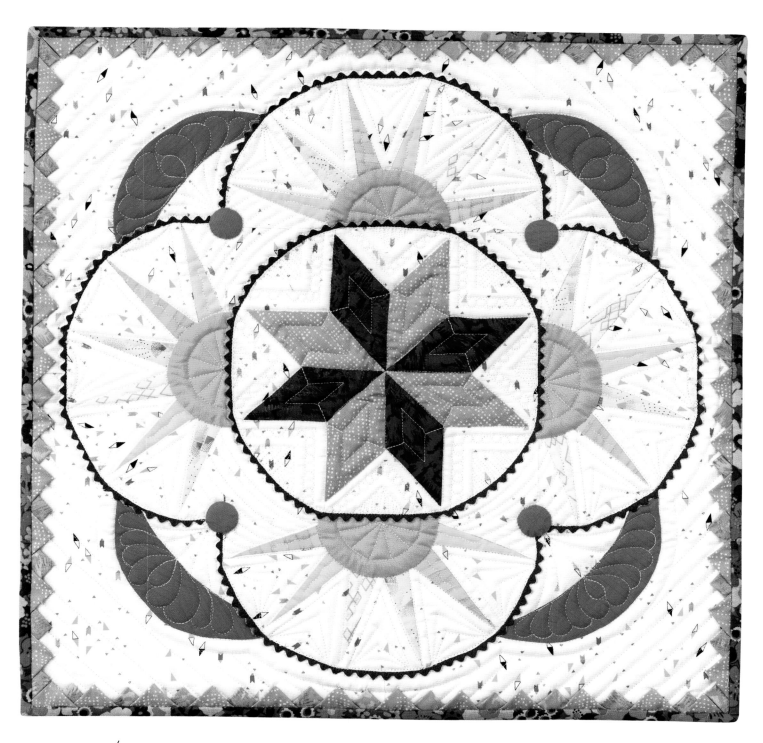

Sunny Side Up / Victoria Findlay Wolfe, quilted by Shelly Pagliai, 2018, 19″ × 19″

Photo by Alan Radom

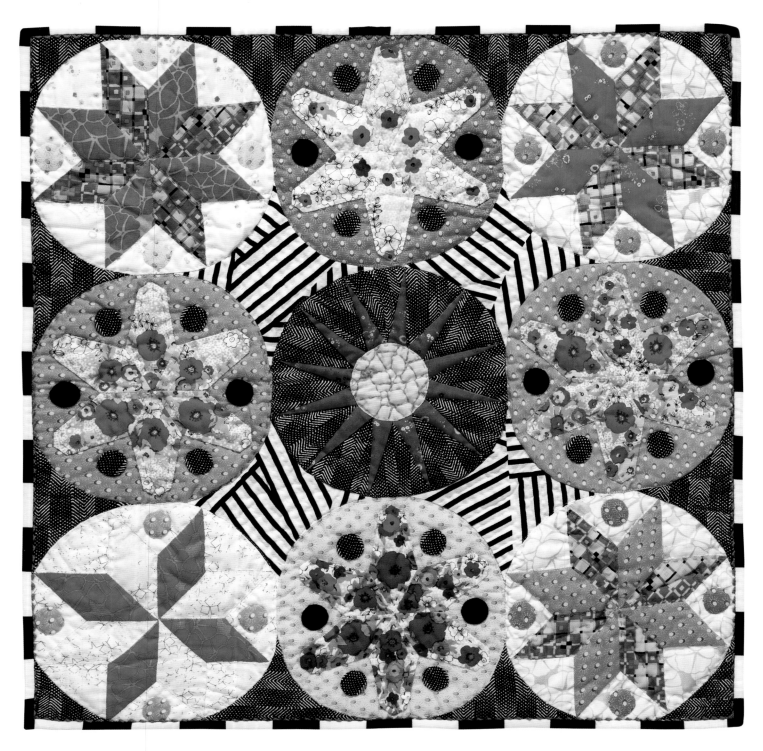

Meadow Blooms / Victoria Findlay Wolfe, 2016, 24″ × 24″, hand quilted

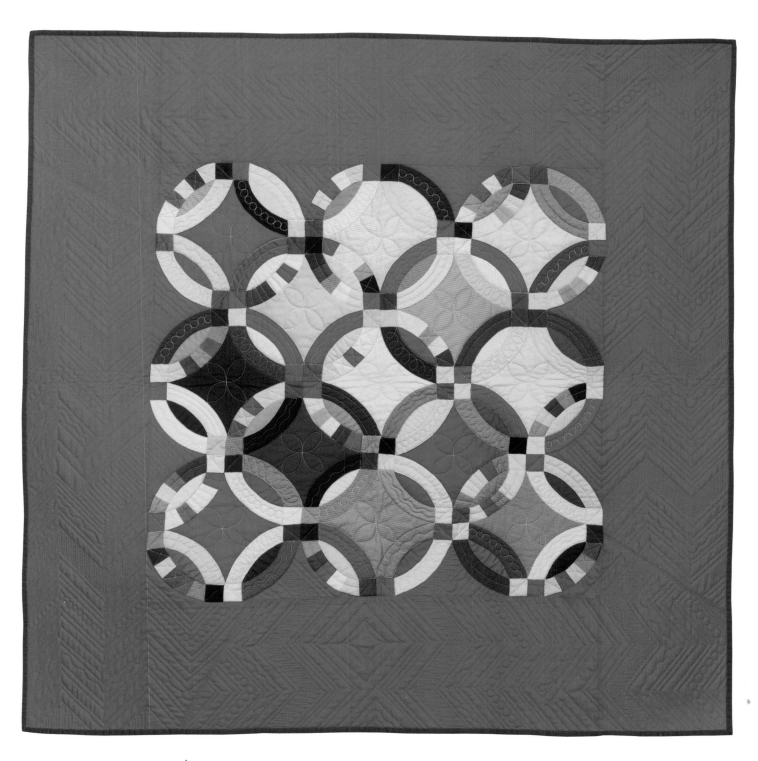

Mini Double Wedding Ring / Victoria Findlay Wolfe, quilted by Shelly Pagliai, 2014, 40˝ × 40˝

Photo by Michael McBride, Sizzix

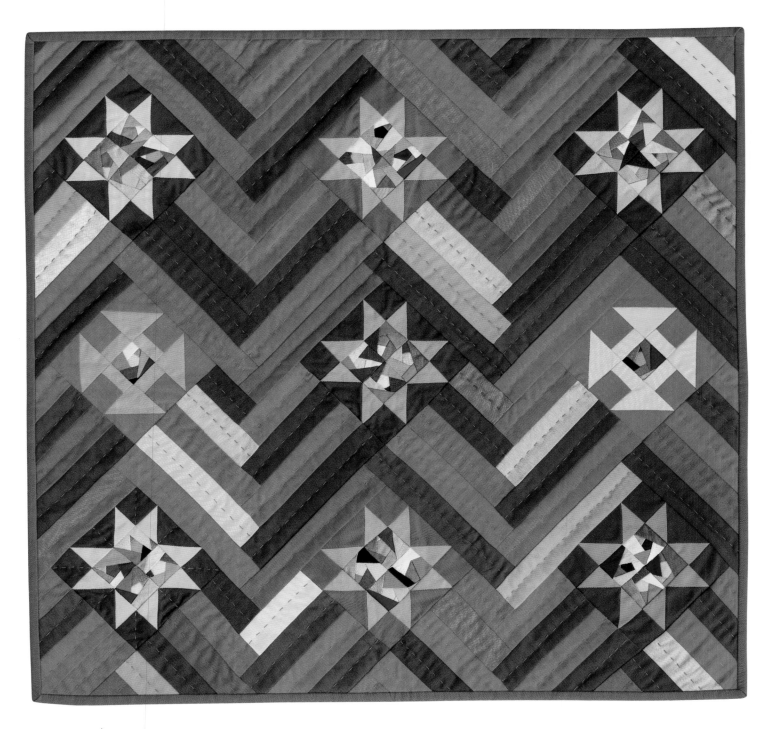

Little Red / Victoria Findlay Wolfe, 2017, 22˝ × 23˝, hand quilted

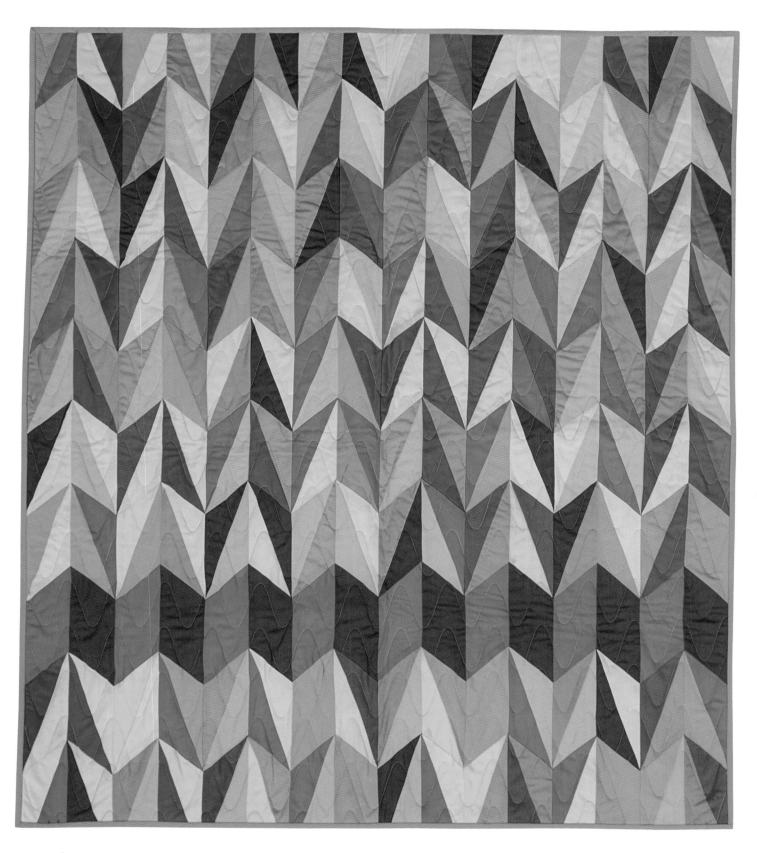

Darts / Victoria Findlay Wolfe, 2014, 36˝ × 42˝

Photo by Michael McBride, Sizzix

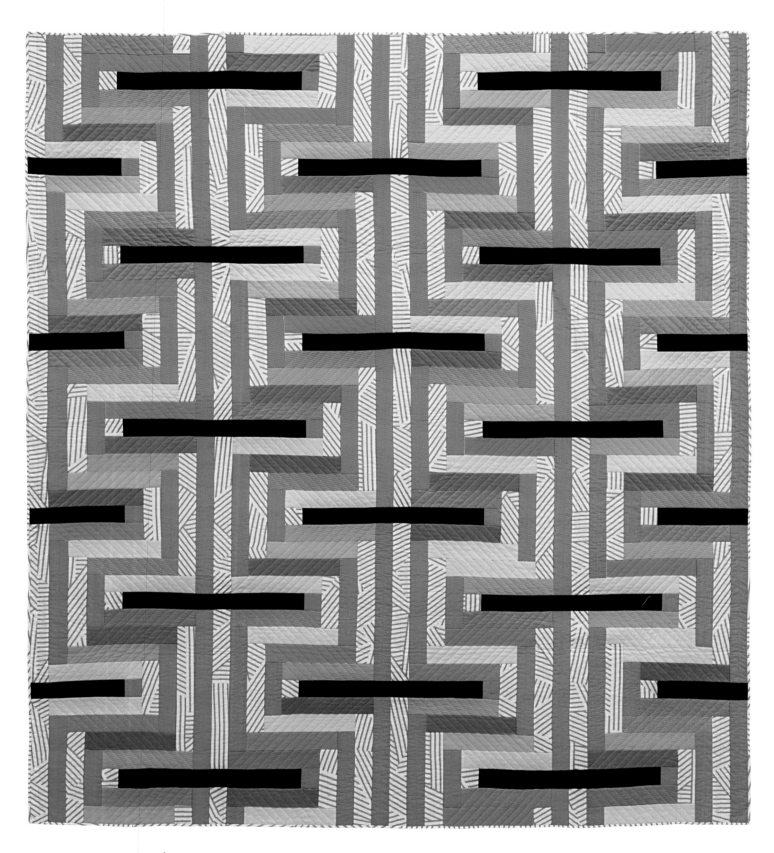

The Happy Wanderer / Victoria Findlay Wolfe, quilted by Shelly Pagliai, 2016, 80˝ × 90˝

Complete quilt instructions can be found in my book *Modern Quilt Magic* (page 159).

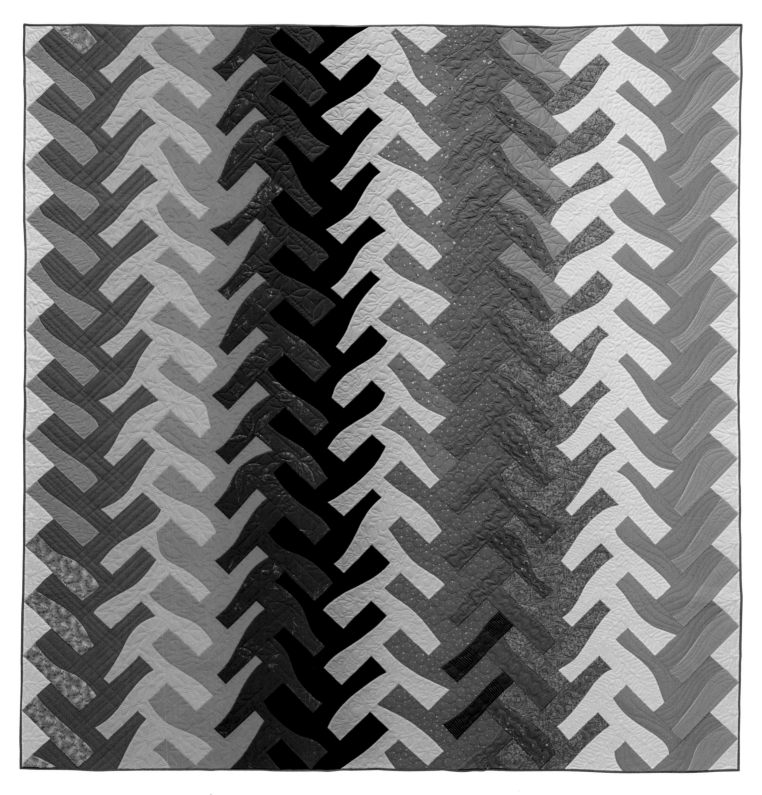

The Difference Between Things / Victoria Findlay Wolfe, quilted by Kelly Cline, 2016, 85˝ × 92˝

Complete quilt instructions can be found in my book *Modern Quilt Magic* (page 159).

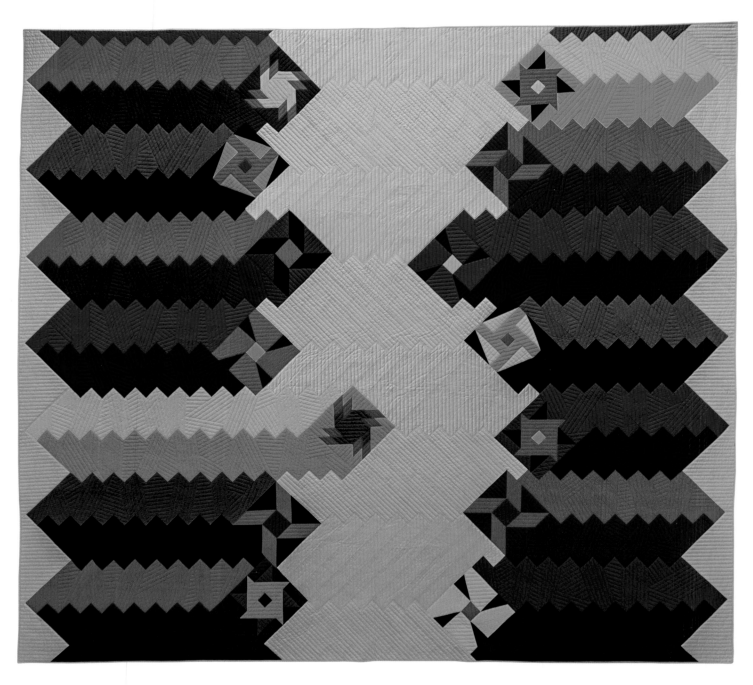

Mindful Balance / Victoria Findlay Wolfe, quilted by Shelly Pagliai, 2016, 100˝ × 89˝

Complete quilt instructions can be found in my book *Modern Quilt Magic* (page 159).

The word *soigné* means elegantly maintained, well put together. Think about all the different techniques you know and which ones you need to learn (or tackle?). Looking for new quilty ideas starts by identifying what you already know (or do), so you can push yourself in a new direction. Buy the same fabrics? Buy the same colors? Make the same quilt? What can you do today to shake up your creativity? Change it up. Play. Enjoy.

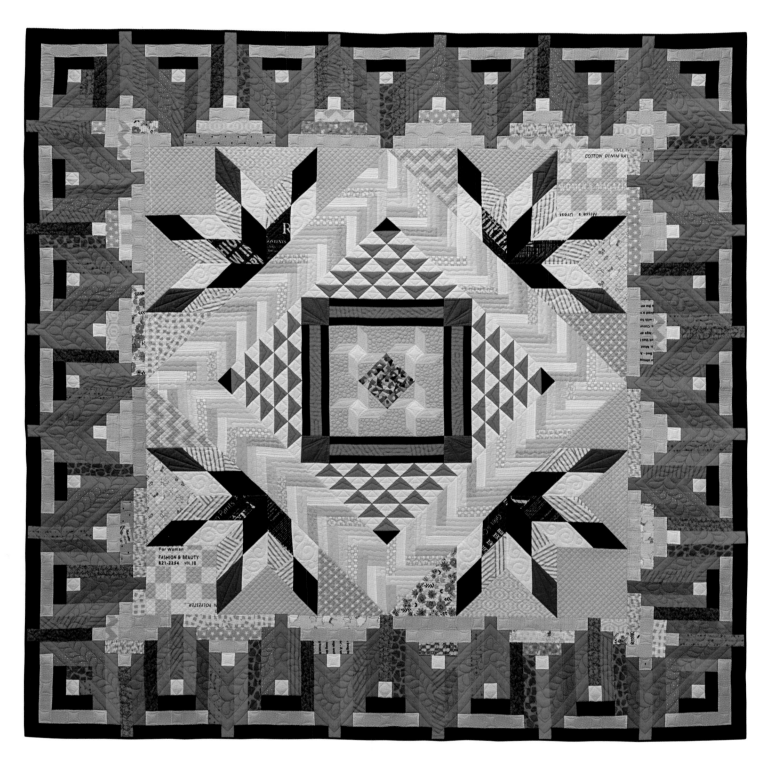

Soigné / Victoria Findlay Wolfe, quilted by Shelly Pagliai, 2016, 87″ × 87″

Complete quilt instructions can be found in my book *Modern Quilt Magic* (page 159).

Many of the quilts I made in my early days are improv. Today, I may make quilts that have a more traditional feel in a modern way. But even those quilts are built improvisationally on my design wall without a predetermined plan. Bringing together different design styles, layers of fabrics, and your technical skills to tell a story, makes for unique and interesting quilts. I love bouncing around between styles and ideas, because I don't want to become stagnant. I want the ideas to keep coming. I have many more quilts to make in my lifetime!

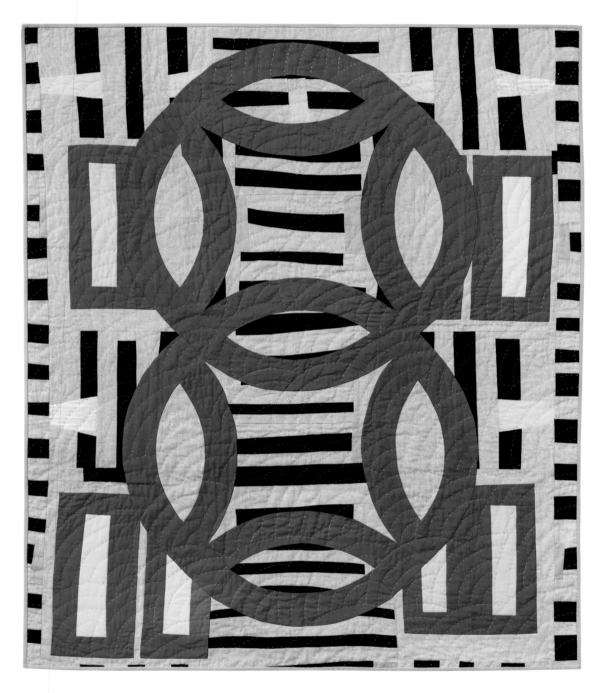

Full Circle Moments / Victoria Findlay Wolfe, 2018, 40˝ × 48˝, hand quilted, made for the Response to Gee's Bend Quilts exhibit at Swarthmore College

Photo by Victoria Findlay Wolfe

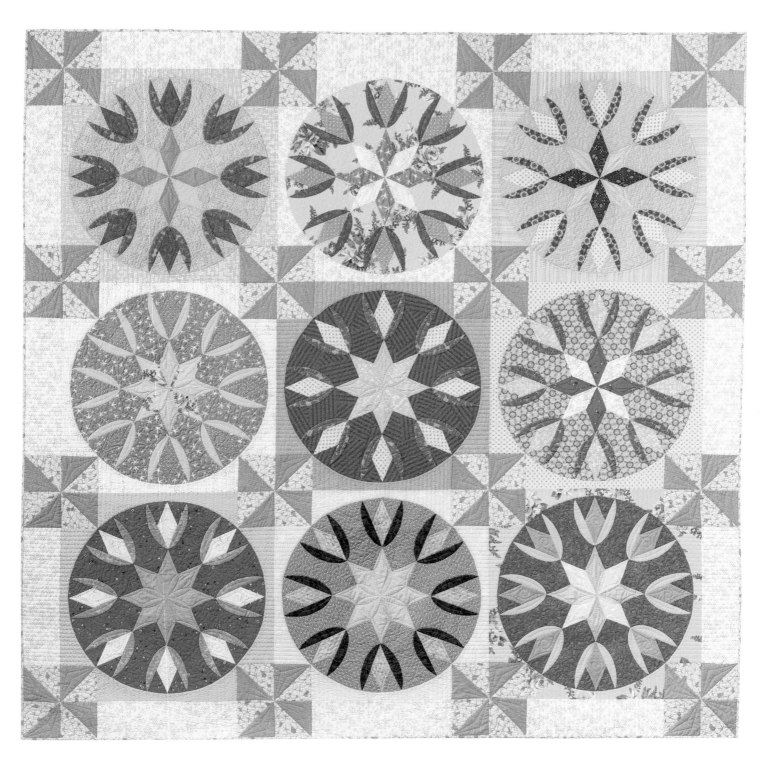

Cottage Tulips / Victoria Findlay Wolfe, 2018, quilted by Shelly Pagliai, 82˝ × 82˝

Complete quilt instructions and acrylic templates can be found on my website (page 159).

Photo by Alan Radom

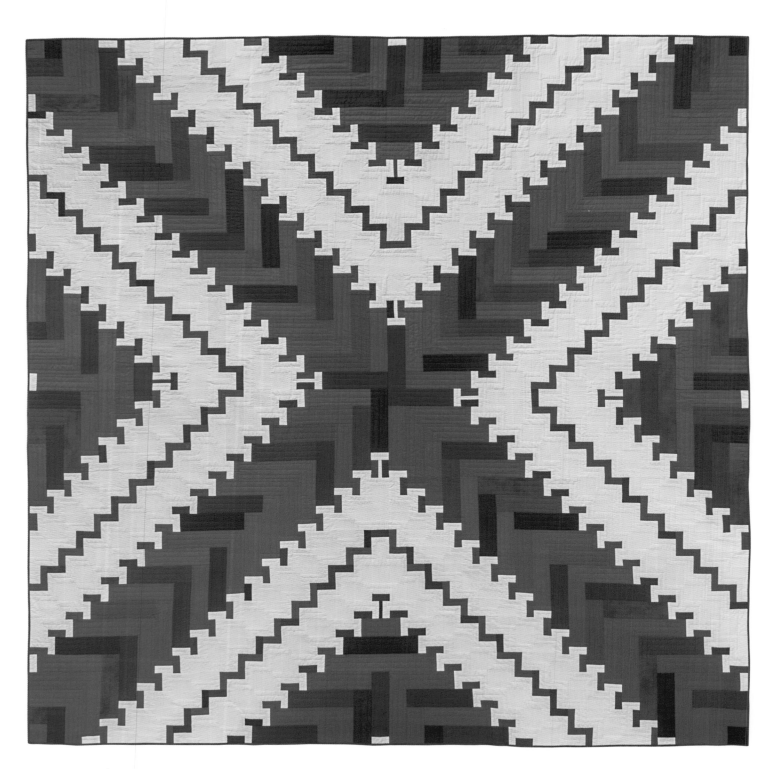

ENOUGH / Victoria Findlay Wolfe, quilted by Shelly Pagliai, 2016, 98˝ × 98˝

Complete quilt instructions can be found in my book *Modern Quilt Magic* (page 159).

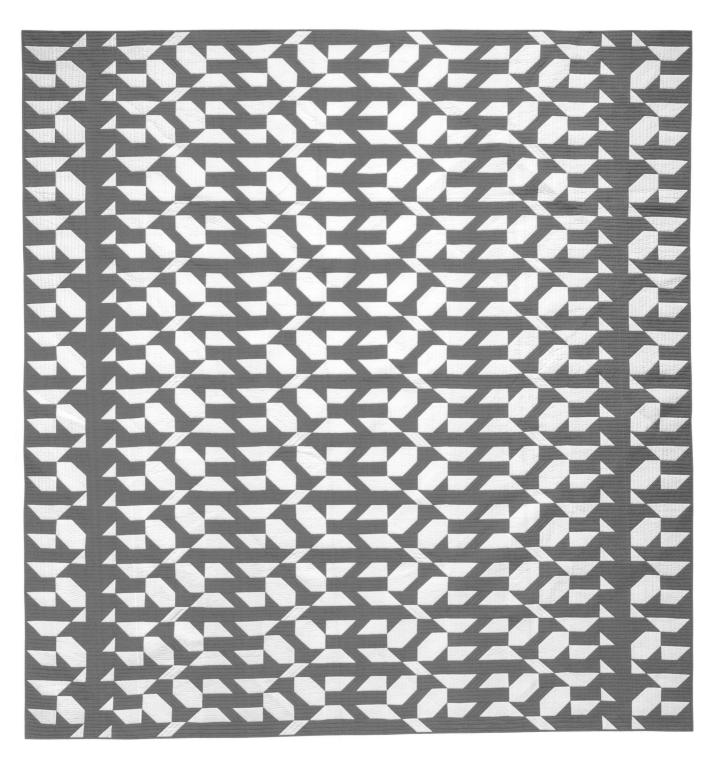

Crowd Pleaser / Victoria Findlay Wolfe and Kim Hryniewicz, quilted by Shelly Pagliai, 2017, 88˝ × 98˝

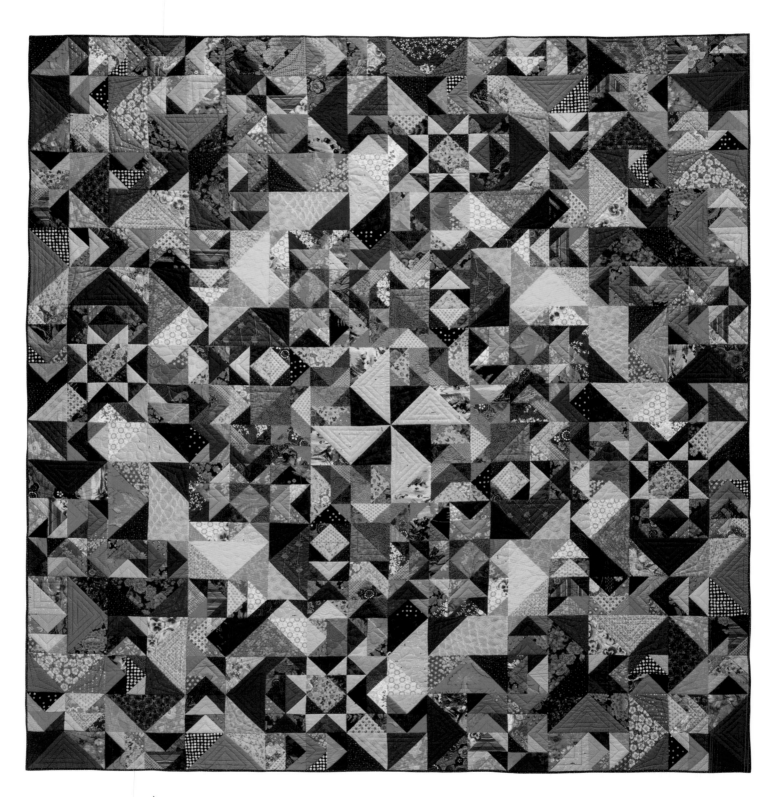

Carol's Jubliee Quilt / Victoria Findlay Wolfe, quilted by Shelly Pagliai, 2017, 106˝ × 110˝, from the collection of Carol Tucker-Foreman

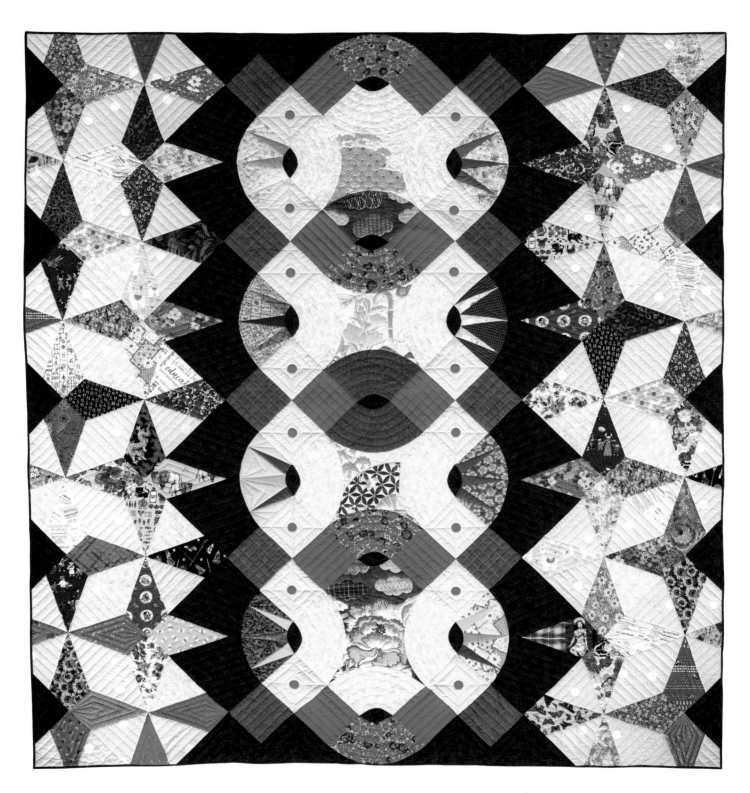

Texture, Travel, and Happiness: Life of Experiences and the Responsibilities of Dreams / Victoria Findlay Wolfe,
quilted by Shelly Pagliai, 2018, 88˝ × 96˝, from the collection of Susan Young

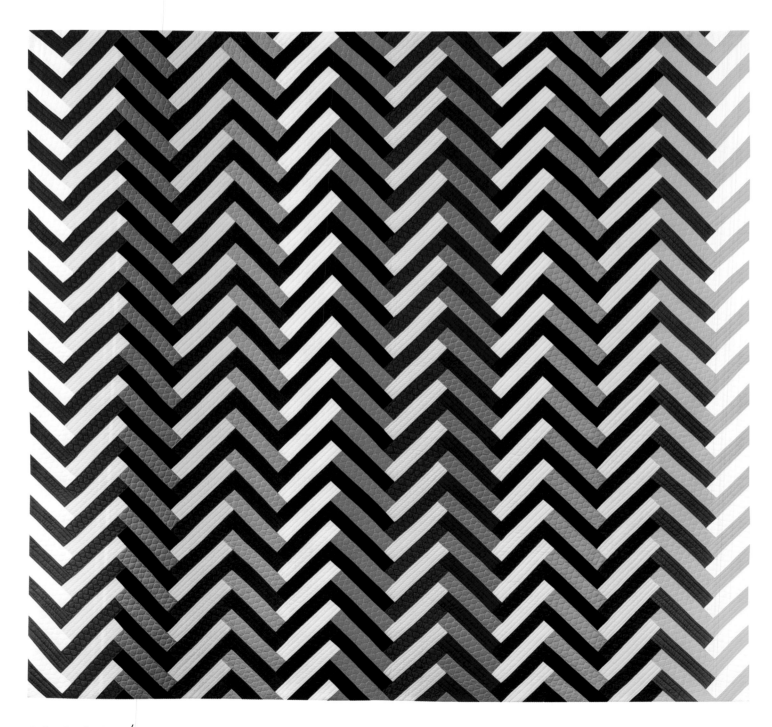

Color Study H1 / Victoria Findlay Wolfe, quilted by Shelly Pagliai, 2017, 70˝ × 65˝

Photo by Alan Radom

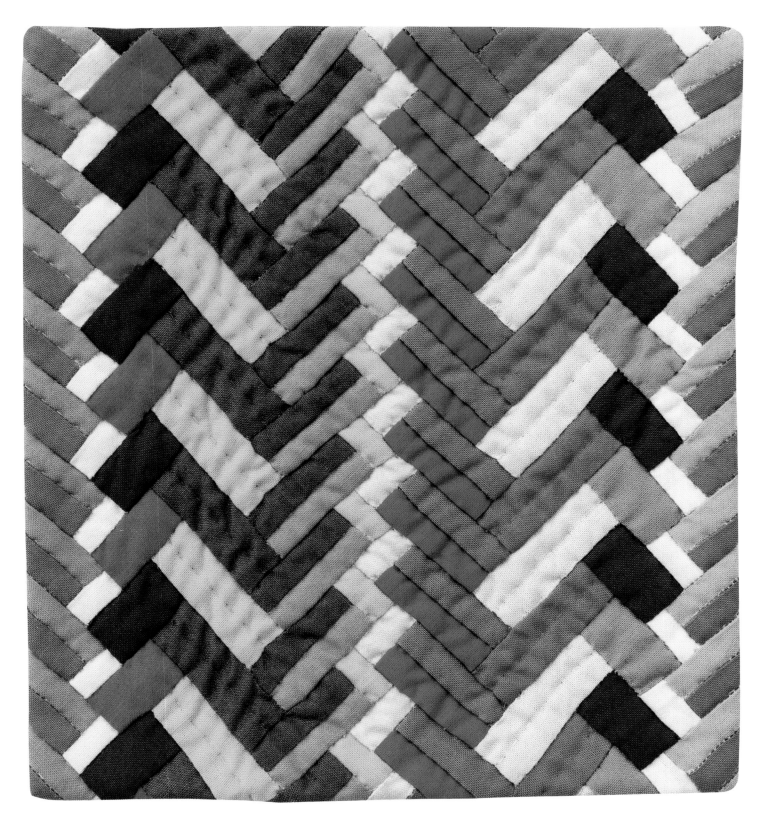

*A **Little Bit More*** / Victoria Findlay Wolfe, 2018, 7″ × 7¾″, hand quilted

Photo by Alan Radom

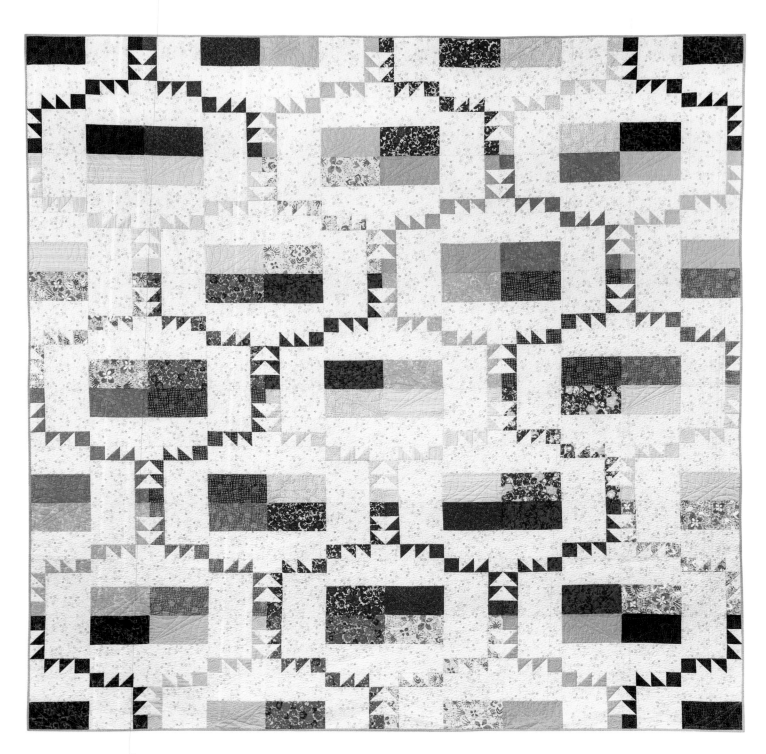

Scenic Overlook / Victoria Findlay Wolfe, quilted by Shelly Pagliai, 2017, 94˝ × 94˝

Complete quilt instructions can be found on my website (page 159).

Photo by Alan Radom

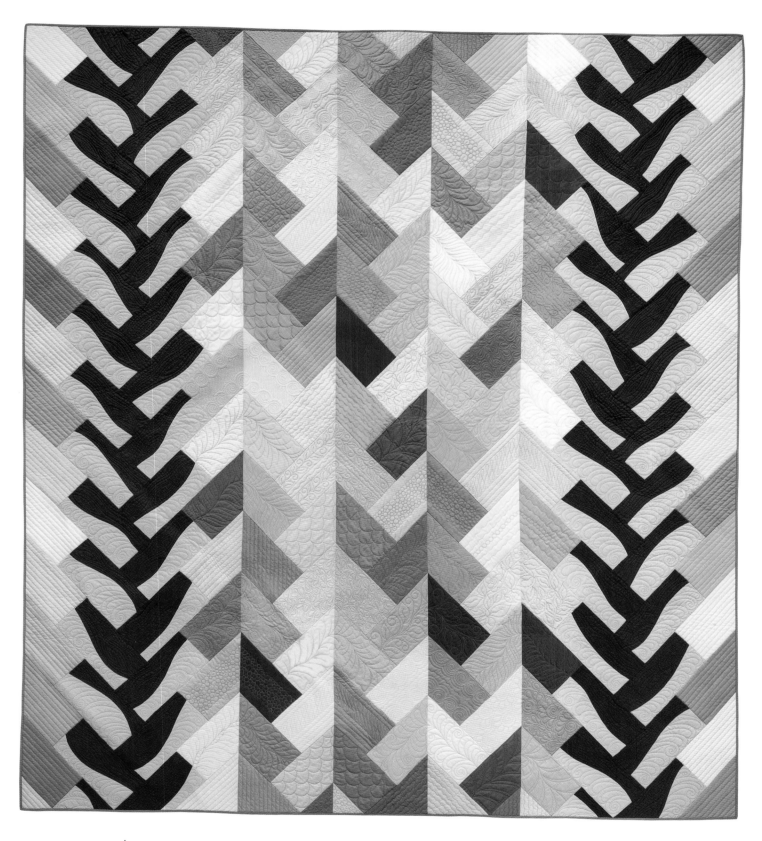

Vines & Valleys / Victoria Findlay Wolfe and Laura Clark, quilted by Shelly Pagliai, 2018, 77" × 91"

Complete quilt instructions can be found on my website (page 159).

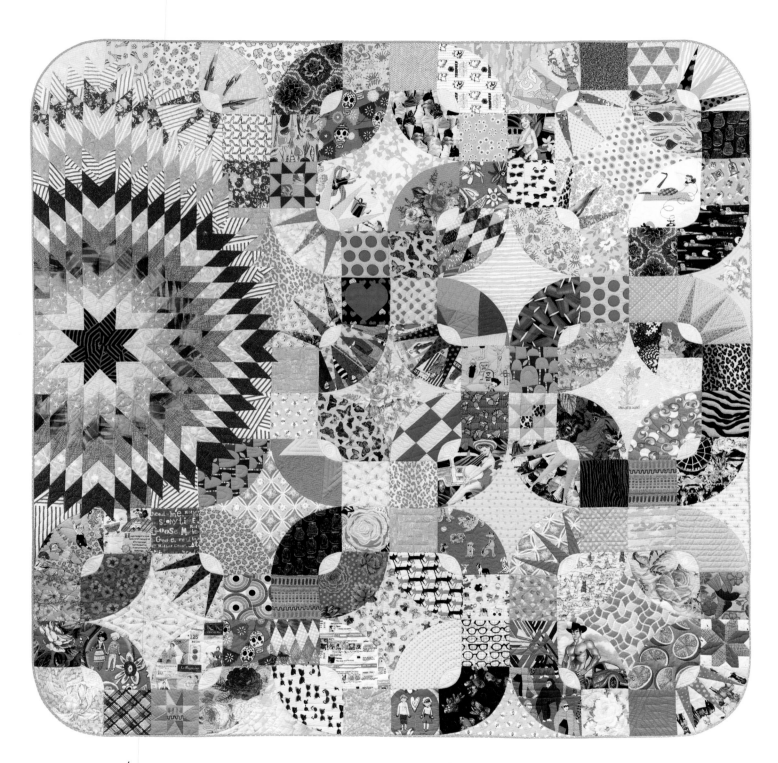

One of a Kind / Victoria Findlay Wolfe, quilted by Shelly Pagliai, 2018, 90″ × 90″, from the collection of Trissa Hill

Photo by Alan Radom

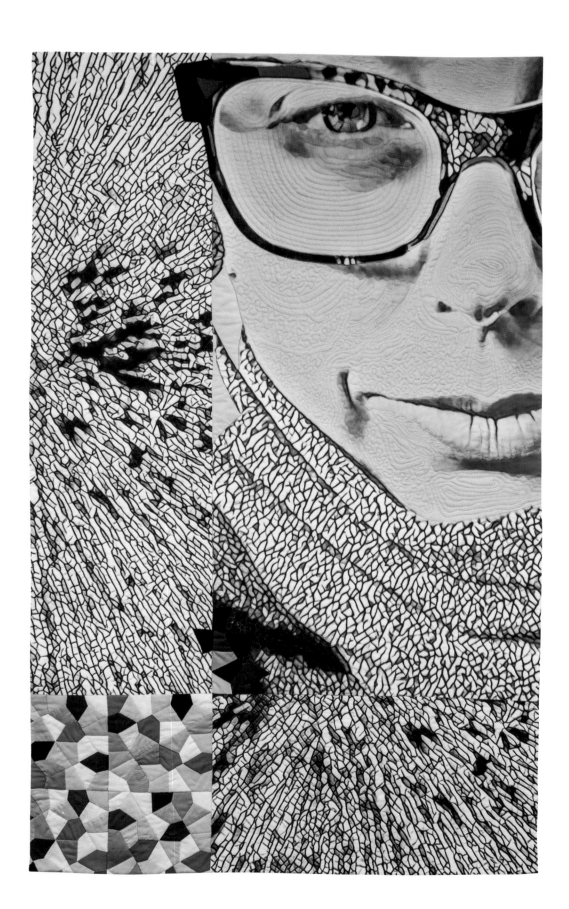

For the longest time, I have not really incorporated my fine arts degree of painting and photography into my quiltmaking, except for the process in which I build a quilt on my design wall. Now I am finding ways to incorporate my photography and I'm very curious to see how far I can push this. Who knows, maybe surface design will start showing up in my work. The possibilities are endless, and I let the path unfold before me. I feel the winds have shifted and a new series of work will be evolving. I love sitting in that place of discovery. I wonder what will be next—and I will have fun finding out.

A Year of Moments
Victoria Findlay Wolfe,
2018, 30˝ × 50˝

Final Thoughts

Looking back at 35 years of quilting and even more years creating, my brain and eyes have found this amusing and enlightening. This is what I know:

- I am restless.

- Every project I start, I consider myself a beginner. The possibilities lie before me as fresh thoughts and fair game.

- I love to make mistakes because they put me in front of new challenges to see what I can do next.

- I can "risk it all" just to see what happens. That fear of cutting up old projects literally gives me a rush. It's a challenge I am always willing to take.

- I'm a horrible student because I cannot stand around and watch. I want to play, discover, and search for the answers on my own. My brain never stops looking, searching, and wondering how to make something. So, that said, I feel that when my curiosity is gone, there will be something seriously wrong with me, or it is my end.

- I said in the early years of my work, that repetition bored me. I needed to find a way to have many directions happening at once. So now, looking back at my work, I can actually see formats and design concepts that I have never been able to get away from. This means repetition was happening, just not sequentially. So, when I now say I am interested in repetition, that irony is not lost.

- I don't ever stop working, although calling what I do "work" is just not accurate. It's *joy!*

—*Victoria Findlay Wolfe*

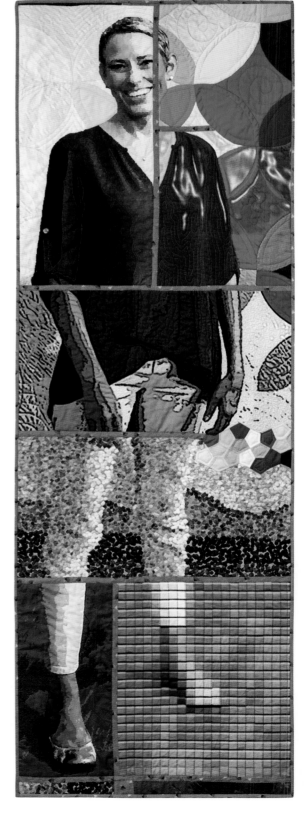

Stitched Together
Victoria Findlay Wolfe,
2018, 24˝ × 72˝

Photo by Alan Radom

About the Author

Victoria Findlay Wolfe is a New York City–based, international award-winning master quilt and fiber artist; teacher; lecturer on the creative process; and fabric and product designer for Aurifil (threads) and Sizzix (die cutting). She is the author of the quilting books *15 Minutes of Play—Improvisational Quilts*, *Double Wedding Ring Quilts—Traditions Made Modern*, and *Modern Quilt Magic* (all from C&T Publishing). She also owns Victoria Findlay Wolfe Quilts—a.k.a. VFW Quilts—a specialty quilting store in NYC that carries all her products, providing inspiration to the fiber maker. She also sells her custom work to museums and collectors in the design world who appreciate finely made quilts: a true classic art form.

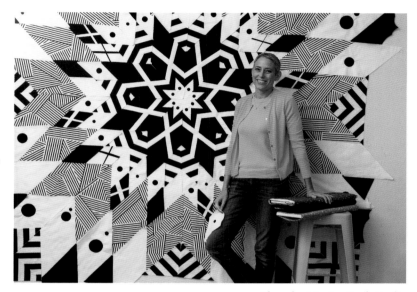

Photo by Monica Buck Studio

Victoria sits on advisory boards for the International Quilt Study Center & Museum and the Wisconsin Museum of Quilts & Fiber Arts. Her quilts have traveled all over the globe, including Japan and Australia, and in museums such as the New Britain Museum of American Art, the International Quilt Study Center & Museum, the San Jose Museum of Quilts & Textiles, the Wisconsin Museum of Quilts & Fiber Arts, and the International Quilt Festival (Houston, Texas). She is proud to be a quilter, a mother to Beatrice, and a wife to Michael Findlay, the true loves in Victoria's life.

Victoria's work balances between art, traditional, and modern quilts and has a master flair, bringing the fine art of quilting to the modern age.

Also by Victoria Findlay Wolfe:

Visit Victoria online and follow on social media!

Website: https://vfwquilts.com

Facebook: /victoriafindlaywolfequilts

Pinterest: /VFWquilts

Instagram: @victoriafindlaywolfe

Want even more creative content?

Make it, snap it, share it *using #ctpublishing*